Pasta™

"I don't believe in God, but when I see Laetitia, I'm tempted to change my mind."

VIVIENNE WESTWOOD

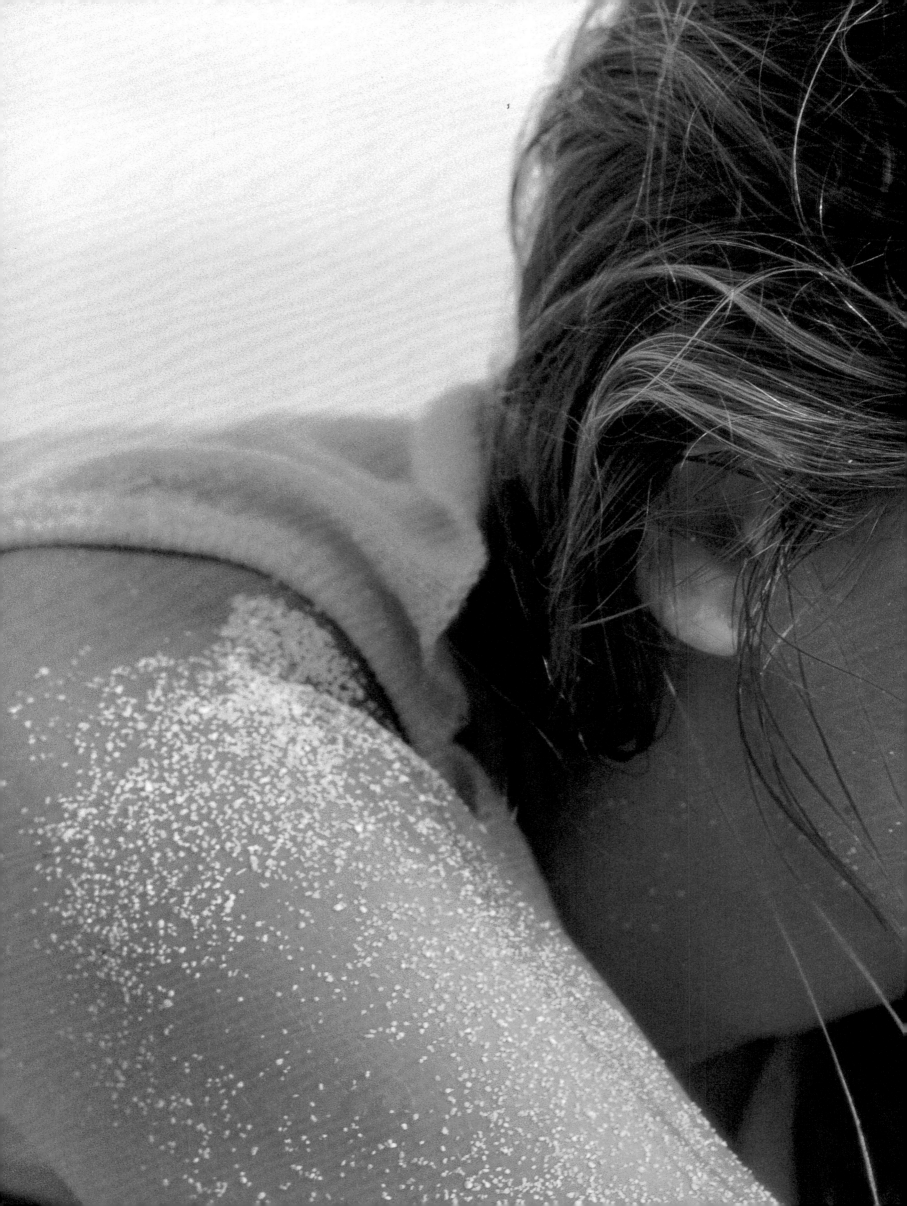

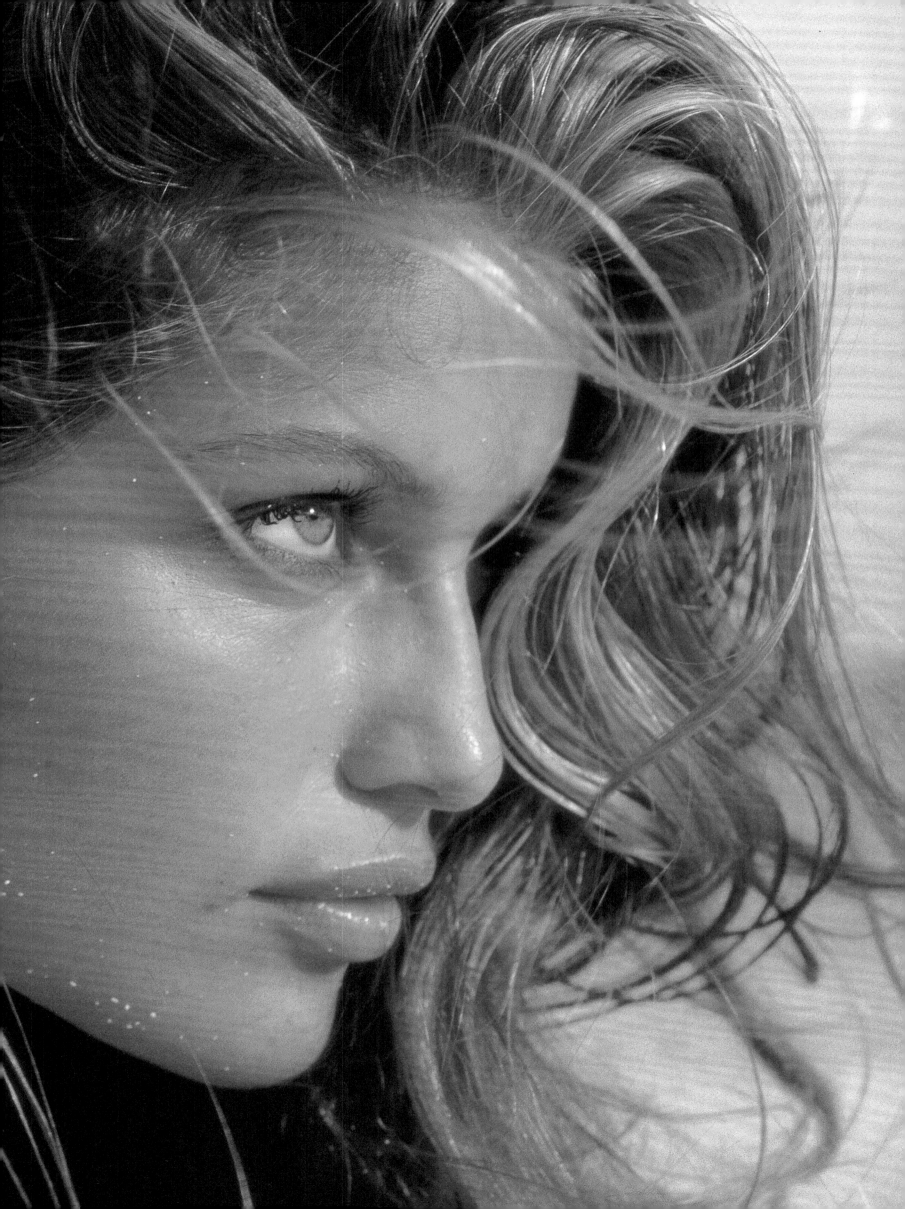

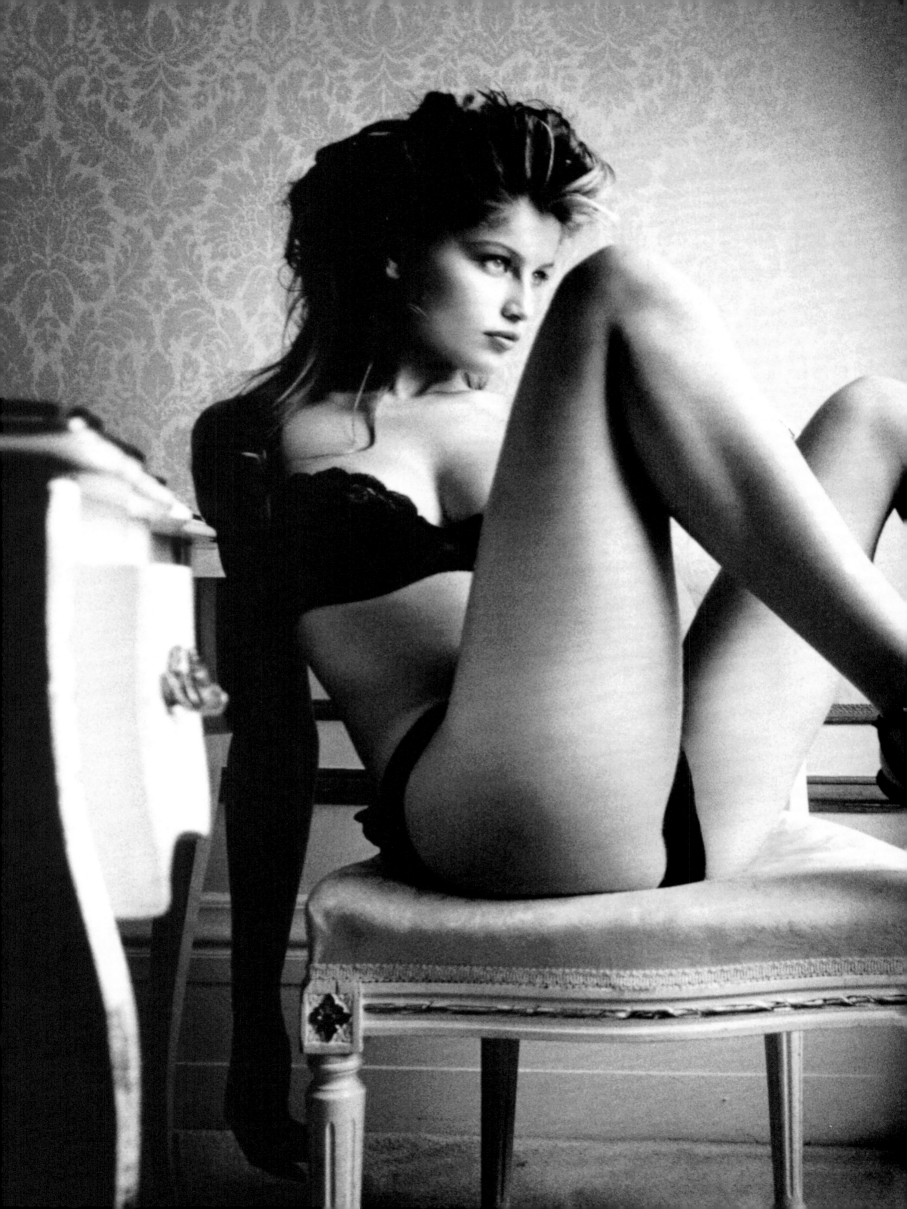

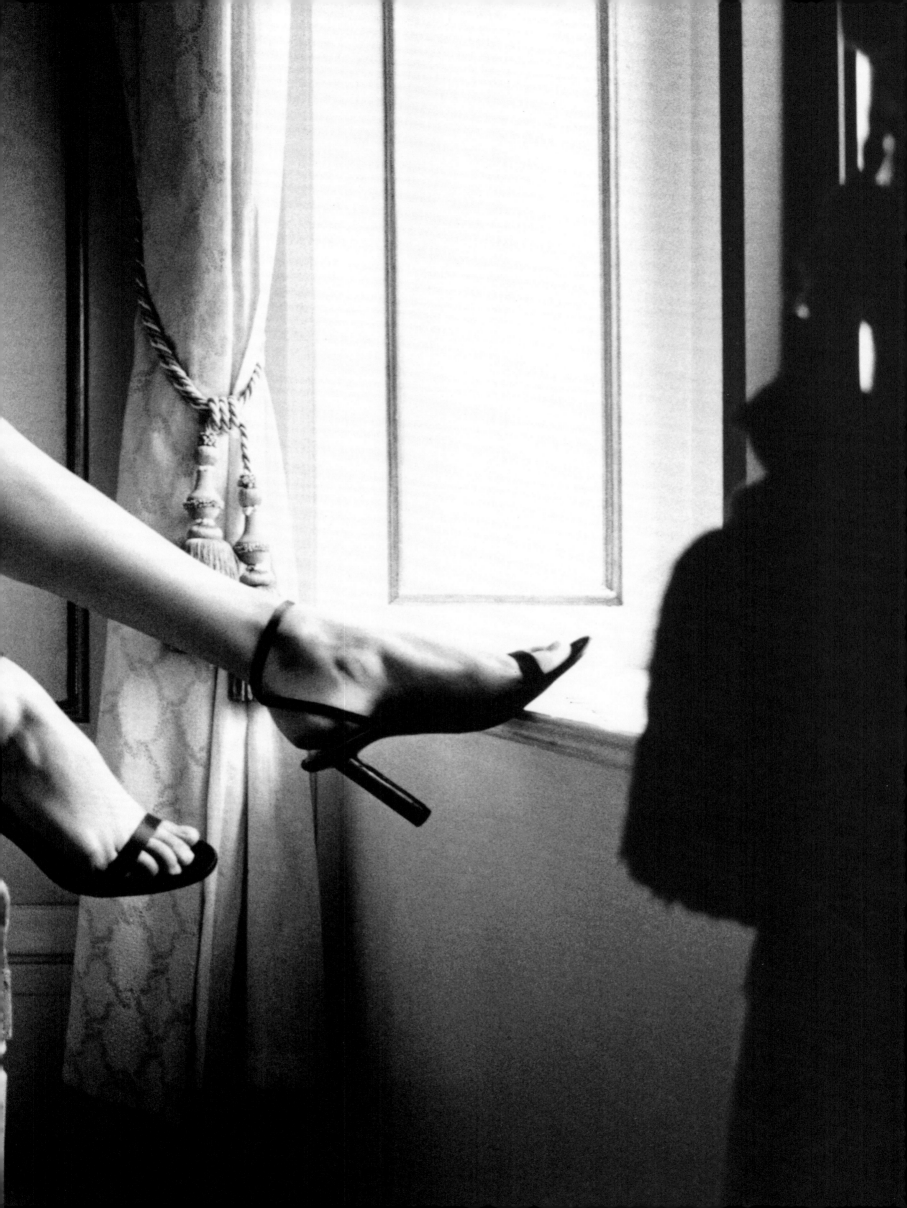

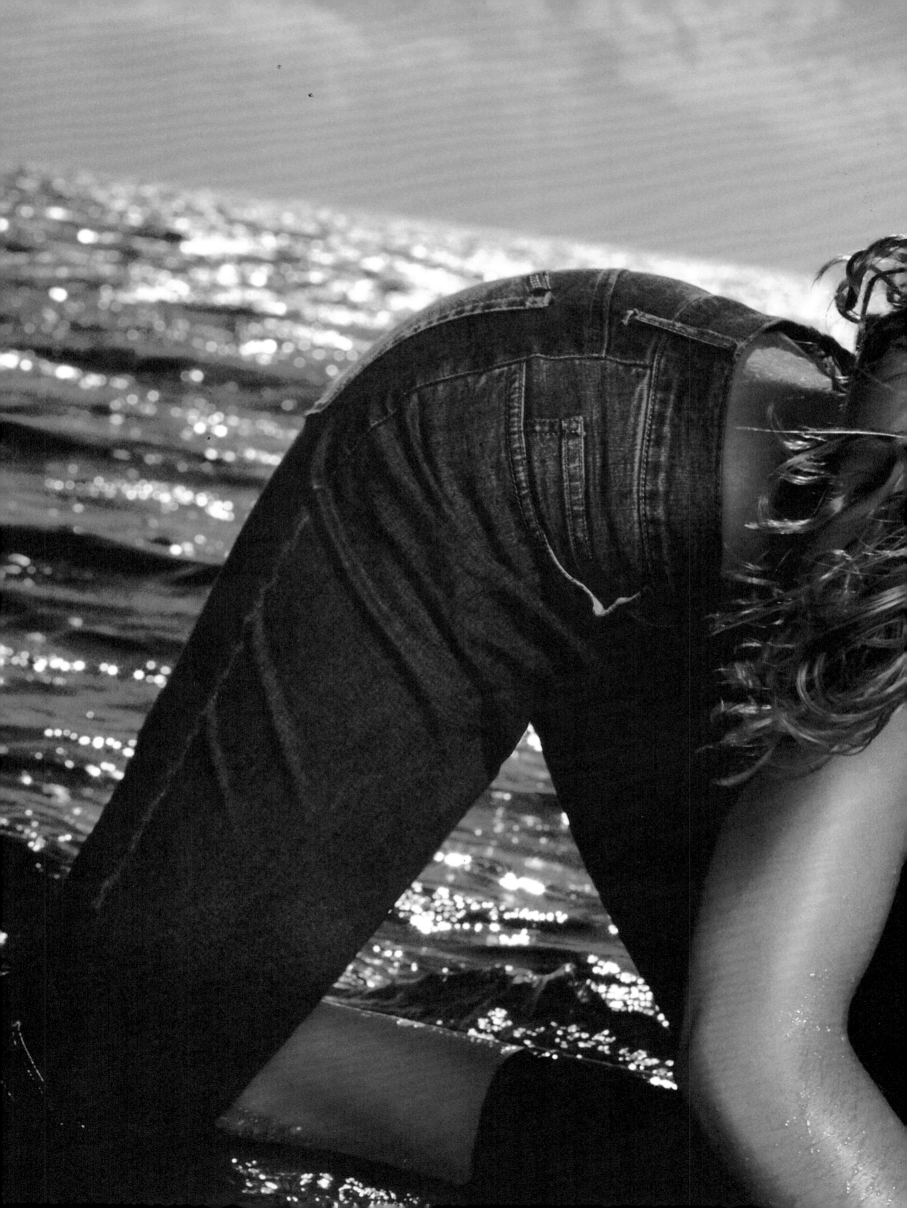

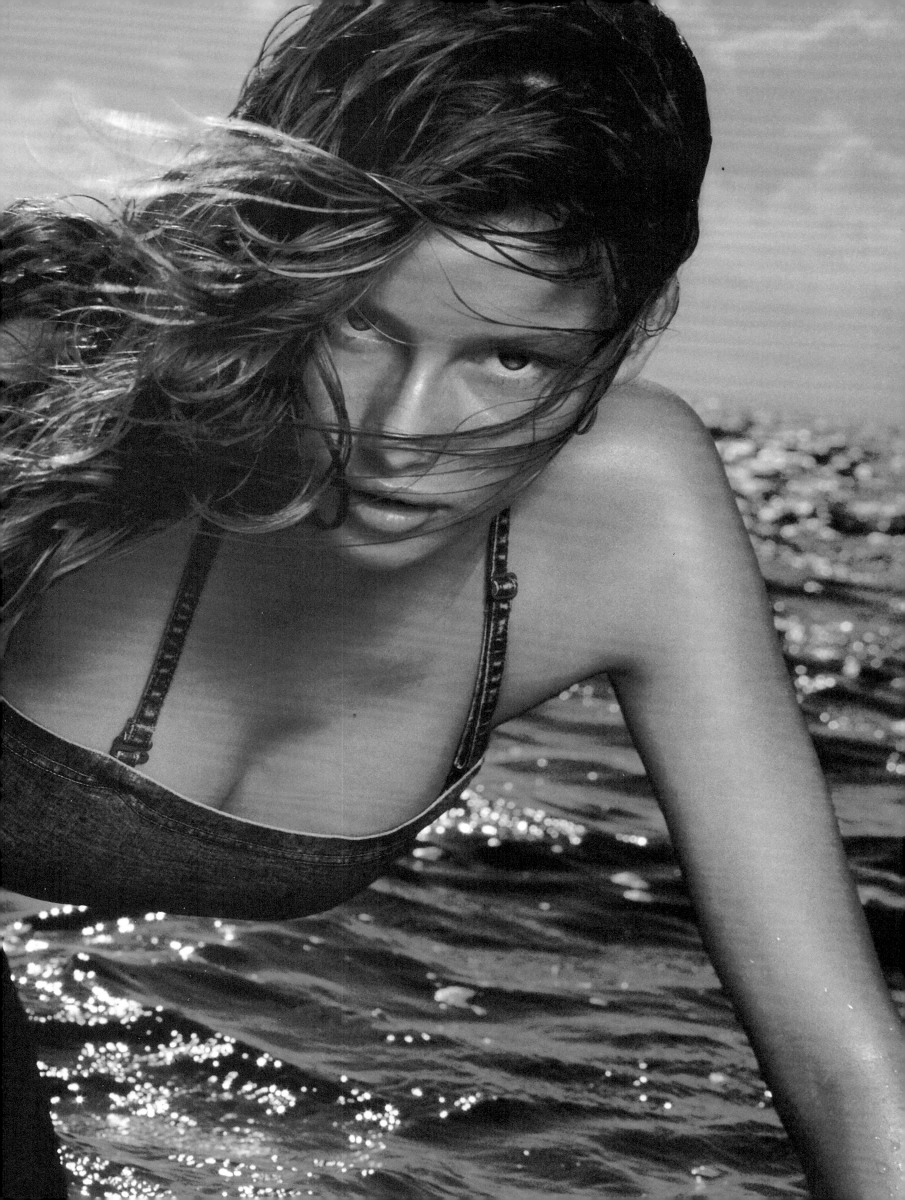

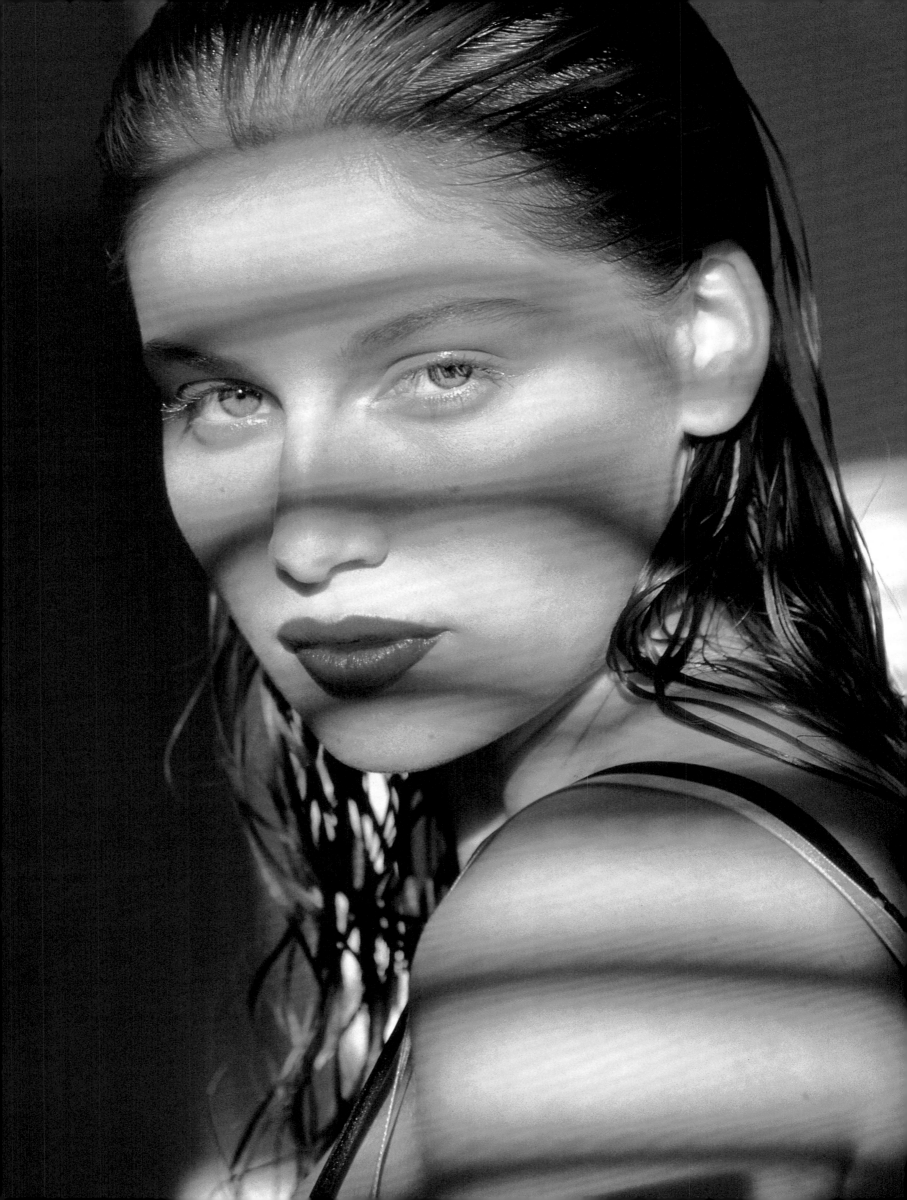

Laetitia Casta

Viking Studio

Callaway Editions

New York

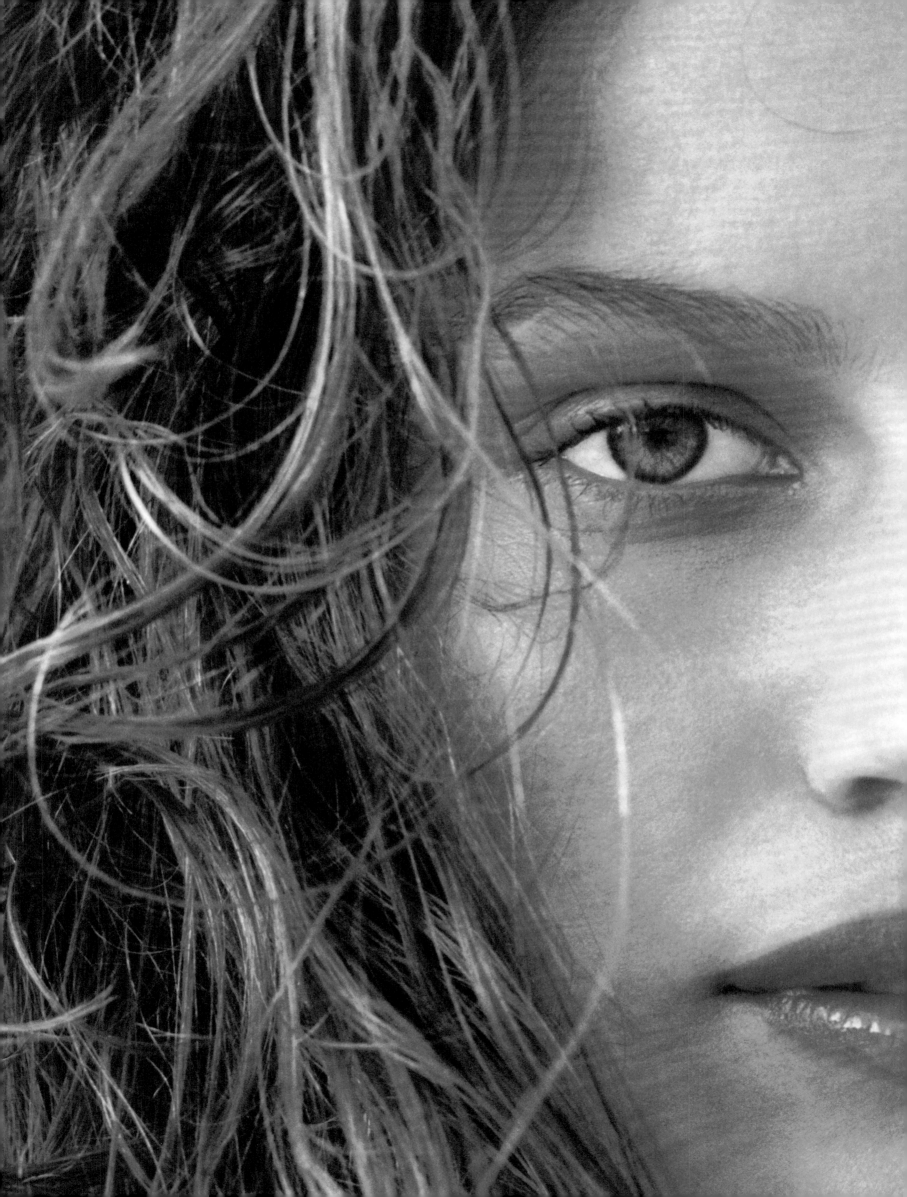

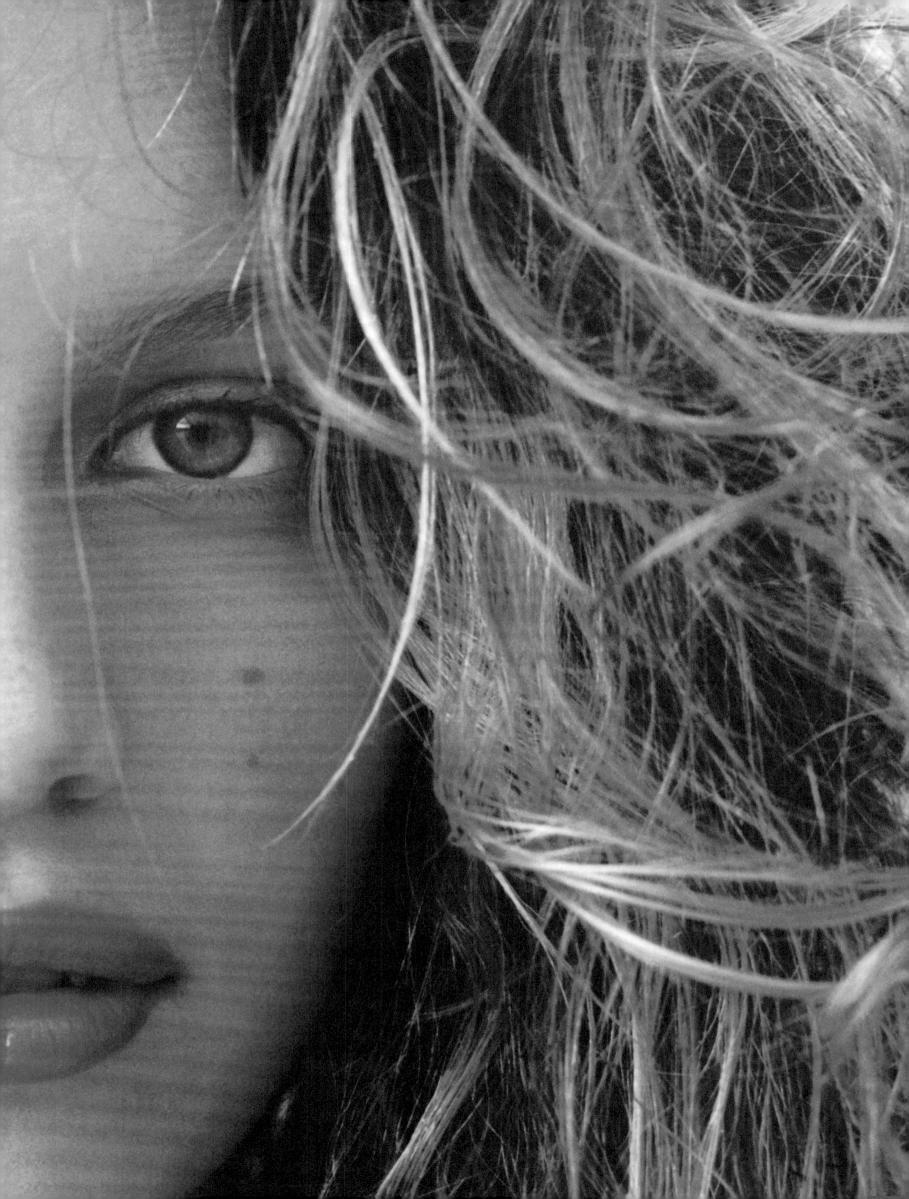

Laetitia, whose name means "joy" in Latin, spent a happy childhood in rural Normandy. "I lived for ten years close to Pont-Audemer," she says, "in absolute simplicity, in a remote house, with few neighbors. I was free to play in the river with the frogs, to play with the pigs, to laugh, to joke, to roam around in the woods. It was fantastic. Even today, I love to throw my arms around trees to embrace them. It gives me energy and makes me feel close to nature."

Of both Corsican and Italian descent, Laetitia's father, Dominique Casta, grew up on the rugged isle of Corsica. When he was about eight years old, the Casta family moved from Corsica to Normandy. There Dominique met and married Line, a beautiful, unassuming woman who gave up a career in accounting to devote herself to raising their family. Their first child, a son named Jean-Baptiste, now attends the London School of Economics. Laetitia was born two years after her brother, on May 11, 1978, and twelve years later, her little sister, Marie-Ange.

A creative child, Laetitia loved to draw and to write stories in school. "I was a dreamer, absentminded, and distracted. My teachers told me I was not as talented as my brother. I was already insecure and stubborn as a mule, so when I heard this I withdrew even further into my private world, my bubble."

She managed to emerge from her bubble around the age of twelve with the help of the Corsican determination she has learned to trust. "I just wasn't ready to grow up before then," she admits. "It was when Marie-Ange was born that I woke up. I forced myself to grow up for her because I felt she was my responsibility. The idea that I could be a role model for her was a great revelation for me." Another revelation was her body: "At twelve my breasts began to grow, and I had to wear a bra. But my friends did not wear them yet, and the kids at school teased me. They would sit behind me in class and pull my bra straps and laugh. I felt awkward, like a grasshopper or a giraffe, and self-conscious. I was embarrassed about my body, which was growing so rapidly. When guests came to our house, I hid under the table. Inside, I was more childlike than my body, and a glance from others intimidated me. Boys never approached me. I was always alone, watching them from a distance, but I was too afraid to say anything. I did not consider myself interesting to them." She did not discover how wrong she was until she was about fifteen.

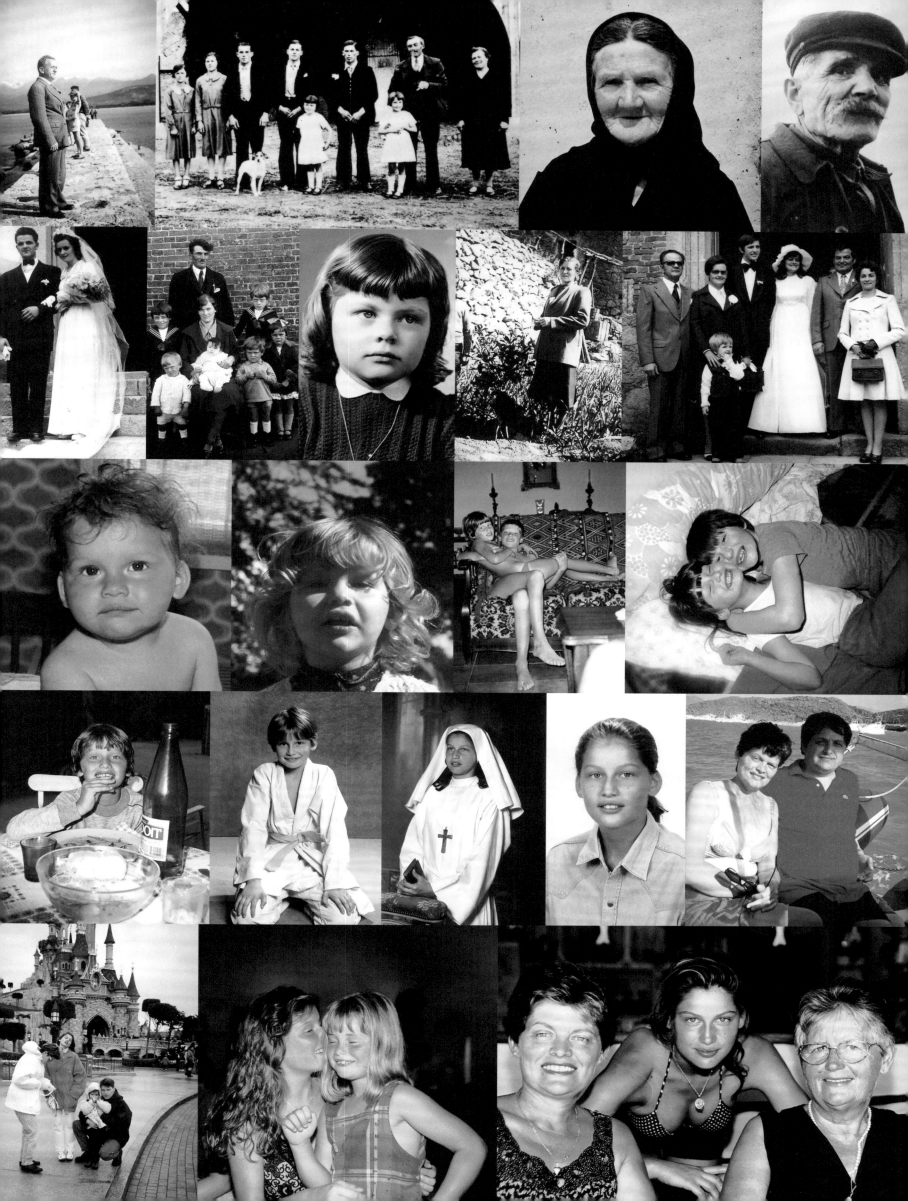

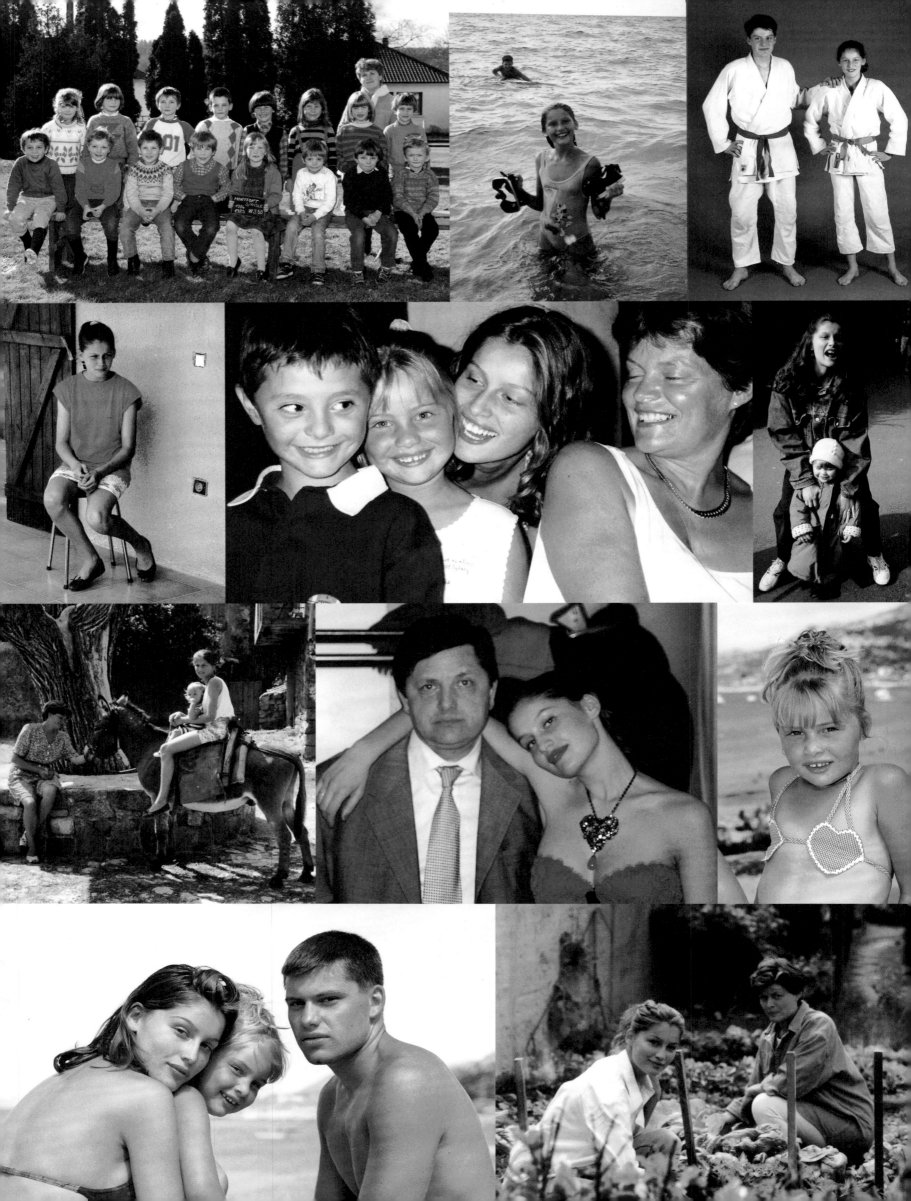

Laetitia kept a diary during those first years of adolescence. In it she confided her thoughts, her emotions, and her worries, but never speculated about a future as a model or celebrity. "I used to imagine myself as a strong woman, one who could do what she wants, whose life is not organized by others. I had never imagined being a model because my parents never told me that I was more beautiful than anyone else. They never suggested that I should do this work, or even that I could do it. I did not think that anything unusual would happen to me."

But one day something unusual did happen. In 1993, while vacationing with her family in Corsica, she was playing on the beach near the village of Lumio with her little sister. A booker from the Paris-based agency Madison Models and a photographer took notice of her. Her father was suspicious of their attention and asked what they wanted, and they explained that their interest was professional. They left him their business cards, and several months later Laetitia found herself on the way to an appointment with Vincent Peter, founder of Madison Models.

As Vincent tells it, "She arrived around lunchtime with her father, wearing blue jeans, a T-shirt, and no makeup. It took about half a second for me to see that she had something rare and very special. It's indescribable, that instant recognition that you have something fantastic on your hands. Laetitia was not yet fifteen and shy and, I would say, a little tense, but only because she was in unfamiliar territory. She knew nothing about the modeling or fashion world. It was something that just happened to her.

"I decided to take her immediately to see Odile Sarron, the casting director at French *Elle*. Odile is a very busy woman who is difficult to reach by phone, and it's almost impossible to arrange to see her. But I was certain that Laetitia would stop her in her tracks, so I took a chance and showed up unannounced at Odile's office with Laetitia in tow. Odile had the same reaction to Laetitia as I did, and that's how it all began."

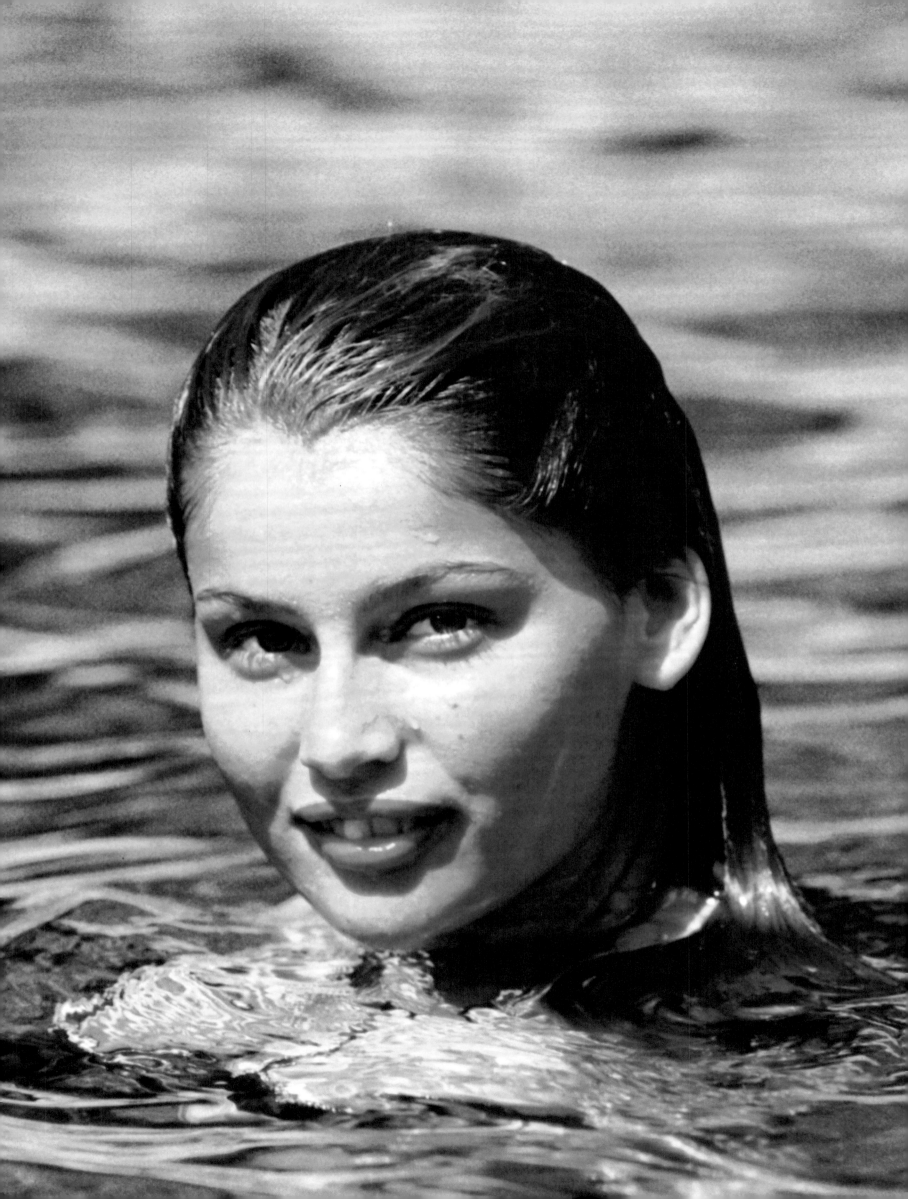

In Corsica

To understand Laetitia you have to know Corsica. It is a rocky island, that lies south of France and only fifty-two miles west of Italy. Its strategic location in the Mediterranean has made it the target of many European nations who have tried to take it by force, but it has had an especially tumultuous and colorful history with France and Italy. It has belonged to France since the eighteenth century, and before that was a colony of Genoa. And although French is the official language today, Corsican – a blend of Latin, Italian, and French – is still spoken. Centuries of fighting to protect their land has led Corsicans to forge their own fiercely independent, very distinctive identity, perhaps best exemplified by their most famous native son, Napoleon Bonaparte. With its crystalline mountain rivers, beautiful beaches, and aquamarine waters, Corsica today is a popular vacation destination and the pride of its people.

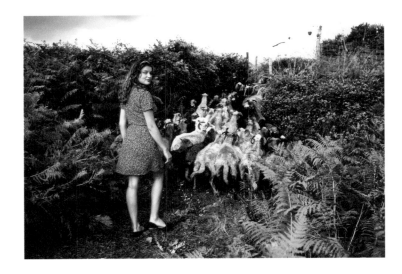

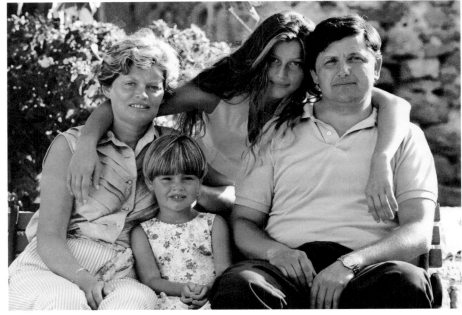

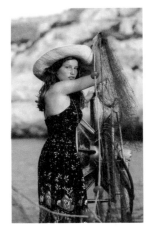

It is easy to understand why Laetitia spends holidays and vacations, and as much of her free time as possible, on Corsica, in the small village of Lumio, where the Castas maintain a home. Corsica is in her blood, she declares with pride. The values of Corsica are very much a part of her life. The education she received at home emphasized the importance of family, and encouraged in her both the freedom to make her own decisions and a delight in rebellion. "My parents taught me to respect others, not to lie, not to steal. And to grow as slowly as possible. They imposed limits on me that my friends did not have. When I went out, I had to tell my parents where I was going and with whom. I was not allowed to stay out late, and I could never be late for dinner. It was hard for me to accept, and sometimes I felt like I was in a prison. But I believe the restrictions helped me to appreciate the freedom I now enjoy. And when I first started to enjoy that freedom – wow!"

Dominique explains: "The family is sacred to us in Corsica, and I am convinced that is exactly what has made the difference for my family. At home

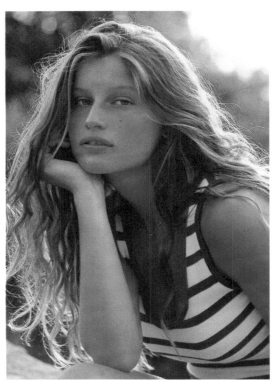

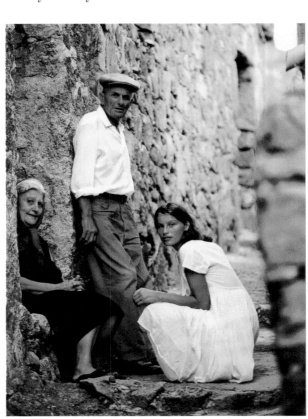

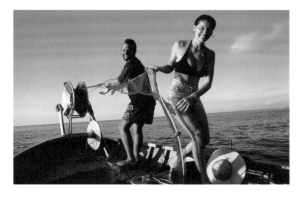

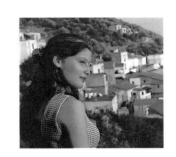

Laetitia is not the center of the world, and there is no professional commitment that would prevent us from spending Christmas together. Of course, she lives her own life now, but she knows that life consists of hard work and determination. She knows that things do not always come easily, nor are they always handed to you on a silver platter. I am not at all afraid that success will change her because I know the education she received at home has made a deep impression on her. Perhaps we have been strict, but at least we are not parents who let their children grow up without guidance and authority, who don't know their children anymore."

Laetitia herself confirms the strength of their love and guidance: "This island, this house, represents a strength of character and a state of mind that I adore and which I haven't found anywhere else. It is my secret garden, my family. I never want to find myself inaccessible and alone, caught up in my job or losing myself, without reality, without values. We, in Corsica, tell the truth. Corsica, that's me. There you have it."

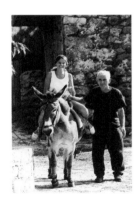

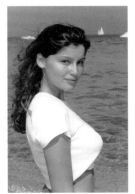
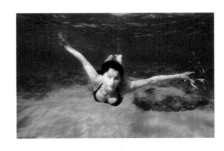
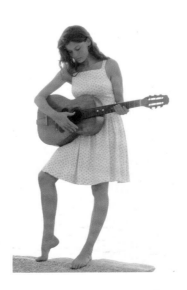

In 1993, Dominique accompanied his young daughter to her first photo shoot. Laetitia recalls that, before she walked through the door, her father took her aside. "He said to me, 'You're my daughter, and for me you are the best and most beautiful, but other people may not think so.' He didn't want me to get hurt; he didn't want me to dream too much."

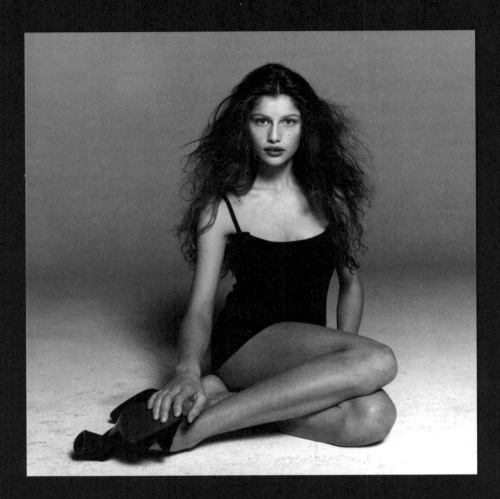

During that first year Laetitia modeled part-time – shoots were on Wednesdays and weekends – while she continued to go to school in Paris. She didn't tell anyone at school about her budding career, but somehow word got out. As Laetitia recalls, her classmates seemed to think her new career was based solely on her looks. "People think it's only about beauty, but it's more than that. It comes from inside, too."

Her kind of beauty is strikingly at odds with the tall, rail-thin mannequins stalking the runways today. At 5'7" she is much shorter than other models, with soft, supple curves. There were a few in the business who suggested she make some changes: "Somebody, I won't say who, pointed out to me that my teeth weren't perfect, that I should have them fixed. At Madison they asked me to lose weight, and they thought I was too short. I simply told them that if I didn't work out for them as I was, they should find another model." She is indeed, as the French say, a *petite crevette* ("little shrimp"), but her height has not prevented her from enchanting a multitude of clients from GUESS? and Victoria's Secret to *Sports Illustrated,* L'Oréal, *Rolling Stone,* and Pirelli. But perhaps most captivated by her charms has been couturier Yves Saint Laurent.

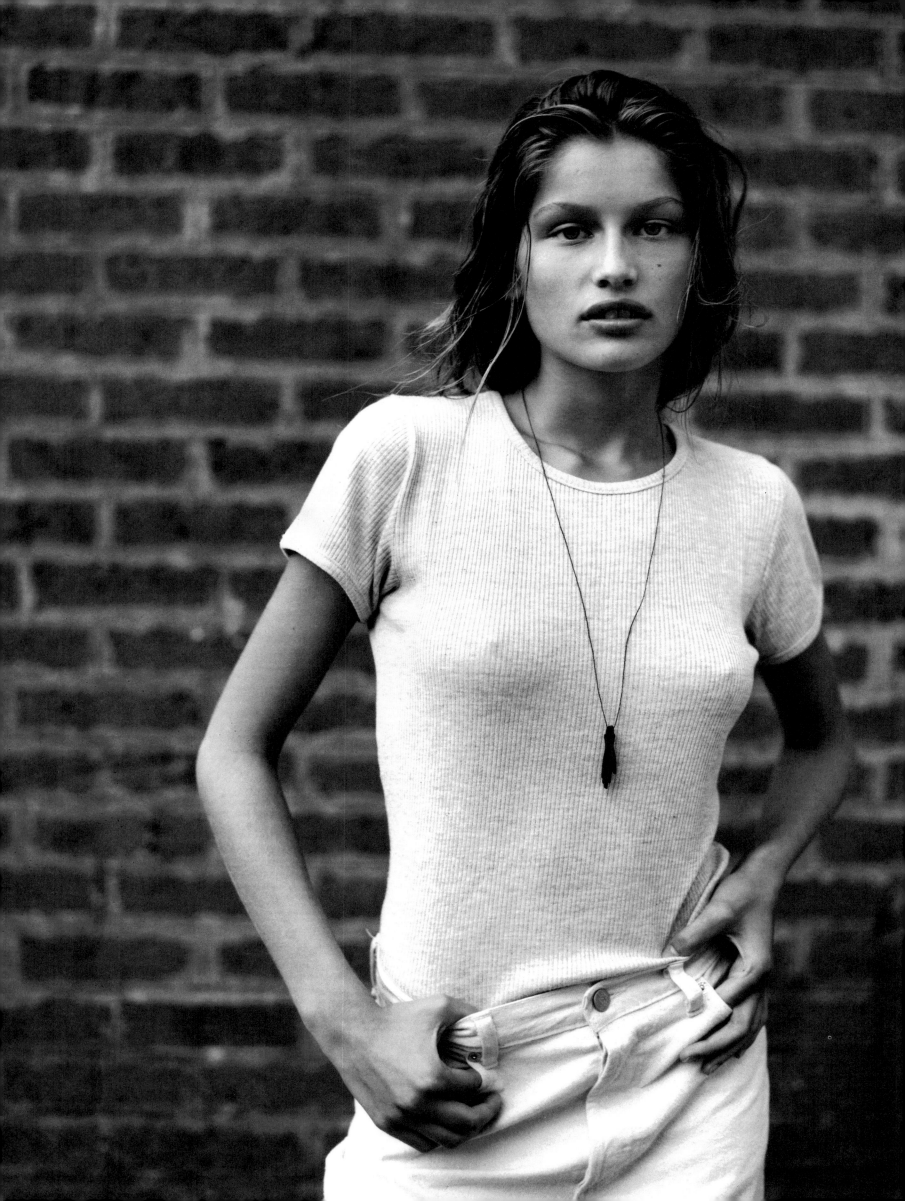

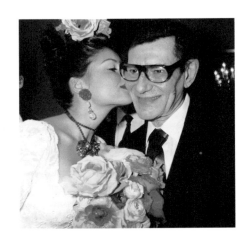

Y S L
Yves Saint Laurent

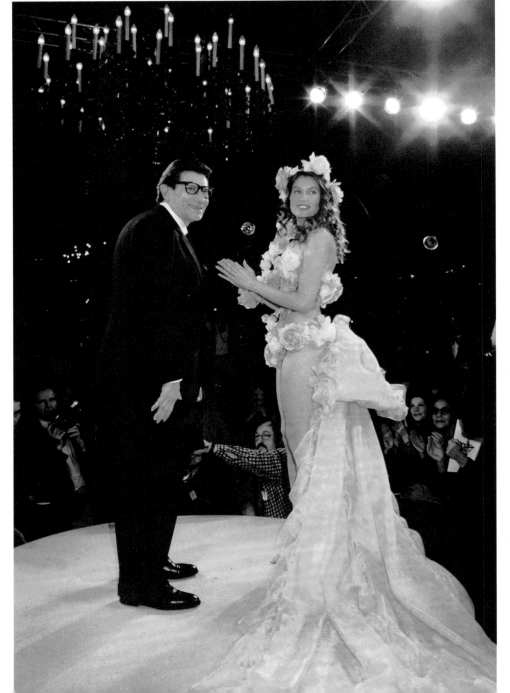

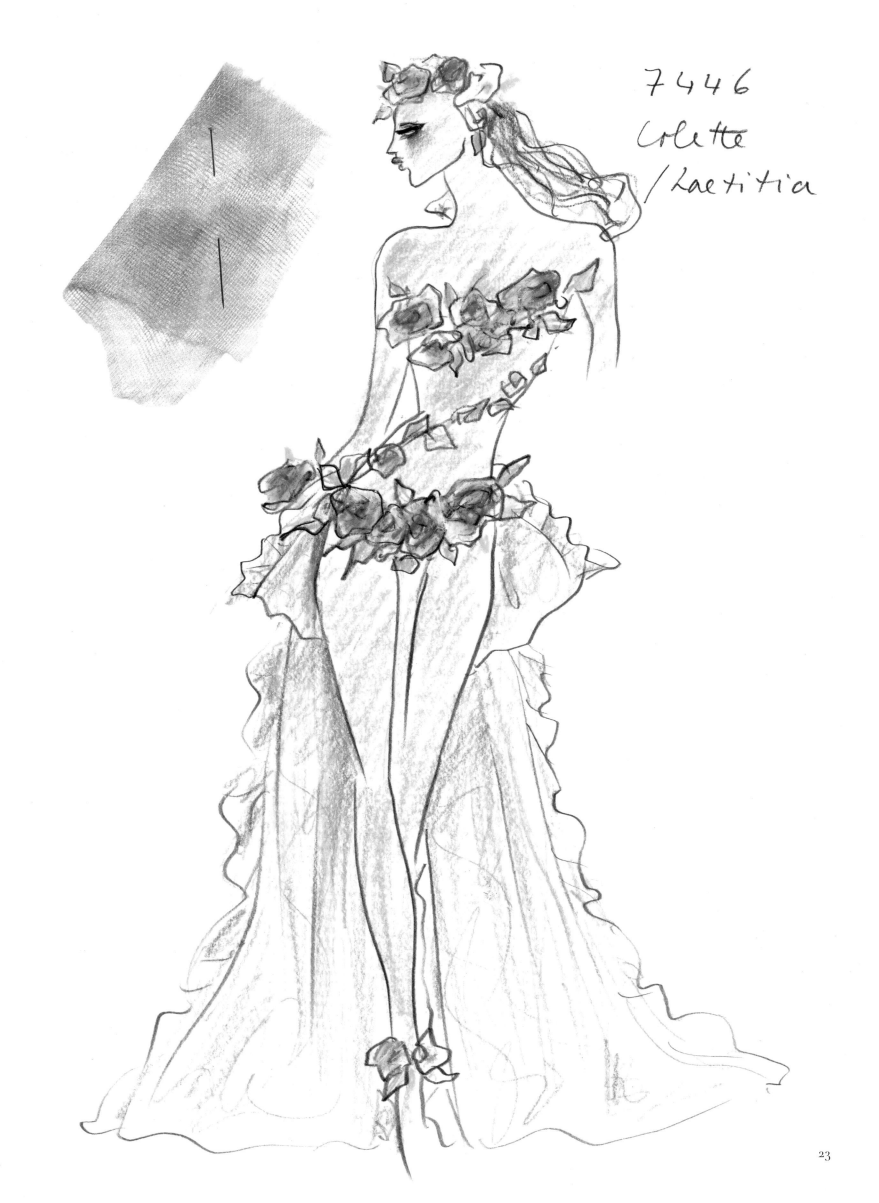

7446
Colette
/Laetitia

23

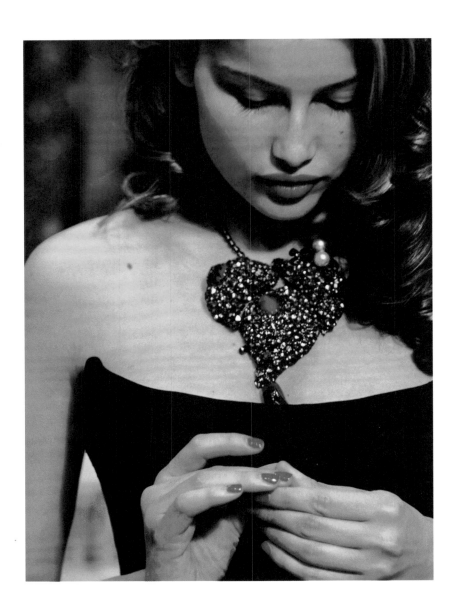

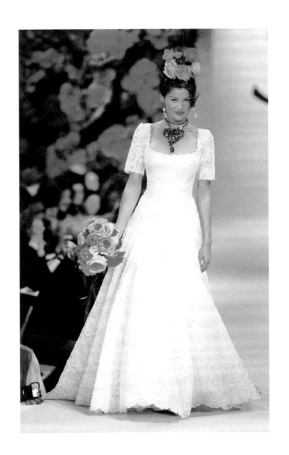

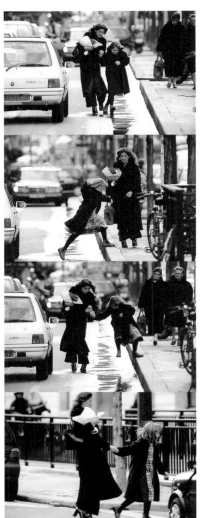

Left: Laetitia and Marie-Ange play in the puddles after the Yves Saint Laurent show. Their mother Line and grandmother Laure follow.

Yves Saint Laurent

AMZ — DOROTA — Daniell — Dominique

Loulou —

Nicole — Audrey — Florence

Mame T —

Colette

Catherine

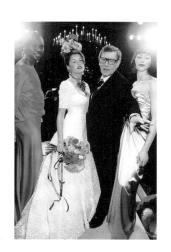

Laetitia was wearing a simple black skirt and sweater when Yves Saint Laurent first set eyes on her in July 1997. The atmosphere at his fashion house was tense because only three days remained before the show, and he still needed five more models. Everyone was on edge.

Nicole Dorier, an elegant woman who is herself a former model, has been selecting Saint Laurent's models for the past ten years. "I showed Laetitia to him, first in black, then in the faux-fur coat we wanted her to wear on the catwalk," she recalls. "But the stylist said, 'These clothes are not for her. It is a shame because she is very beautiful.'" Laetitia didn't say anything, but deep down she was wounded by the comment.

Six months later, while preparing for the anniversary fashion show representing forty years of Saint Laurent designs, Dorier again thought of Laetitia. "I knew she would be perfect in the bridal gown. I put a white smock that the girls wear between fittings on her, and took her to Saint Laurent's office. The other girls are usually intimidated when they are brought before Saint Laurent, but Laetitia seemed so relaxed and natural. Saint Laurent draped some fabric around her, sketched a design, turned toward her, changed it, turned again, and touched up the sketch. She moved and presented herself exactly as he hoped. At that moment, the ice was broken between them – it was like magic. Within five minutes Laetitia's fate was determined."

For her appearance at the 1998 Cannes Film Festival, Laetitia chose to approach Saint Laurent. "I would be very happy if you dressed me," she said to him, and from that point on Saint Laurent has designed Laetitia's wardrobe for all her public appearances. Saint Laurent does not merely lend Laetitia his dresses as he sometimes will to other models. He designs and creates them especially for her, as he has done only for Catherine Deneuve, Jeanne Moreau, and a few others, but never before for a model. "It's as though he sees in her a ray of sunlight," Dorier says with a smile, "as though Laetitia is becoming the woman of his dreams."

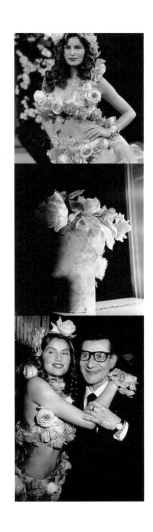

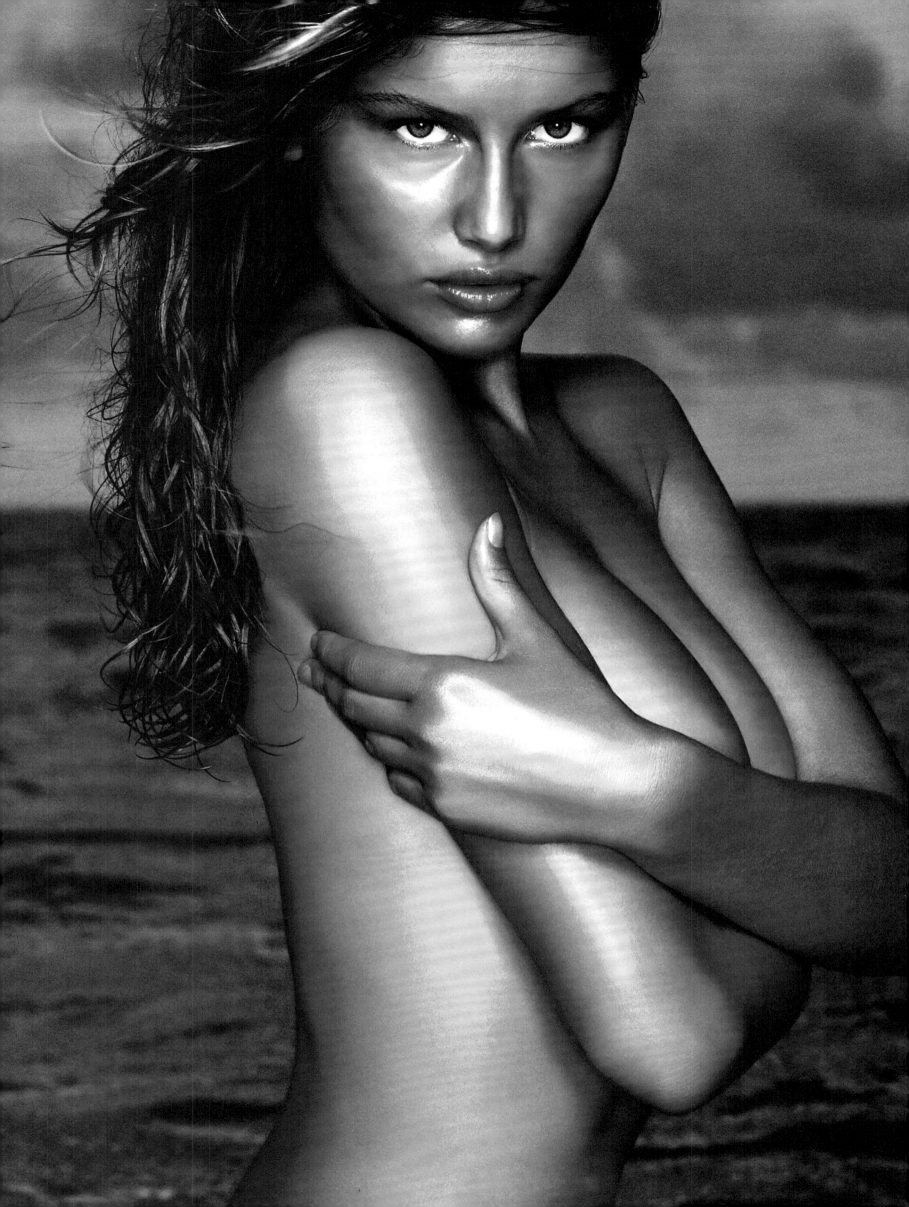

GUESS?

Paul Marciano, art director and a founder of GUESS?, fell under Laetitia's spell several years before her first encounter with Saint Laurent. Marciano saw Laetitia for the first time in 1993 and soon thereafter offered her a GUESS? advertising campaign. It was through the famous GUESS? campaigns that Laetitia was introduced to the American market, and her career was launched worldwide.

Marciano is unabashed in his admiration for Laetitia and the impact she had on him. "I first met Laetitia in 1993 when she was about fifteen years old. I had seen just two head shots of her, but never saw her in person. The first time she walked into my office, I thought she was lost in the GUESS? building with her parents – she looked like she was no more than twelve years old! But when I looked more closely, I was blown away by the perfect features of her face. And those eyes – I couldn't look away from them! Then she spoke to me in French, and I was so pleasantly surprised. She was so appreciative and enthusiastic about the possibility of being a part of the GUESS? campaign, that I have to say it was the sweetest and most refreshing moment I had had in many years.

"Laetitia and I share a deep personal friendship that has developed over years of working together. I consider myself very fortunate to have been the one to give Laetitia her first advertising campaign."

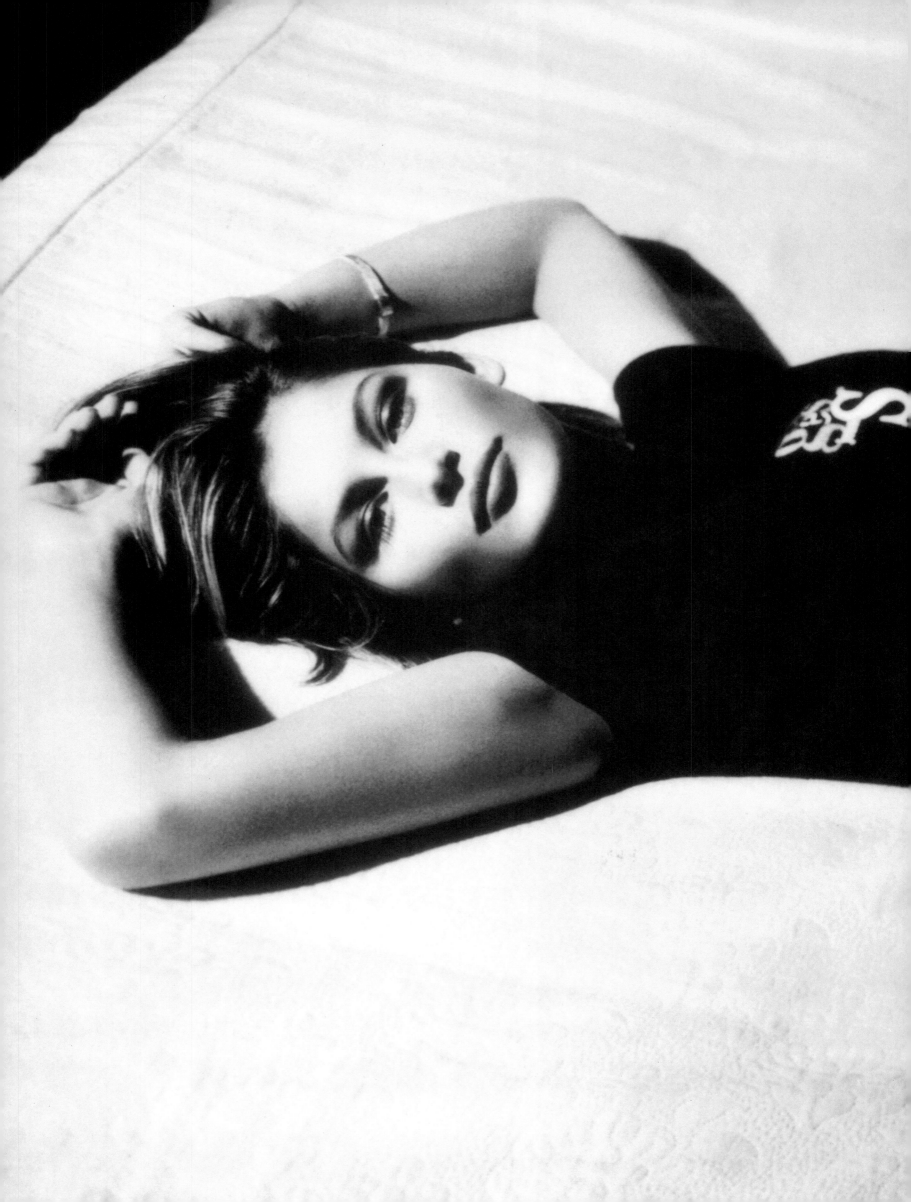

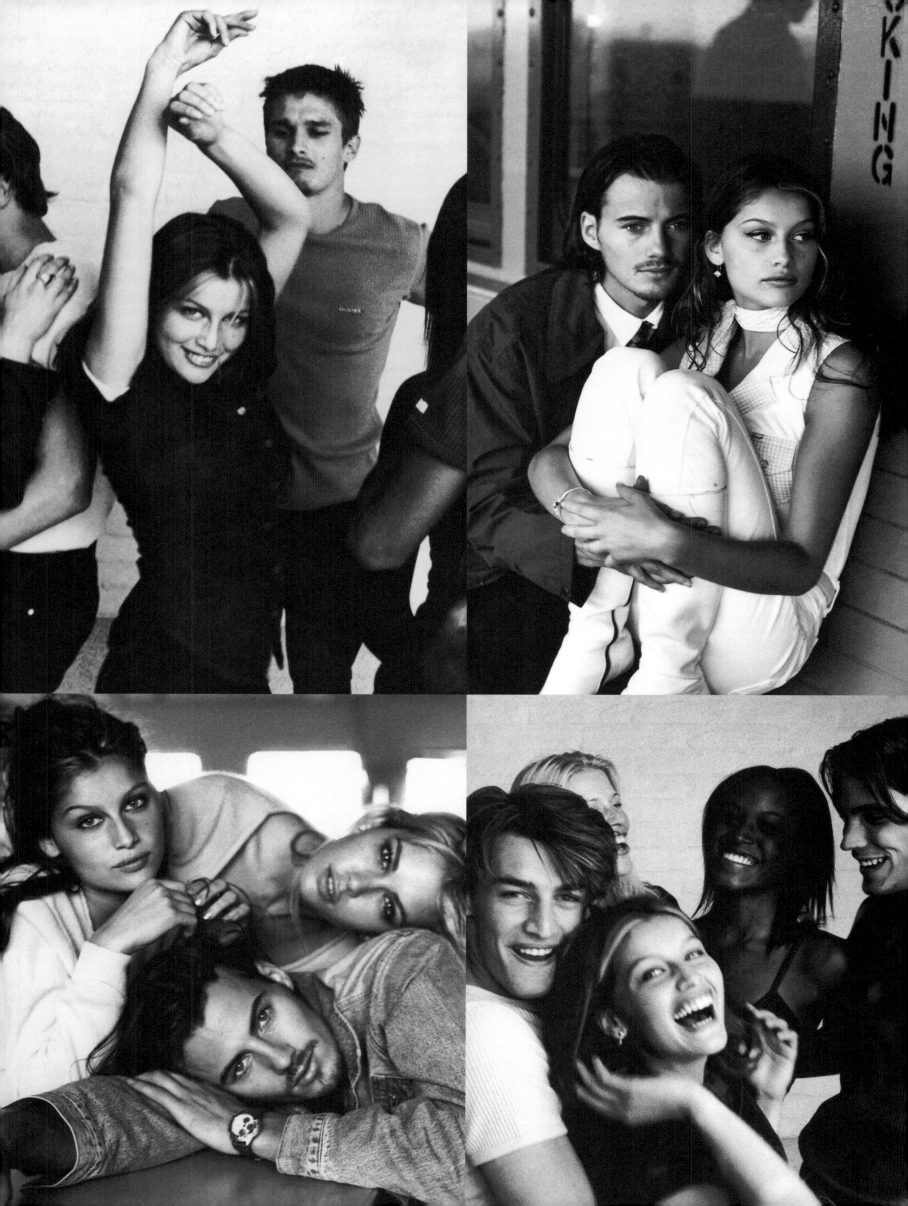

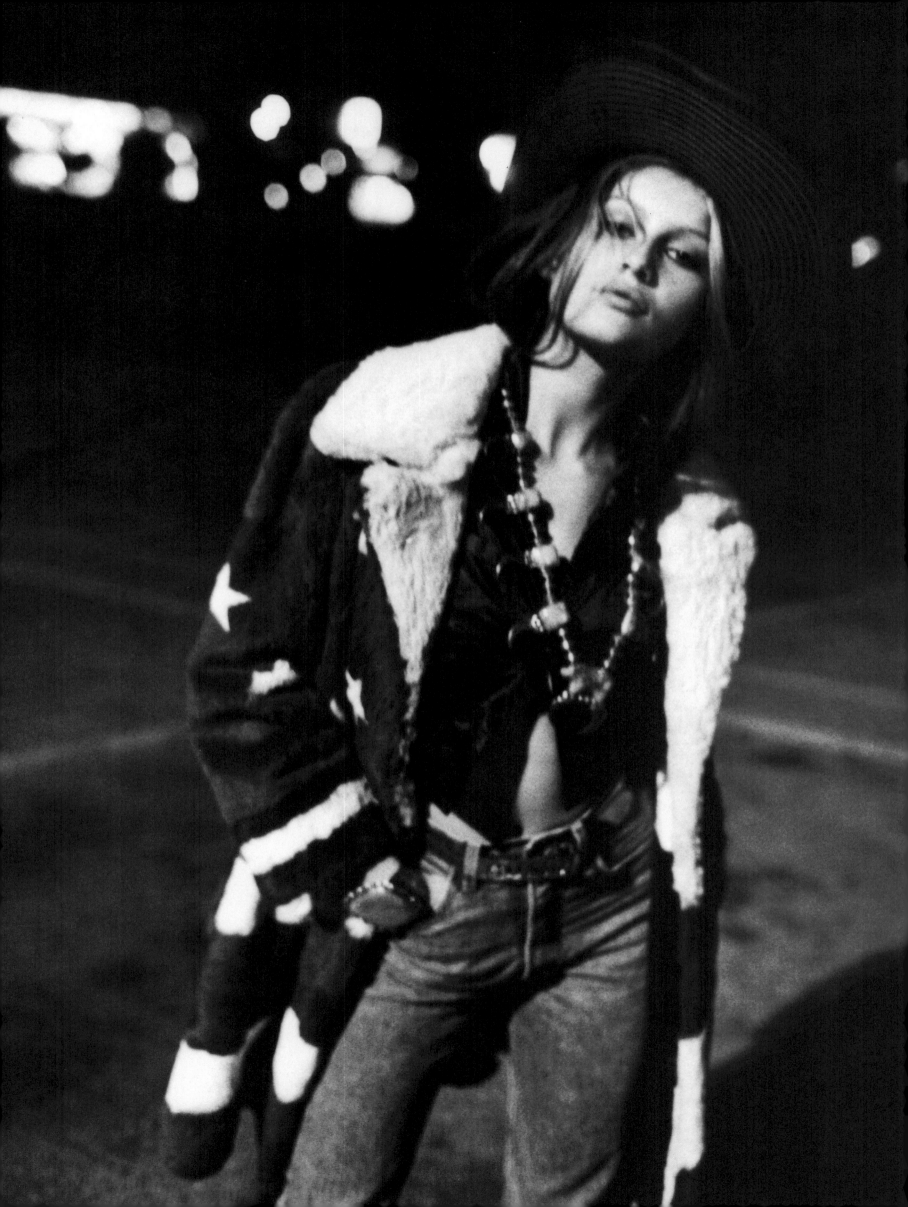

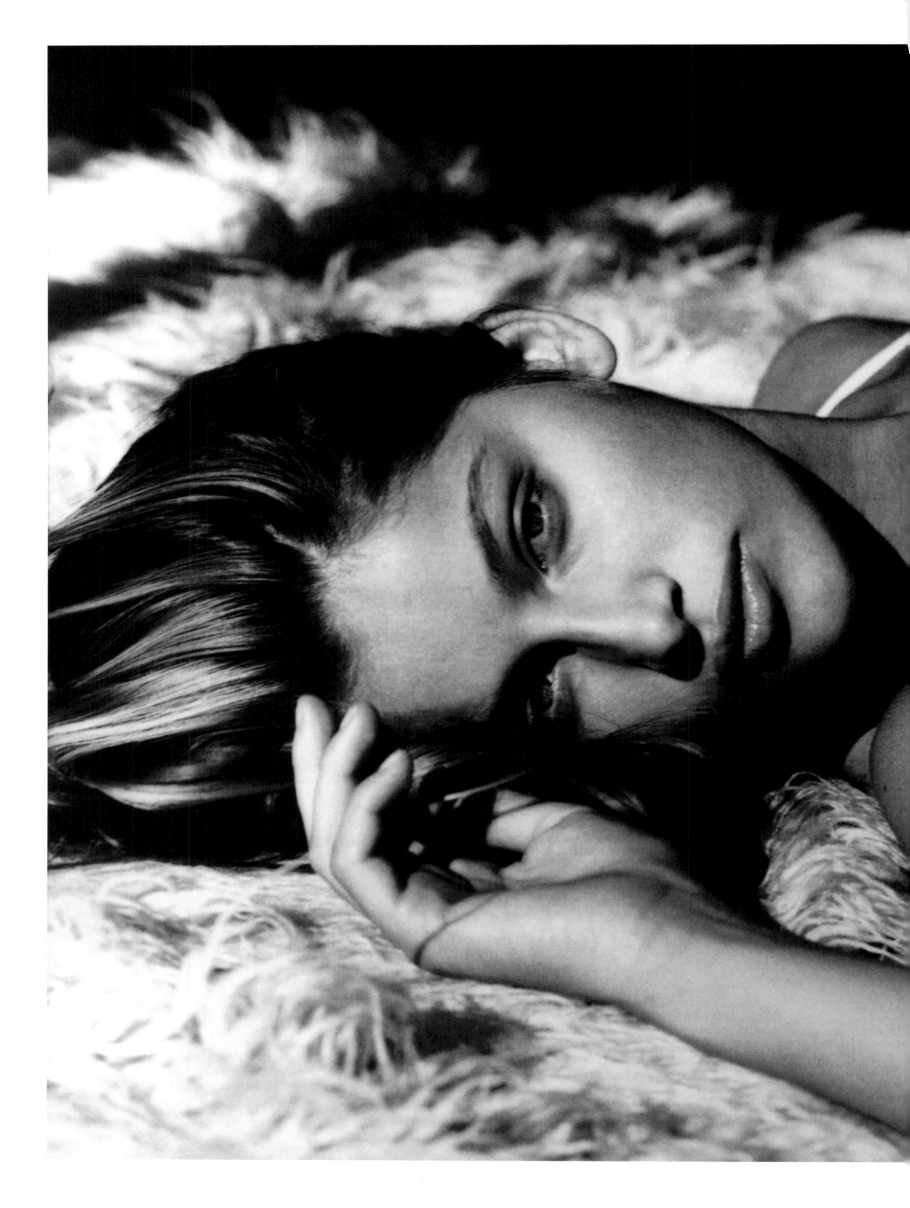

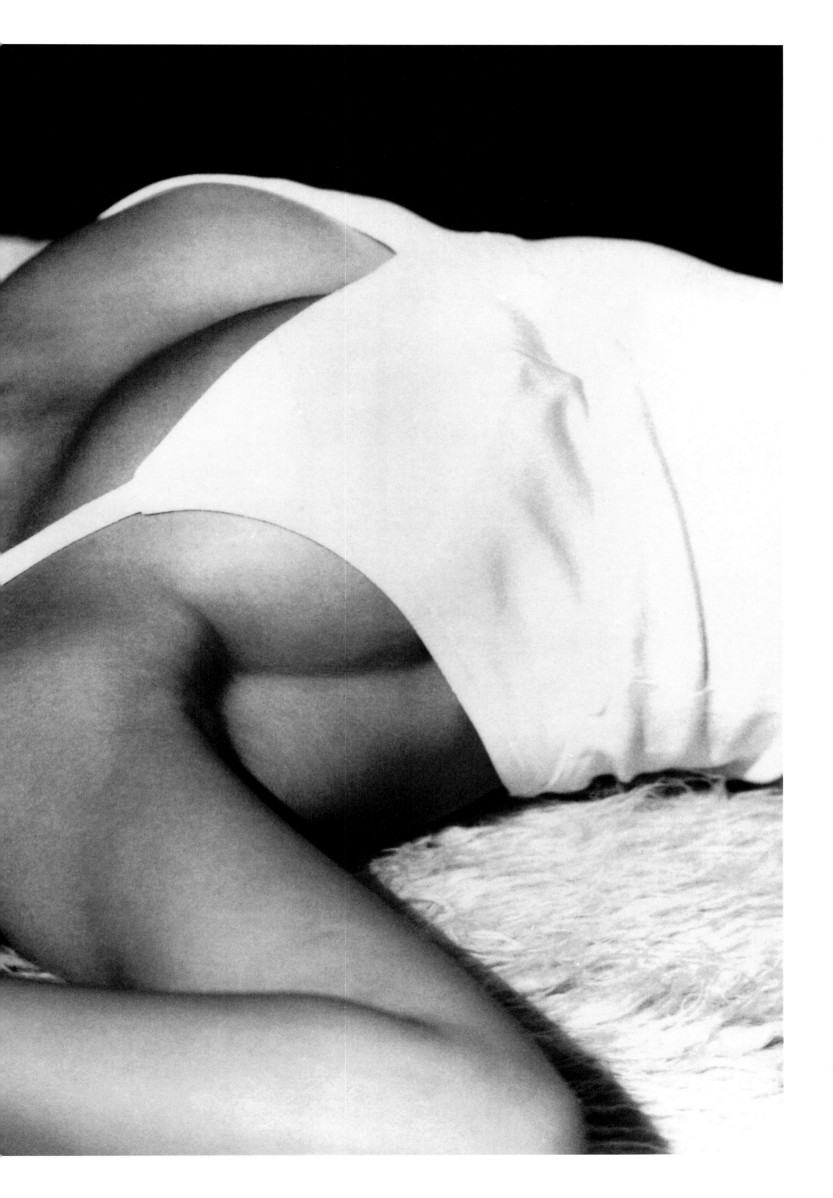

Victoria's Secret

Laetitia signed another major contract in 1996 with Victoria's Secret, the leading catalog for intimate apparel in the United States. In 1998 she was named one of the company's five top spokesmodels, known as Angels. When Victoria's Secret aired a cyberspace fashion show in February 1999, it drew a record-smashing 1.5 million worldwide hits to its website. "We were thunderstruck by the response," exclaimed Ed Razek, president and chief marketing officer of Victoria's Secret.

"I first met Laetitia about two years ago on a photo shoot in Bermuda," recalls Razek. "I walked onto the set as they were photographing her, and my first impression was that she had a very different kind of beauty. She was unlike anyone we had ever shot for Victoria's Secret.

"I knew immediately that she had a special quality. But to be frank, it took me awhile to understand how completely rare her beauty is, and how enormous her self-confidence is. She is utterly unique, not only in the business, but also, in my experience, as a personality."

According to Razek, the customer response to Laetitia is consistently enthusiastic. He says, "I decided to make her an Angel because there was no way to keep her out of the lineup. She was just too strong, too beautiful, and too important to the brand, to not be an Angel. That decision has proven to be the right one. She was our Christmas cover girl and has graced the covers of more issues, I believe, in the past year than any other Angel. She is a real beauty, a first-class talent, and a wonderful human being. I think the world of Laetitia."

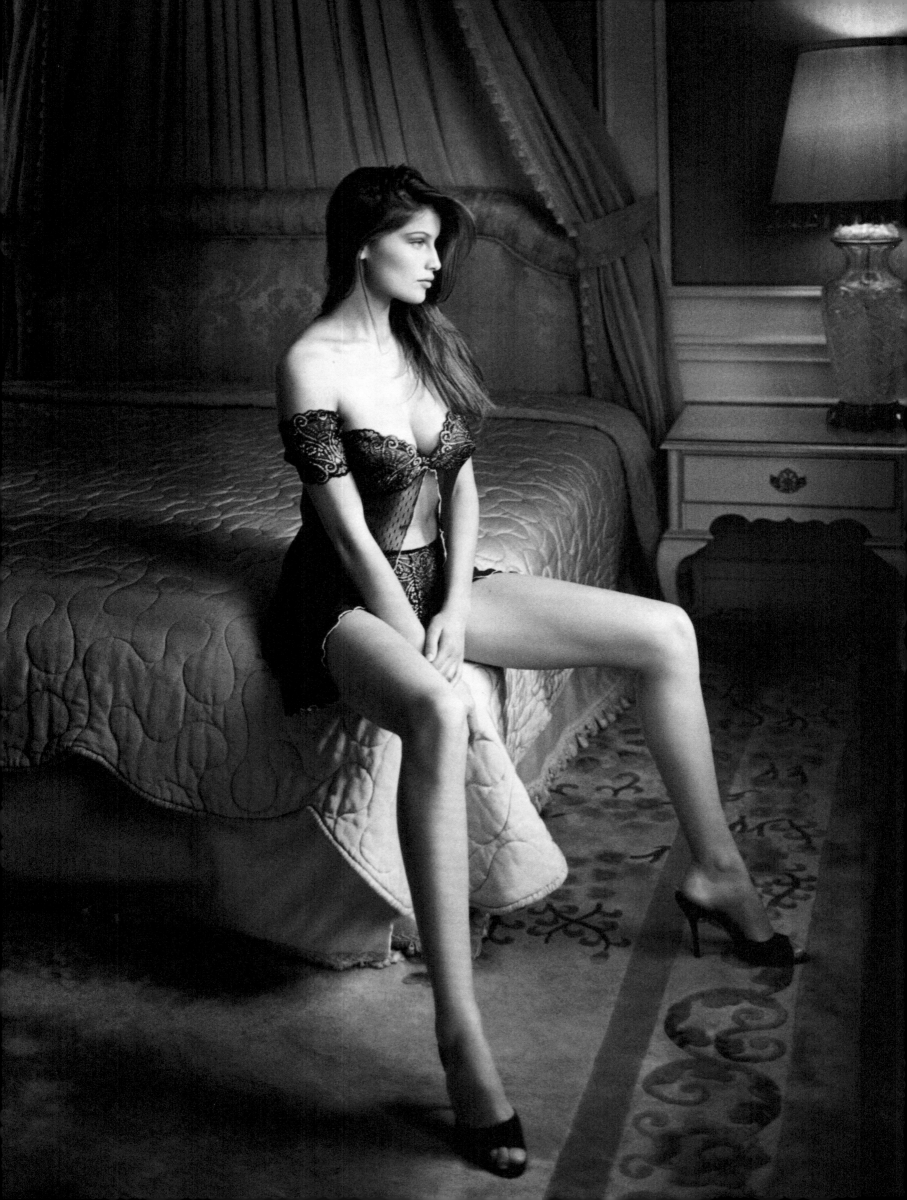

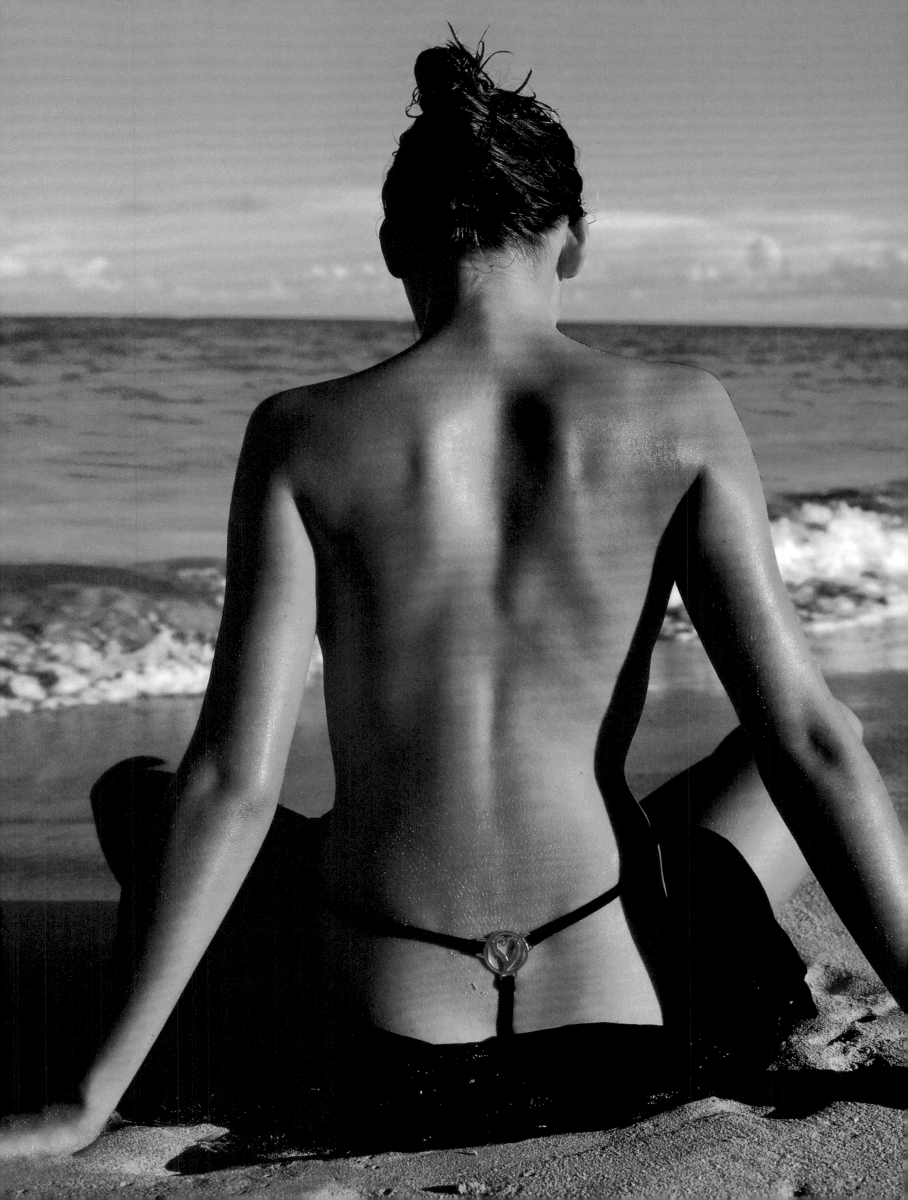

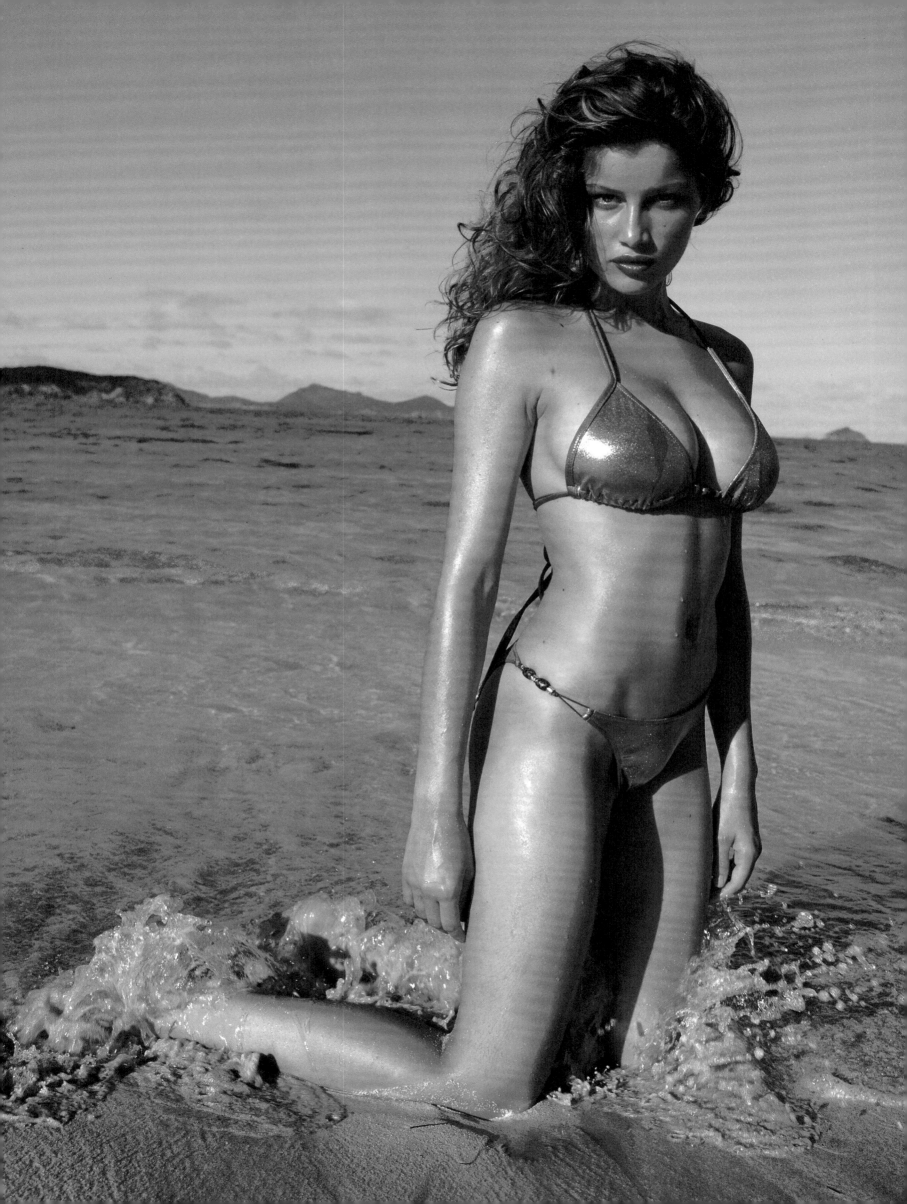

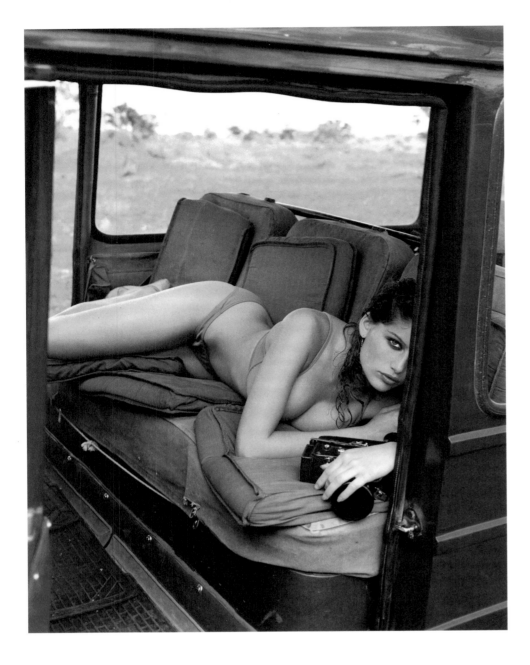

Laetitia has been chosen to fill one of the highly coveted spots in the annual swimsuit issue of *Sports Illustrated* for three years, appearing in 1997, 1998, and 1999.

While shooting in Kenya for the 1998 swimsuit issue, Laetitia found herself among the Masai.

Sports Illustrated

"When they love a woman, they slap her with their long hair. At the end of the day, my cheeks hurt a lot. And hands on everything – they love to touch, the Masai."

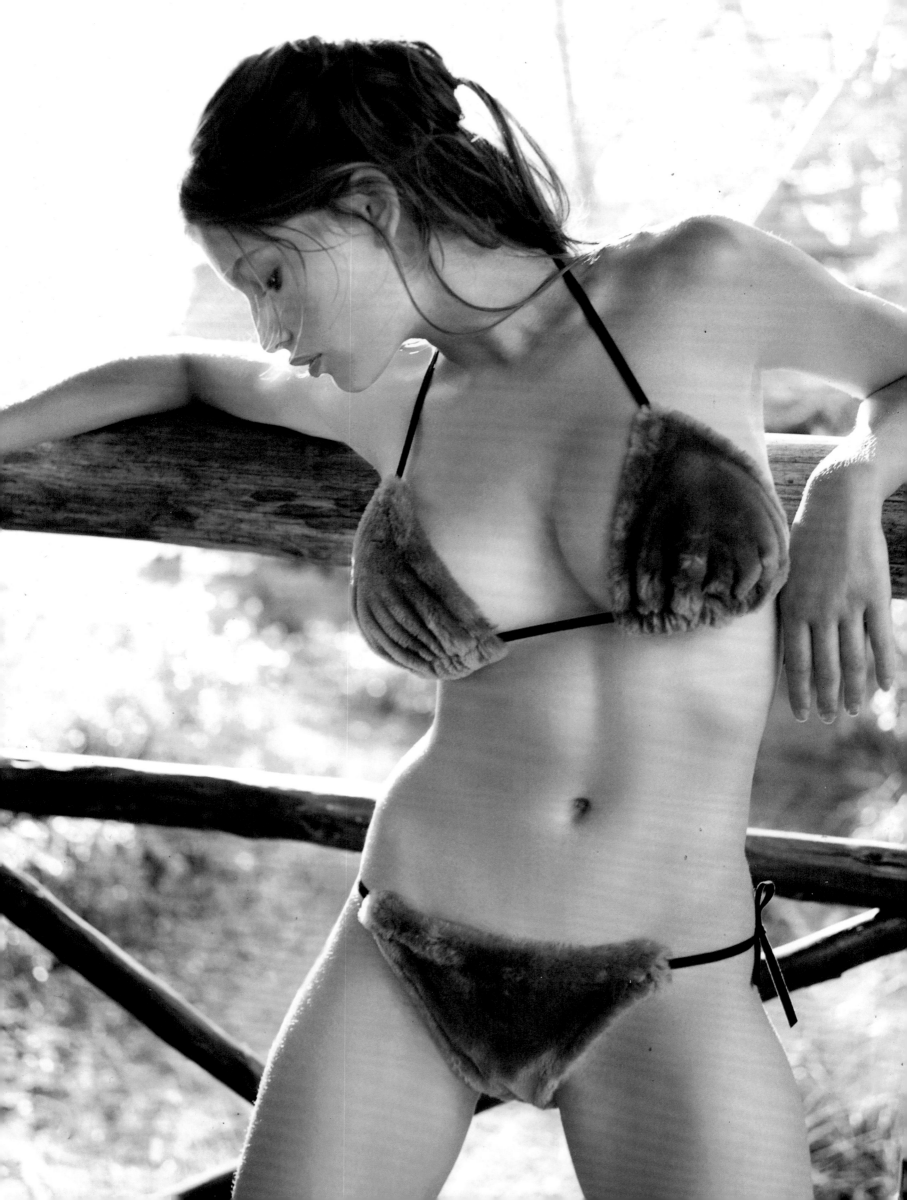

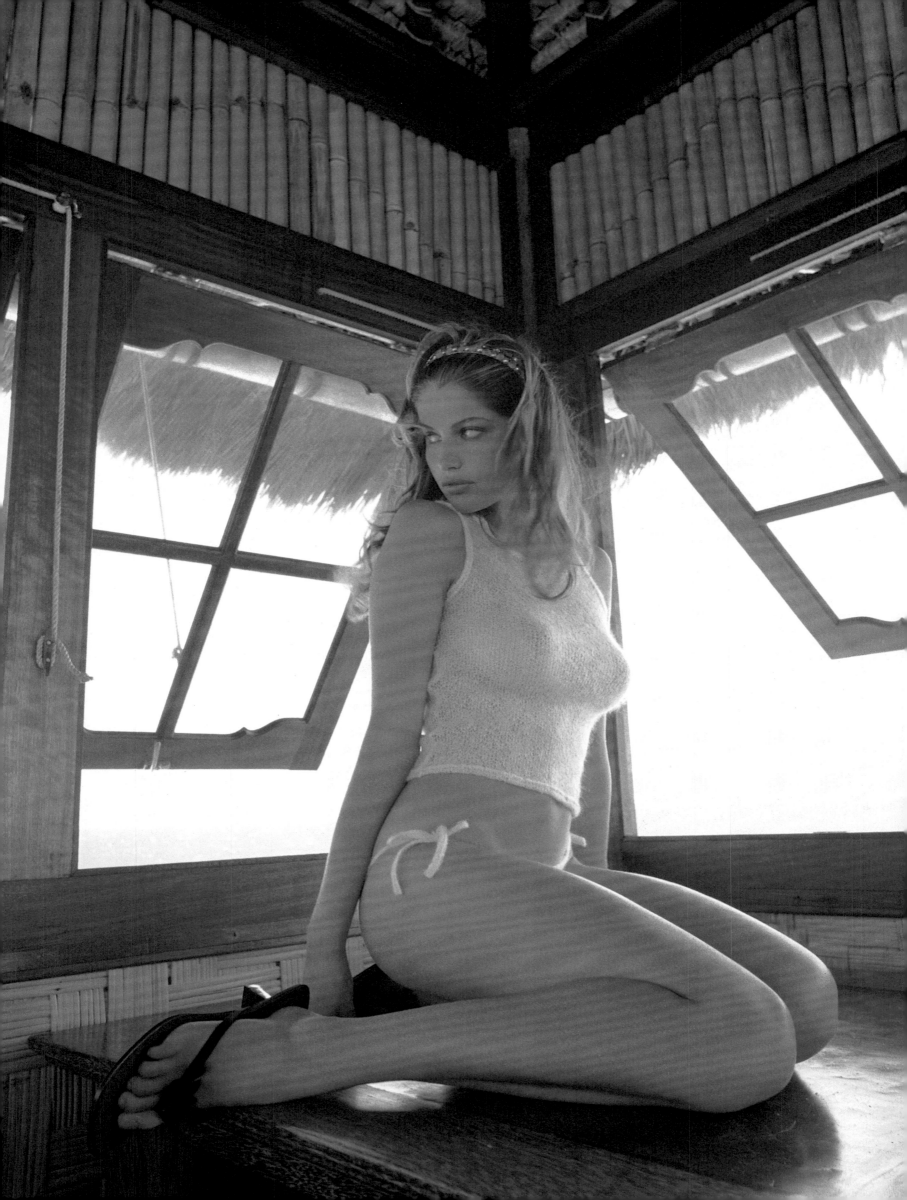

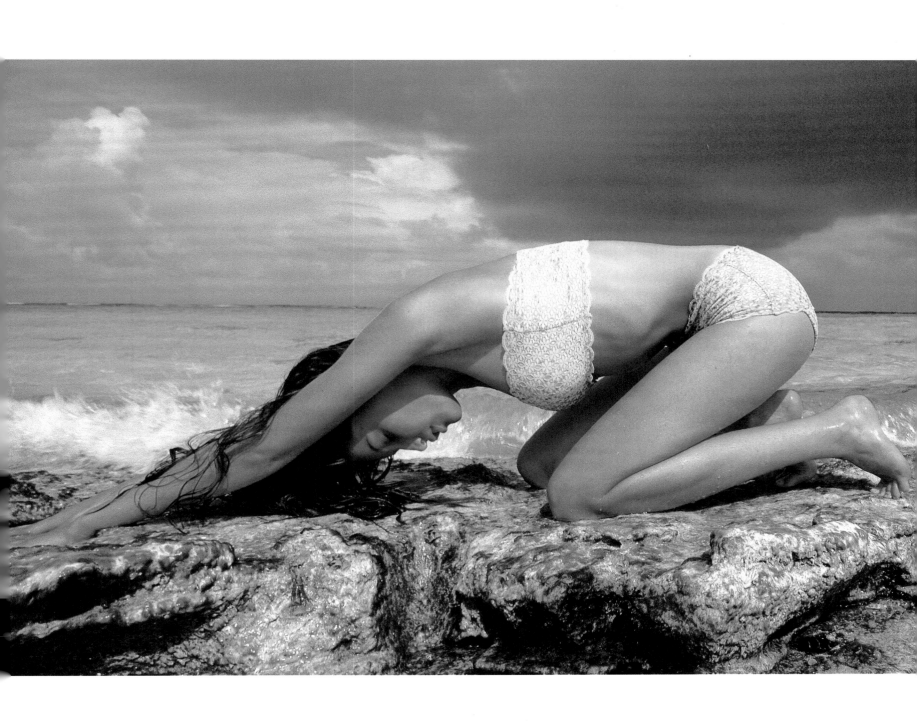

Laetitia traveled to Necker Island in the British Virgin Islands to shoot the 1999 *Sports Illustrated* swimsuit issue.

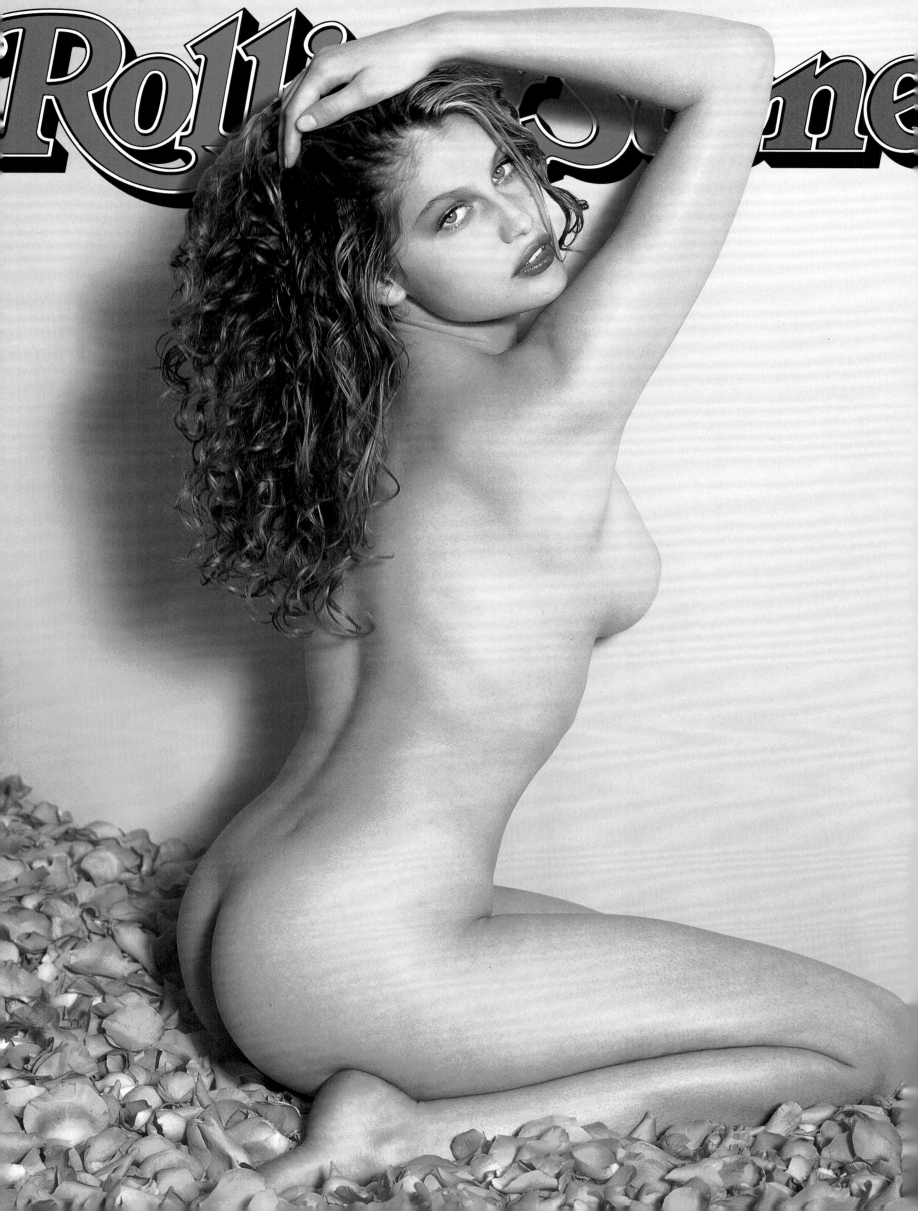

Rolling Stone

Laetitia was named the hottest model of the year in *Rolling Stone*'s HOT issue in August 1998. The sizzling image of a nude Laetitia on the cover sparked a major controversy, and several retailers refused to carry the magazine. *Rolling Stone* had featured nude stars on its cover in the past, but never before had it seen this kind of heat.

Pirelli
Calendar 1999

Pirelli Tyres Limited, world-renowned manufacturer of automobile tires for the road and raceway, is also famous for its sexy calendars, which they have published since 1964. The calendar has never been sold in stores and is available only to those fortunate enough to be included on the exclusive Pirelli mailing list.

Photographer Herb Ritts collaborated closely with L'Wren Scott, Pirelli's creative director, and Jennifer Starr, Pirelli's casting agent, in developing the concept and choosing the models and locations for the 1999 Pirelli calendar, "Women Through the Decades." The shoots took place over five days in May 1998 in three locations: Ritts's private studio, a beach house in Malibu, and the Smashbox Studio in Los Angeles.

For this calendar, a different model was chosen to represent each decade. Ritts and Scott compared pictures of model icons from twelve decades, beginning with the belle epoque (1890s), with pictures of today's supermodels. When they saw Laetitia, their reaction was immediate – Laetitia, with her classic beauty and curvaceous figure, was the perfect choice for the 1950s. As the French magazine, *Paris Match* was moved to proclaim, "The souls of all the fifties pinup girls are reincarnated in Laetitia." The unofficial word at Pirelli is that Laetitia is the favorite of everyone who has seen the calendar.

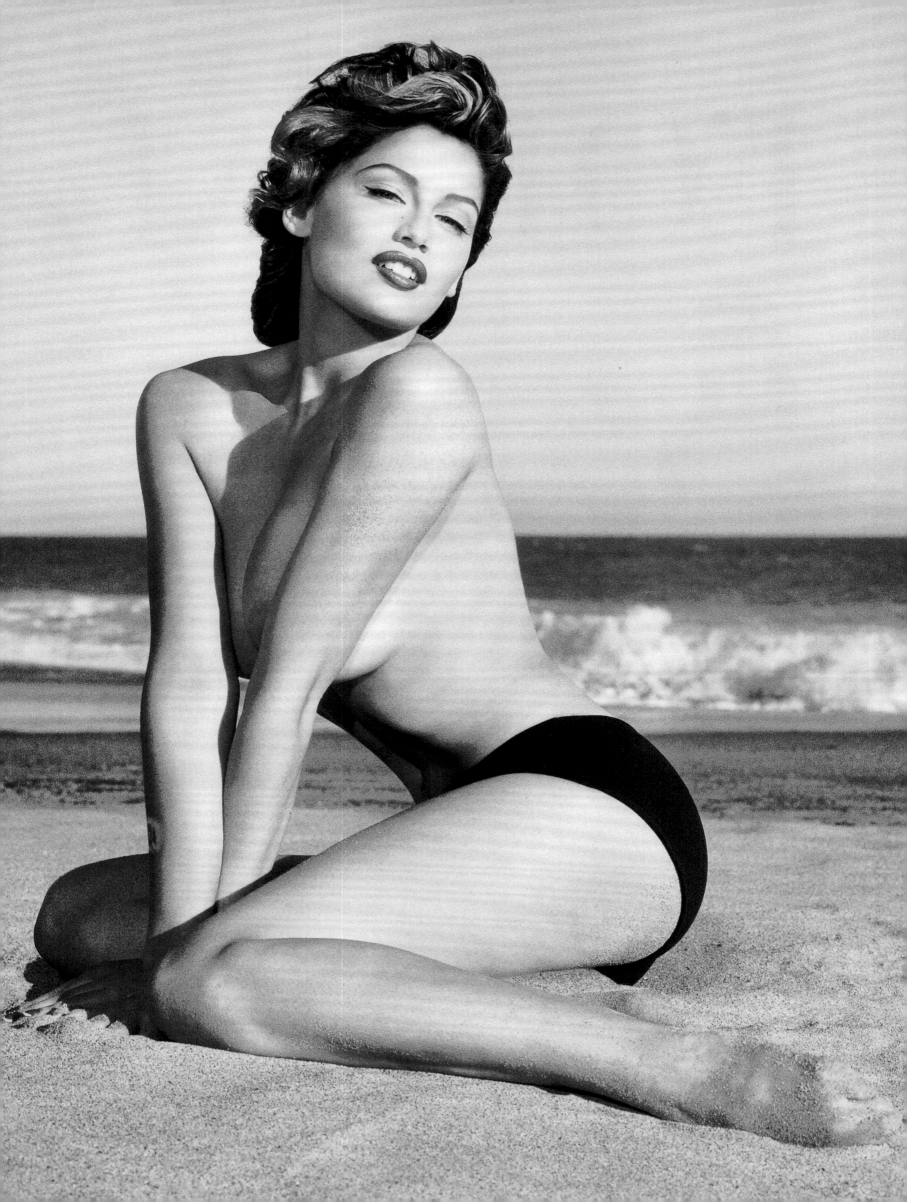

L'ORÉAL

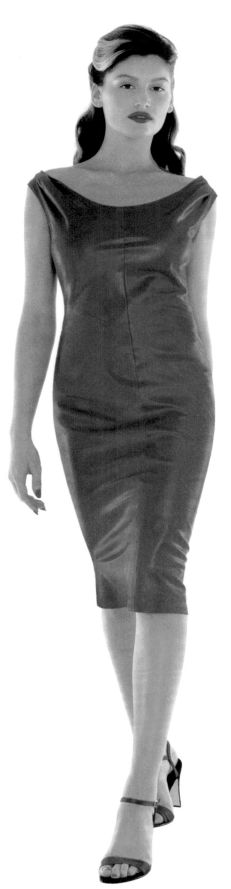

Laetitia signed a contract with L'Oréal in 1998. Appearing at the 1999 Cannes Film Festival, she was a radiant representative for the company, which sponsored the festival for the second consecutive year. She appeared as one of L'Oréal's "diplomats of charm" along with top models Claudia Schiffer and Kate Moss, as well as an assembly of international movie stars.

L'ORÉAL
PARiS

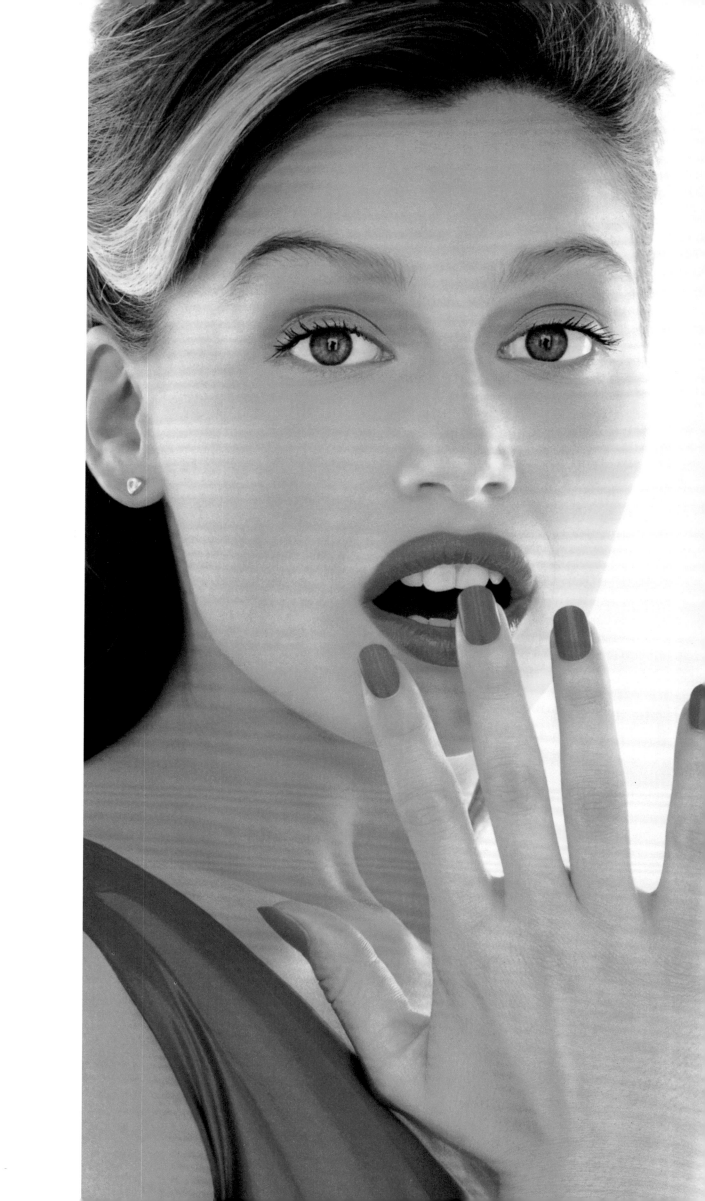

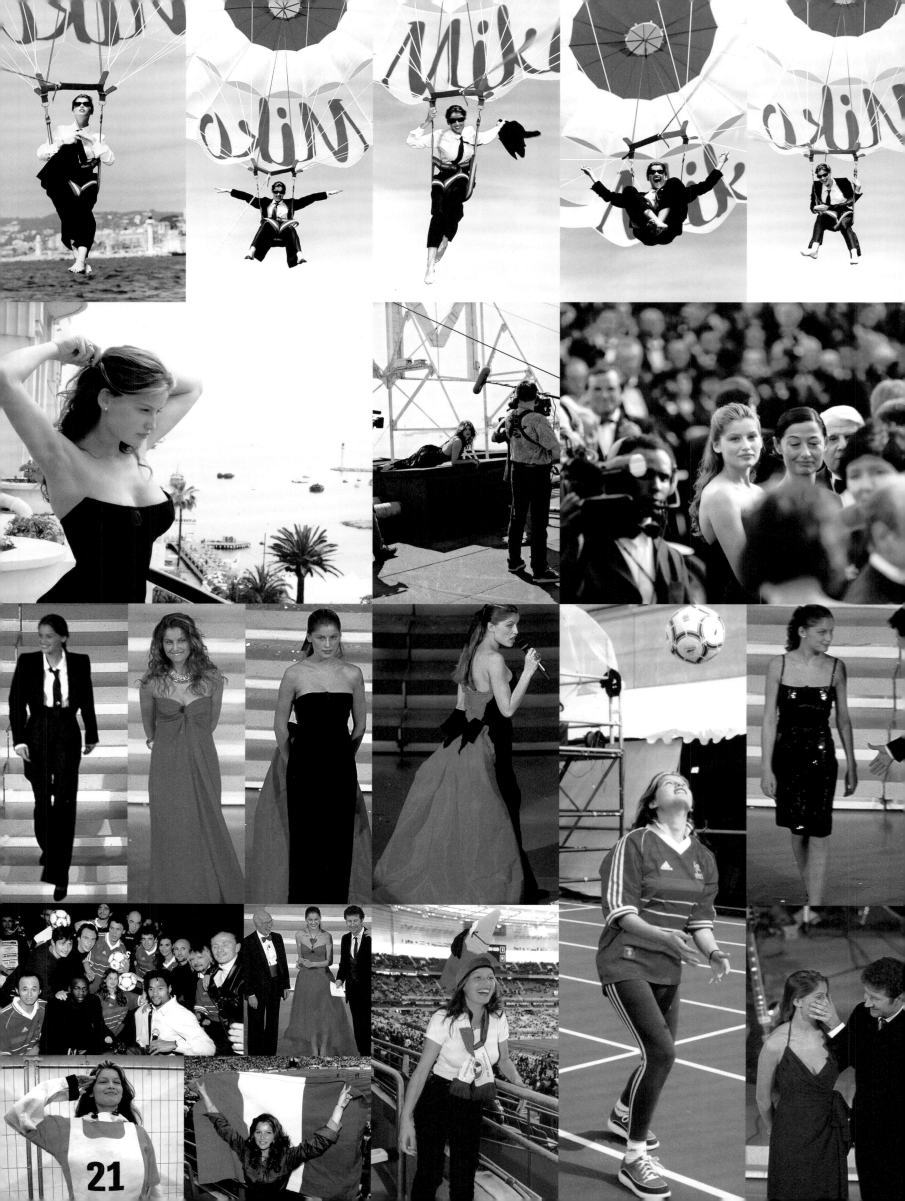

Her Star Is Rising

Whether posing with the champion soccer team at the World Cup Tournament, singing "Volare" on-stage at the San Remo Music Festival in Italy, or floating from the skies by parachute into the glamorous crowds at the Cannes Film Festival, Laetitia never fails to disarm her audience.

In February 1999, Laetitia was invited to co-host and present awards at the San Remo Music Festival, the most important musical event in Italy, comparable to the American Grammy Awards. Yves Saint Laurent provided her wardrobe for the weeklong event. The designer's entire fashion house was at her disposal, with twenty seamstresses preparing fifteen dresses for the stage and as many to be worn off-stage.

When presenting the San Remo Awards, she delighted the guests with songs, jokes, and a few little mistakes that only served to accentuate her charm. She laughed with Gorbachev, the last president of the Soviet Union, and bantered with Neil Armstrong, the first astronaut to land on the moon. She declared on-stage there was "a chemistry" between her and Renato Dulbecco, Nobel Laureate in Medicine, only twenty minutes after first meeting him.

"Rita Hayworth comes down the steps and you discover that she has the voice of an *enfant fatale.* It's fantastic," exclaimed Sergio Bardotti, one of the two Festival coordinators. Each time Laetitia entered, the audience instantly rose to its feet, because she is beautiful, certainly, but above all, because she is real.

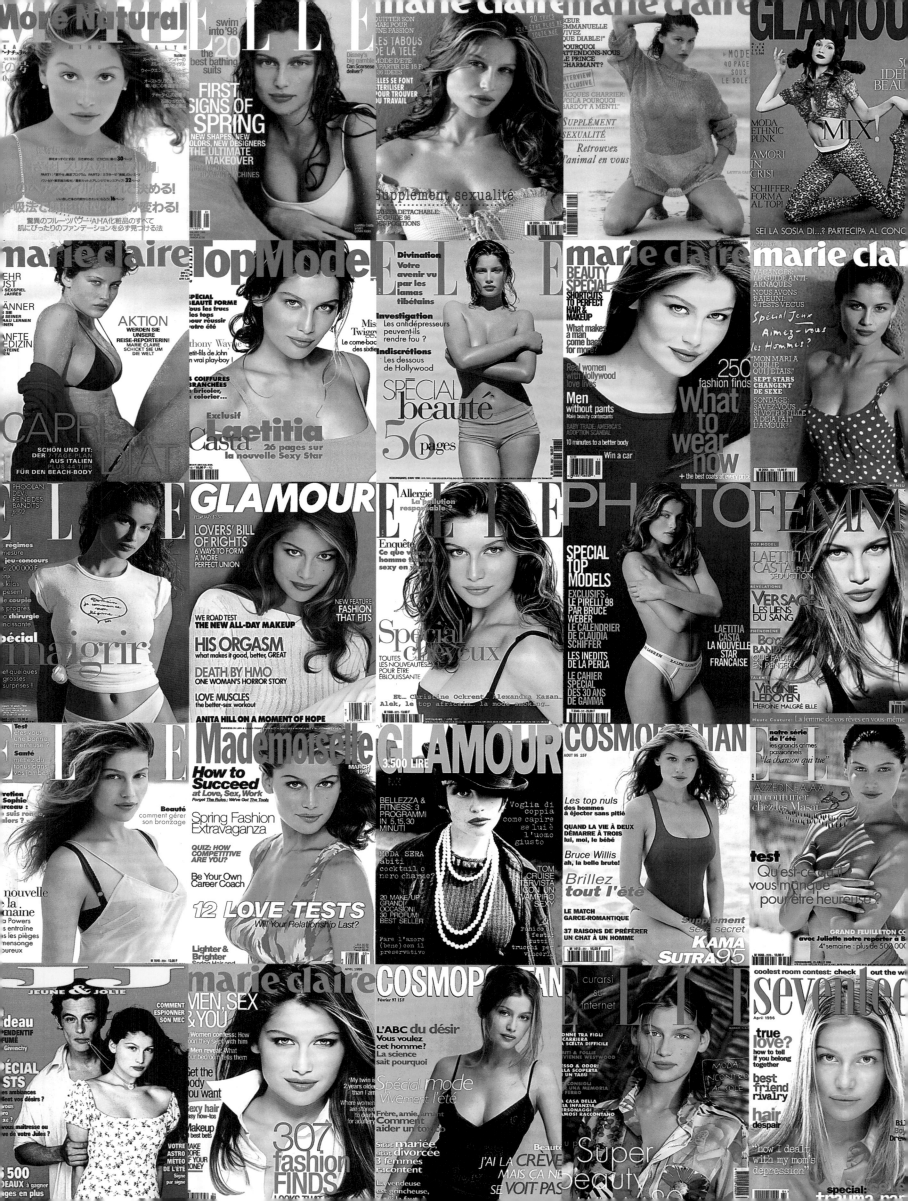

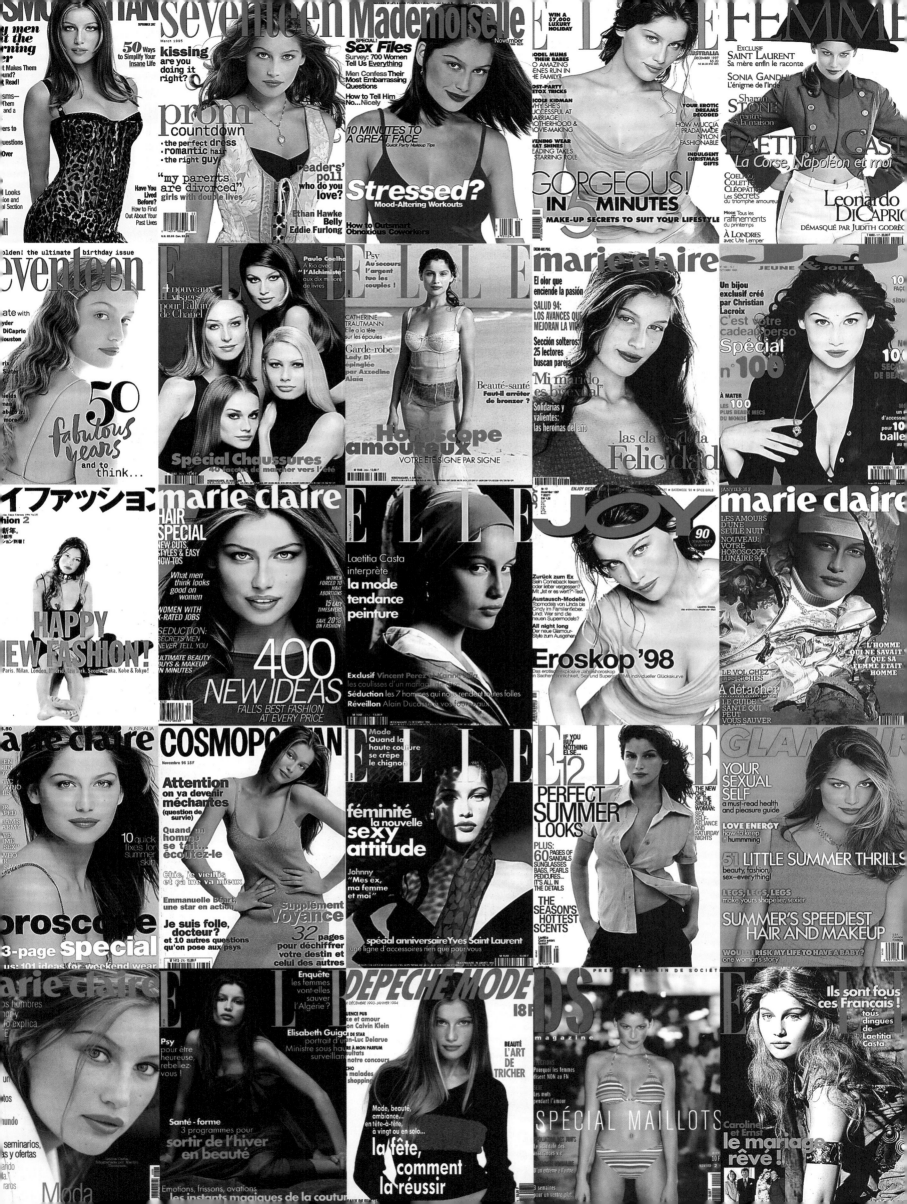

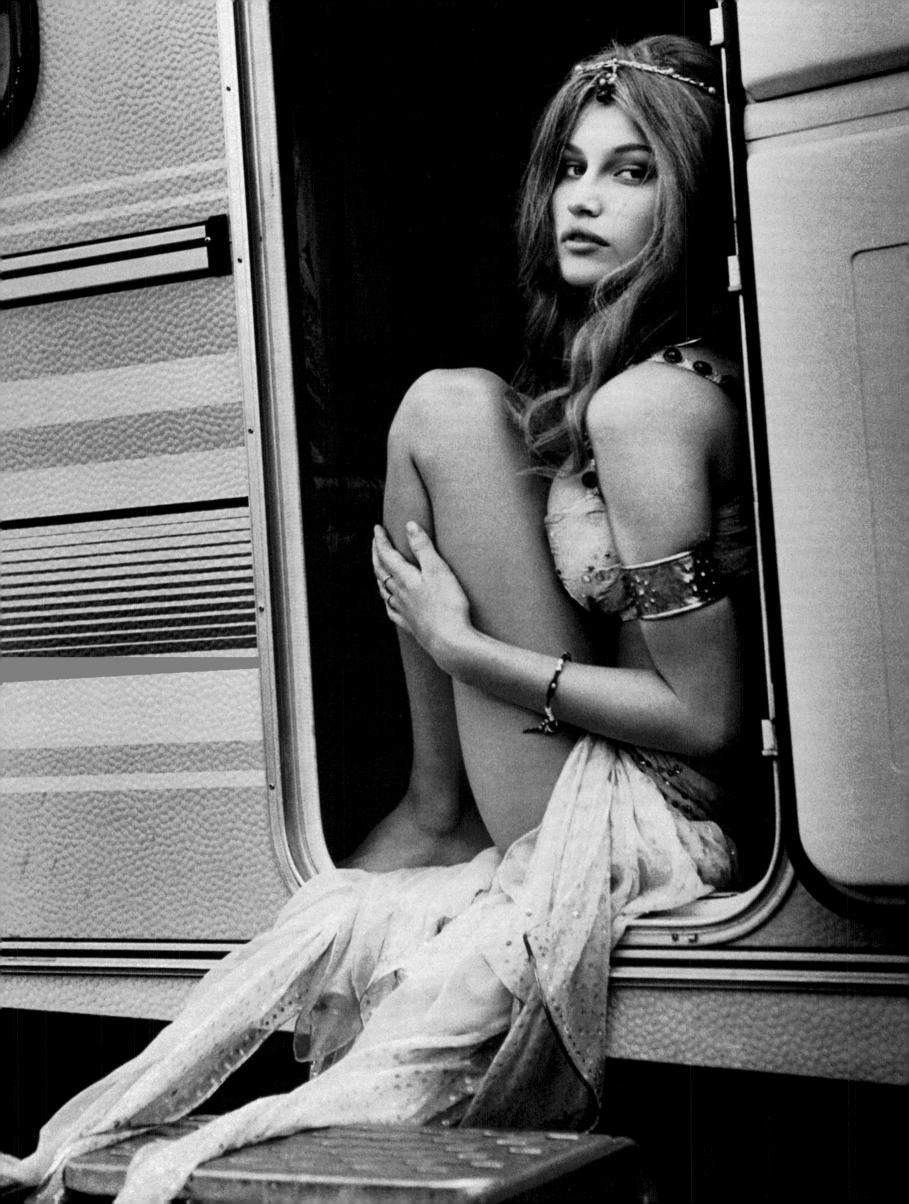

Astérix & Obélix

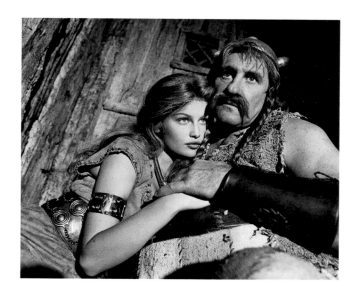

The eagerly awaited film, *Astérix et Obélix contre César,* directed by Claude Zidi and produced by Claude Berri, was released in France in February 1999. With a $50 million budget it was the most expensive French film ever made, and has been a smash hit in Europe.

The live-action film is based on the wildly popular ongoing series of French comic books *Astérix & Obélix,* and takes place in Gaul, around 50 B.C. The country is entirely occupied by the Romans, but for one tiny village of indomitable Gauls who are holding out against the invaders. To aid them in conquering the surrounding fortified camps is the beautiful Falbala, along with her friends Astérix and Obélix. The film revolves around their misadventures as Falbala uses her abundant charms to distract the enemy and conquer the hearts of the Roman world.

Laetitia plays the sexy, lovable Falbala, opposite Gérard Depardieu as Obélix and Christian Clavier as Astérix. The encouragement and warm support she received from Zidi and her costars made Laetitia's first experience as an actress memorable. As she describes her acting education, "If you are merely reciting your lines, people won't believe you. Your feelings have to be genuine. Or at least they have to come from a genuine source. Once you know where your feelings come from, you can act them out through your lines."

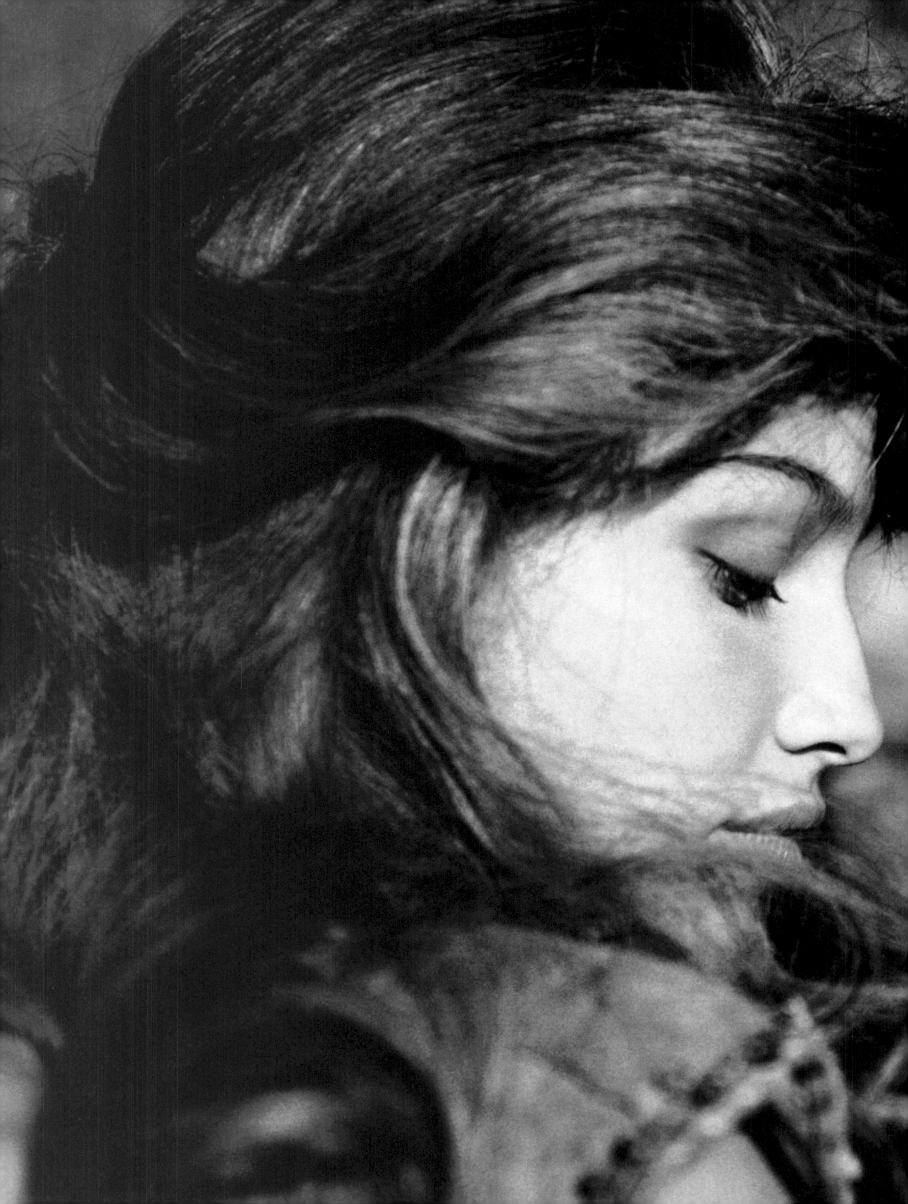

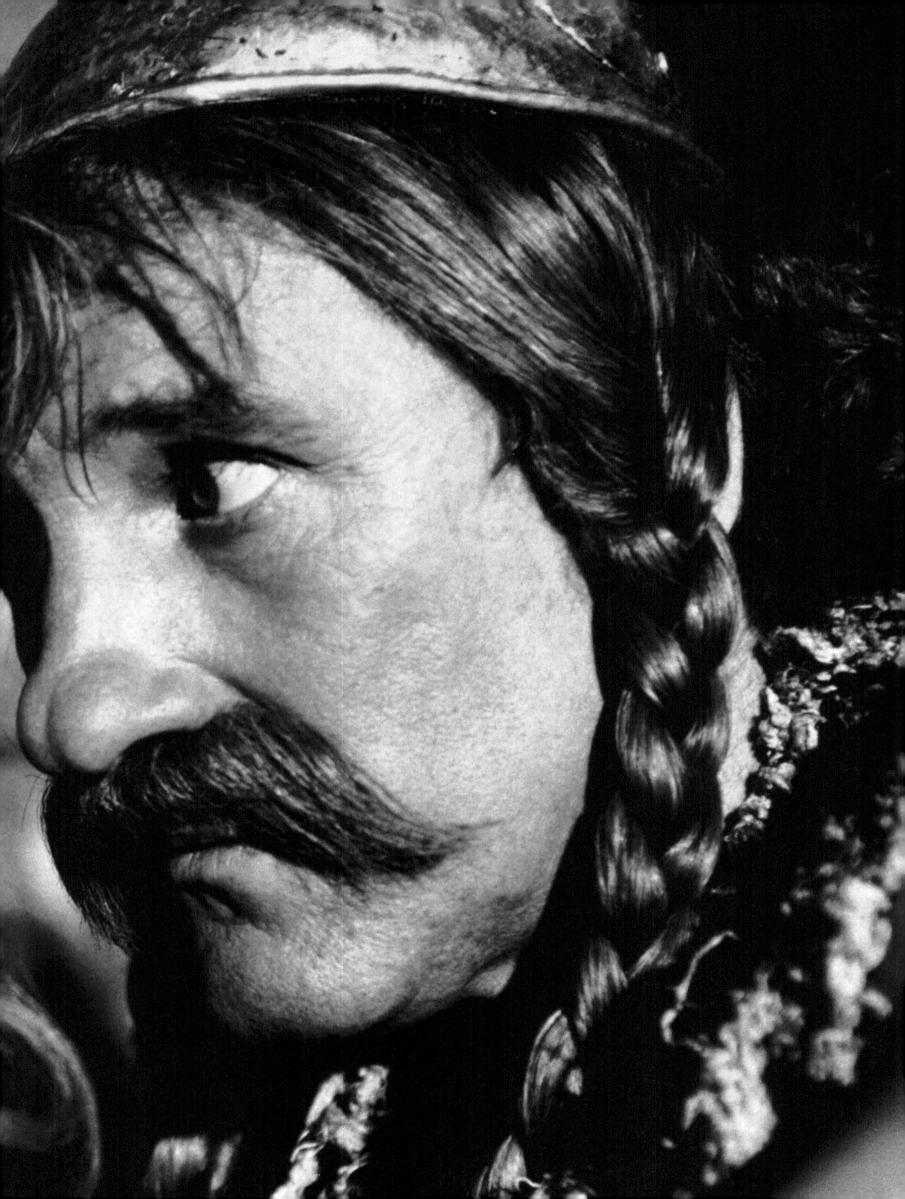

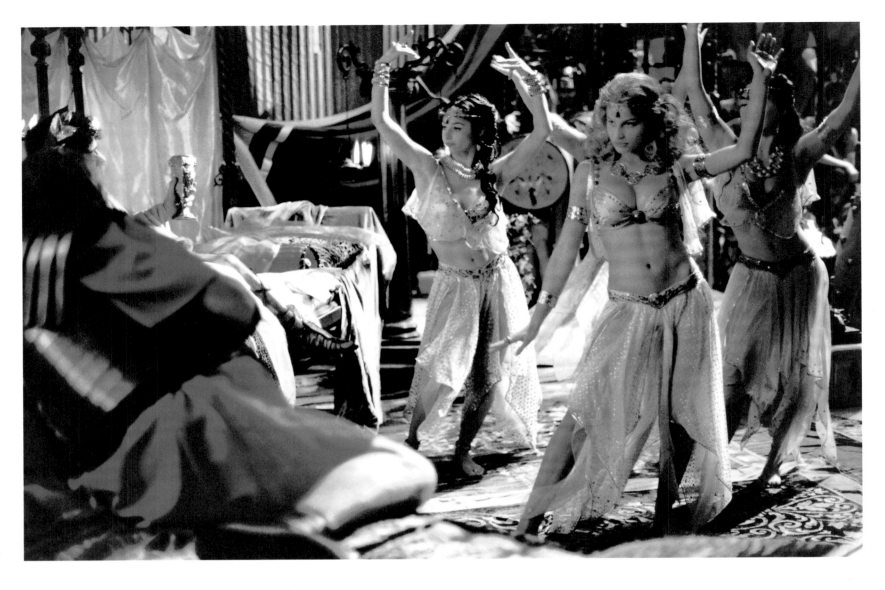

Laetitia
bella!
et sage.
Comme une image!
F. Lacaf.

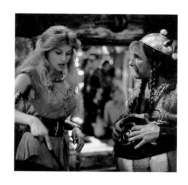

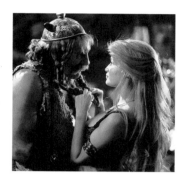

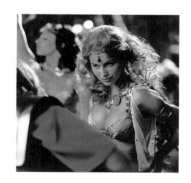

"It was great to shoot this film with Laetitia – my head is still spinning! She radiates an incredible freshness, and is talented to boot."

GÉRARD DEPARDIEU, "OBÉLIX"

"I know Laetitia as a nice, reserved, almost shy young girl, without any model/celebrity affectations. This lovable, endearing naturalness translates well on screen – an aura that moves the hearts of the audience. With this rare talent, everything is possible for her."

JOHN GOTTFRIED, "CÉSAR"

"I had enemies on the set because I was the only one allowed to kiss Laetitia. She has so many faces – one minute she is a young, sweet girl; then suddenly a hilarious, mature, knock-out woman! During shooting, she was unbelievably professional, which certainly doesn't come only from her recent work as a model. With her experience and her naturalness, she can become a huge success."

HARDY KRÜGER, JR., "TRAGICOMIX"

"Laetitia: From this juicy, full-bodied grape grows a vintage wine, full of earthy spices, that will flow like a heavenly nectar through the veins of those of us on earth. But business-minded wine growers do not allow this rare fruit enough time to ripen, and squeeze its intoxicating juice too early into the gullet of lustful consumers."

MARIANNE SÄGEBRECHT, "GUTEMINE"

A Laetitia, A la Corse

Une île c'est féminin
Posée sur l'univers
Et sur le bleu des mers
Comme un cœur sur la main

Une île c'est après
Cette pierre qui restait
Une histoire d'enfant
Le silence et le chant
C'est aussi comme un lien
Aux lignes du destin
La douceur d'un voile
Une algue et une étoile
Mon île…
Mon île c'est demain
Une maison un chemin
Ce bonheur qui étreint
Des bergers musiciens
Une lanterne une voix
Dans les mots d'autrefois
Un battement sous la terre
Une aube qui espère
Mon île …
Mon île c'est un chemin
Et vos mains dans nos mains
La liberté du vent
L'étranger qu'on attend
C'est parfois le trajet
D'une larme inutile
L'eau marine oubliée
La peine au bord des cils
Une île …
Une île c'est féminin
Un enfant qui revient
Des rivières en chevelure
Comme un printemps qui dure
La mer jusqu'au bout
Et l'horizon partout
Jusqu'au pied de ma ronde
Pour l'autre amour du monde
Jusqu'au bout de ma ronde
Pour tout l'amour du monde
Une île …
Une île c'est féminin
Comme un cœur sur la main …

Words by G.F. Bernardini,
lead singer of I Muvrini

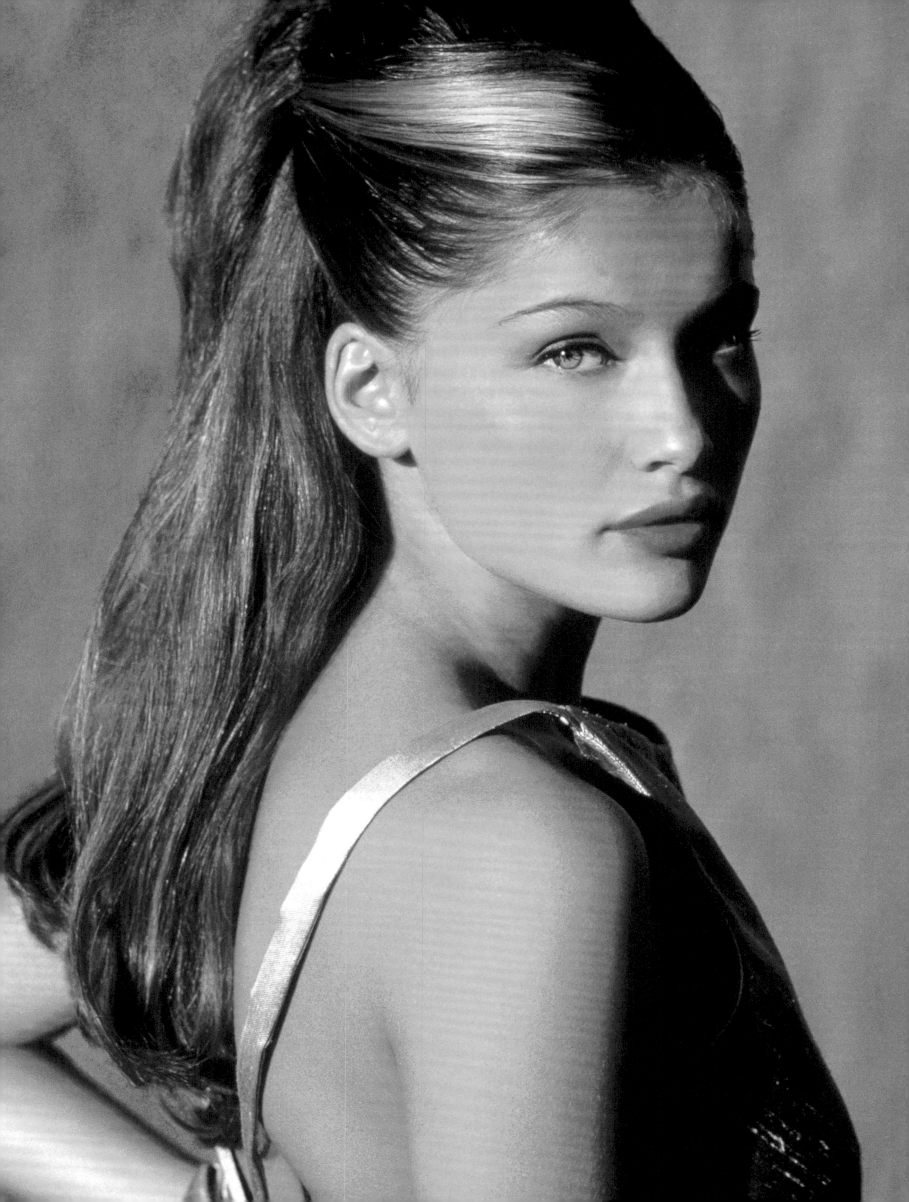

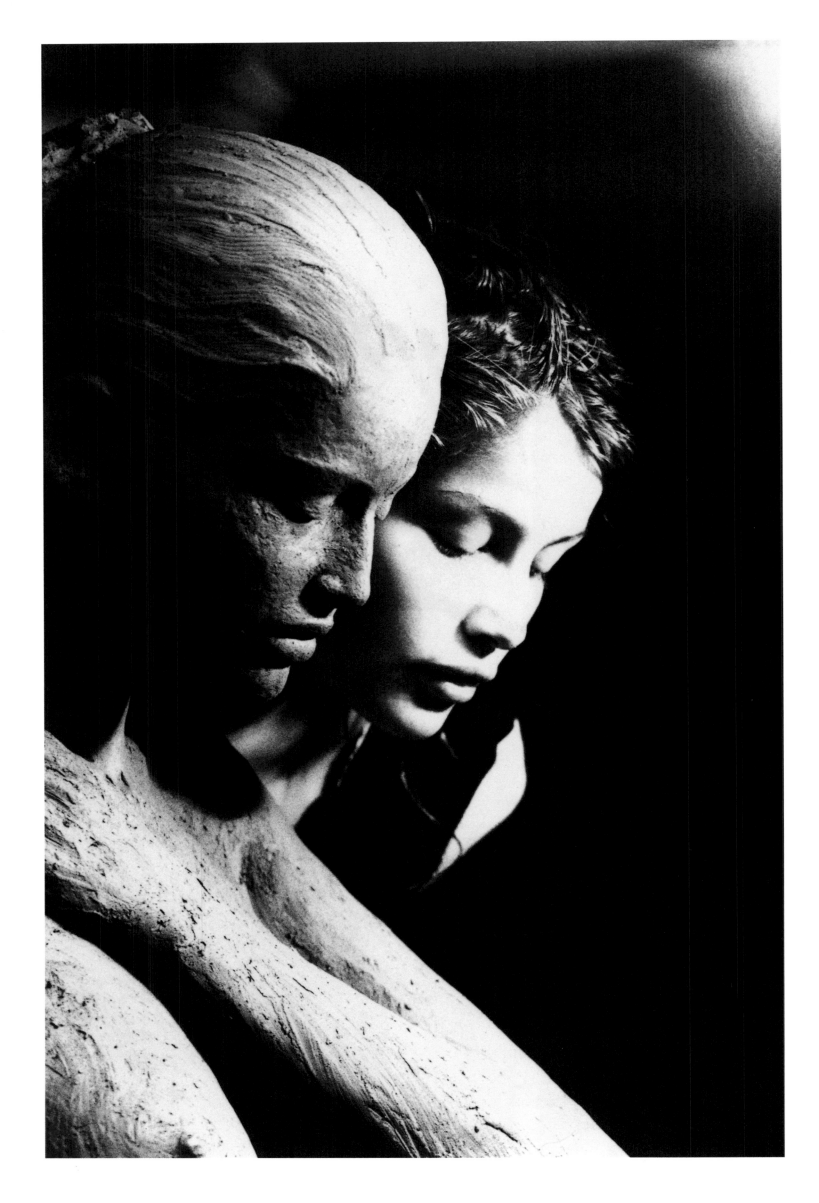

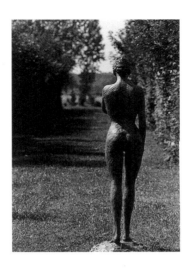

"If I start talking about Laetitia, it's going to take hours. I cannot stop about Laetitia. She has a childlike gift with the camera, then she delivers something incredible.... Laetitia is the most beautiful woman in the world."

DOMINIQUE ISSERMANN

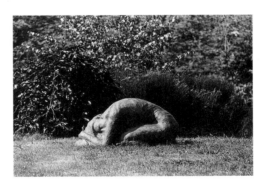

"I looked into her eyes to understand her soul, and I saw there a beautiful, radiant soul. For that I chose her, not only for her splendid body."

PAUL MARCIANO

These bronze sculptures are the creation of artist Jean-Marc de Pas. Laetitia decided she would feel more at ease posing nude at home, so he took up temporary residence in the Castas' garage while the molds were being created. This was the first time Laetitia had ever posed nude.

"Laetitia is beautiful inside

and radiant outside. She is pure, honest, open, and natural. There is no advice that I can give her; she has her own life under control. The most important thing is not to become a star but to remain one! This I wish for her with all my heart."

BRIGITTE BARDOT

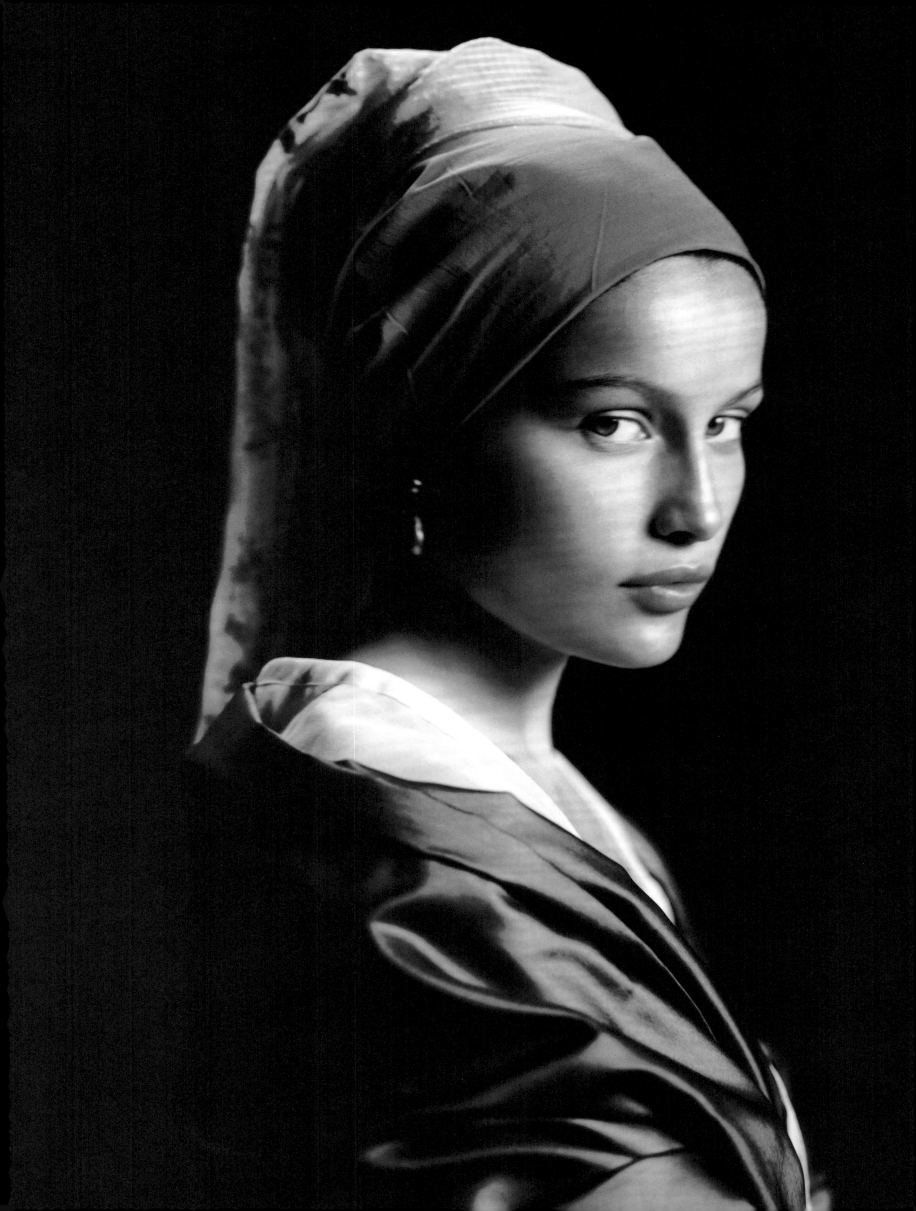

Laetitia by Laetitia

"I have to say what I feel. Like all Corsicans, I love truth, and I speak from my heart. Sometimes I ask, 'Why is all this happening to me?' I don't know, but it gives me opportunities to express myself that I never dreamed I would have. Like this book, which I hope reveals many of my values. It contains many of my truths – my ideas, my beliefs, my sentiments. This is me."

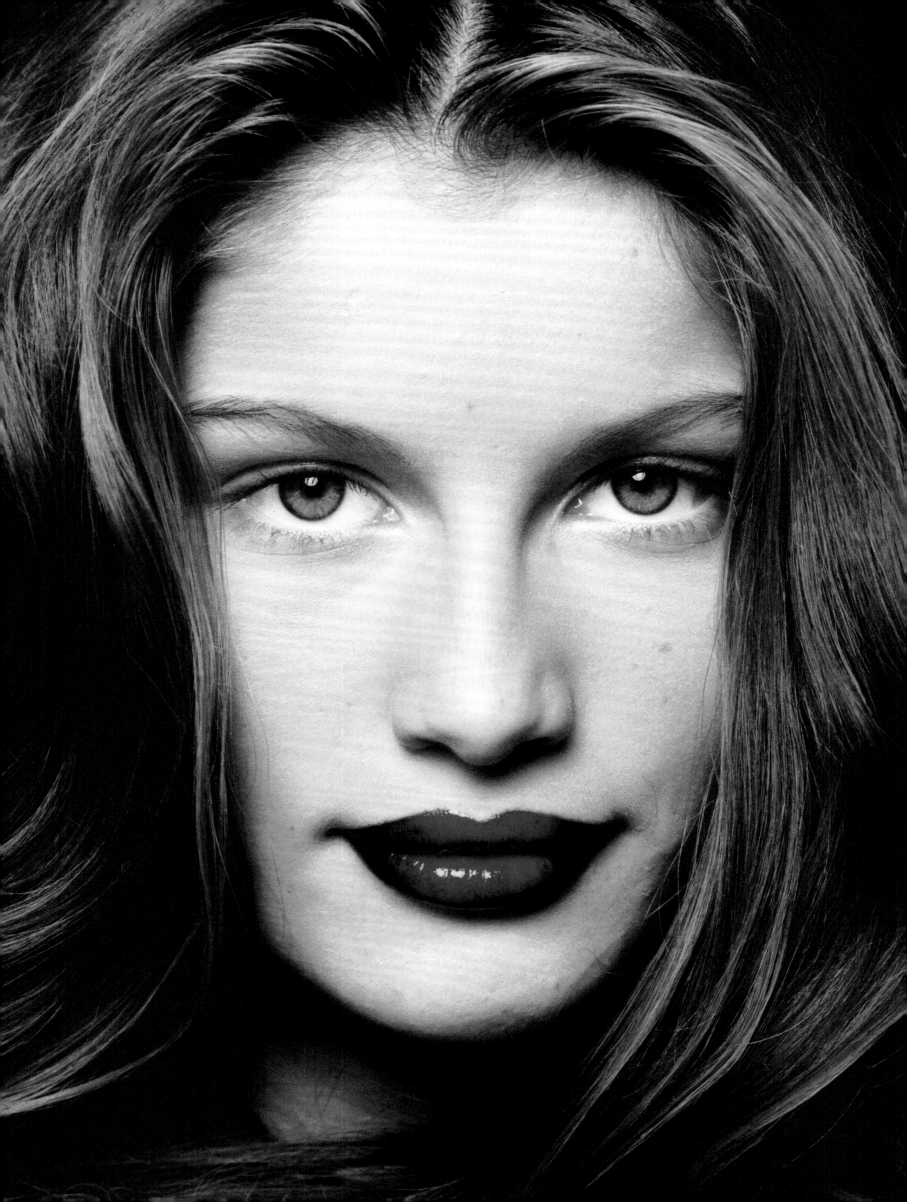

Modeling

"In life, I don't like it when a woman uses her power, but on the set, it's different. The different roles one plays at being a woman: sexy, cheerful, sad – it is remarkable. I enjoy this game with the camera.

"[The fashion world] is full of sharks. In this world the young girls lose themselves, become the property of others, live but for the job and their craziness, don't know anymore where their home is. Many take drugs. It's strange. Perhaps the girls understand that this does not work for me.

"I don't have many friendships with other models. I respect them and I enjoy working with them, but I probably would not invite them into my home. My house is like my heart, and I open it only to those with whom I have a close relationship."

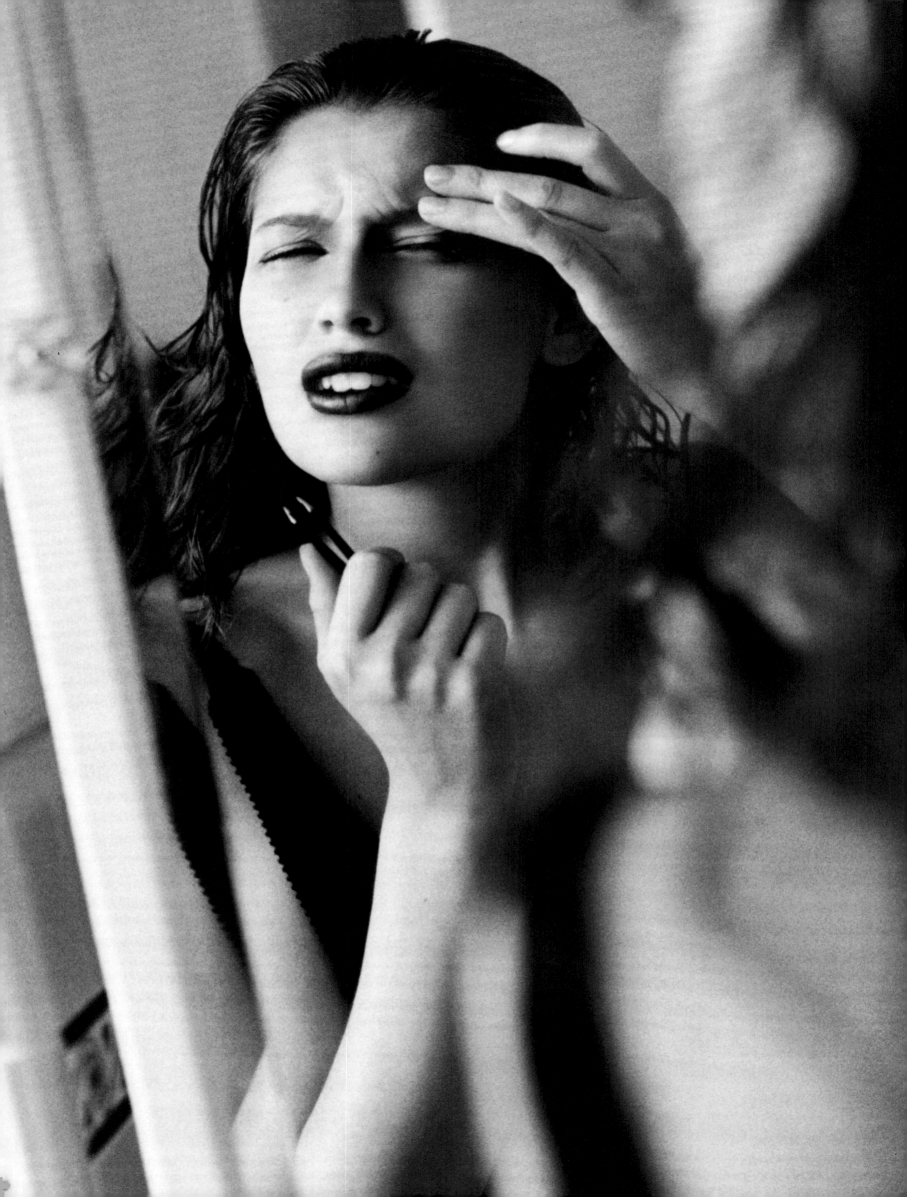

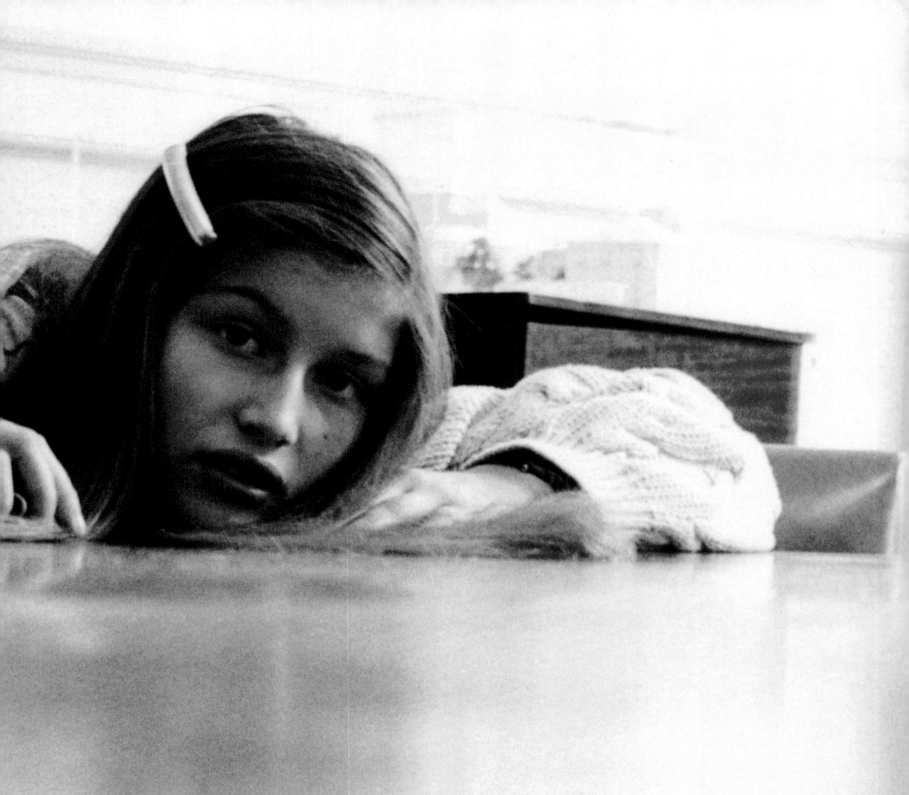

"I don't want to be an image.
It frightens me."

"We are all like the Russian doll called the matryoshka – made with many layers. On the outside, my skin is as tough as a crocodile's. But in the smallest doll, in my most intimate sphere, I am tender, fragile, and sensitive."

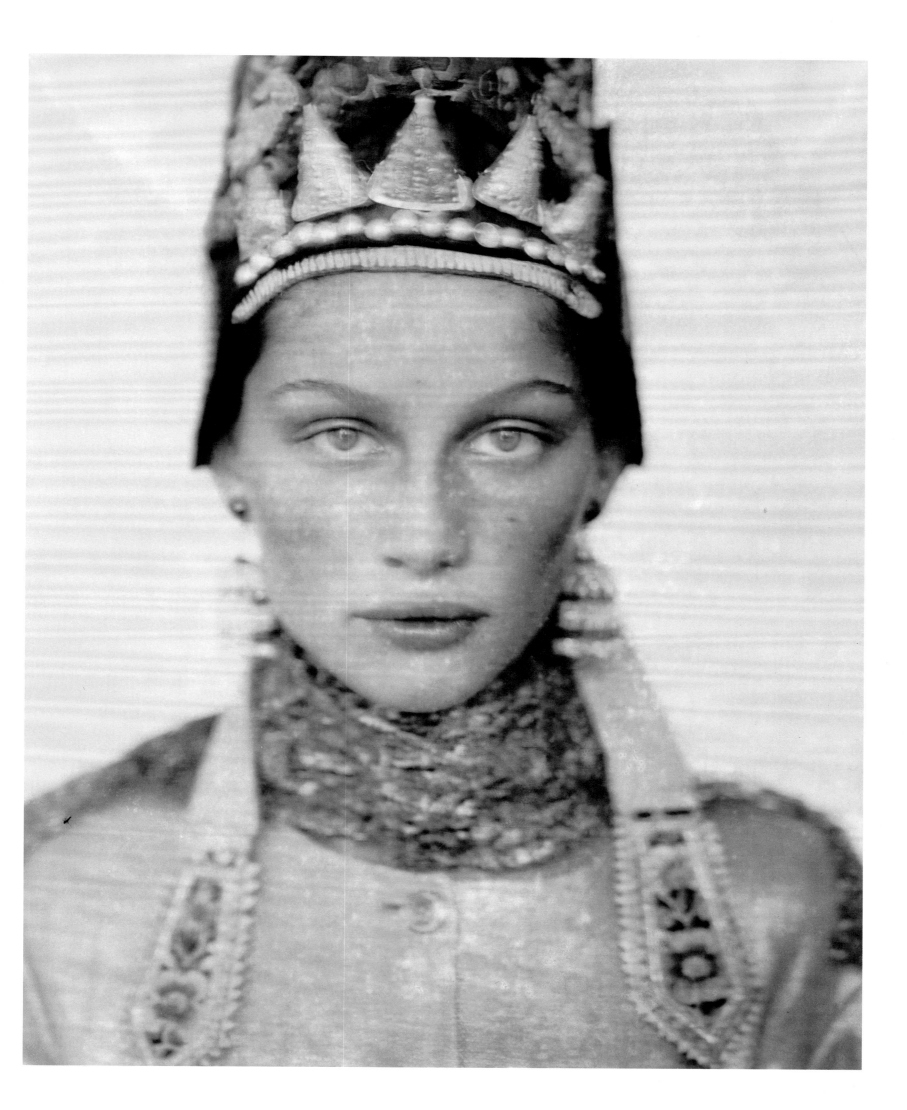

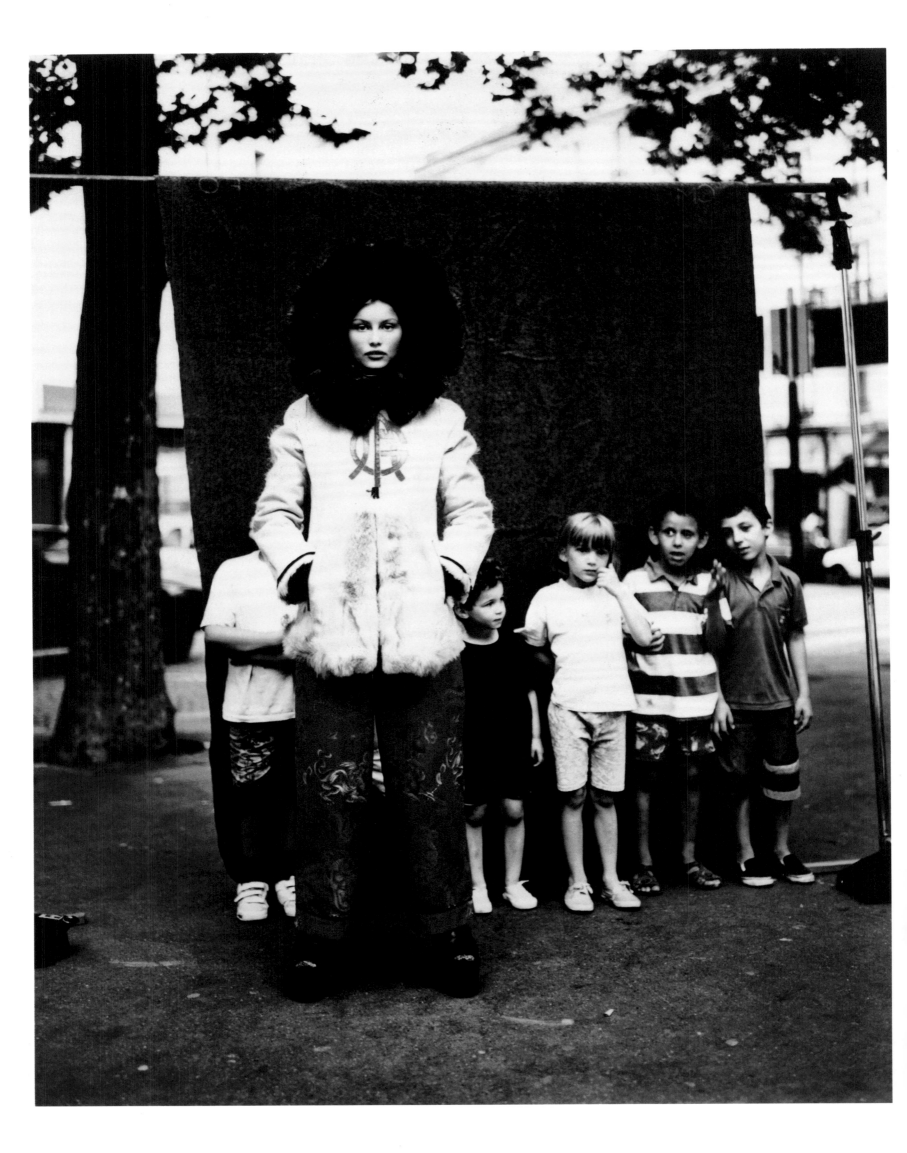

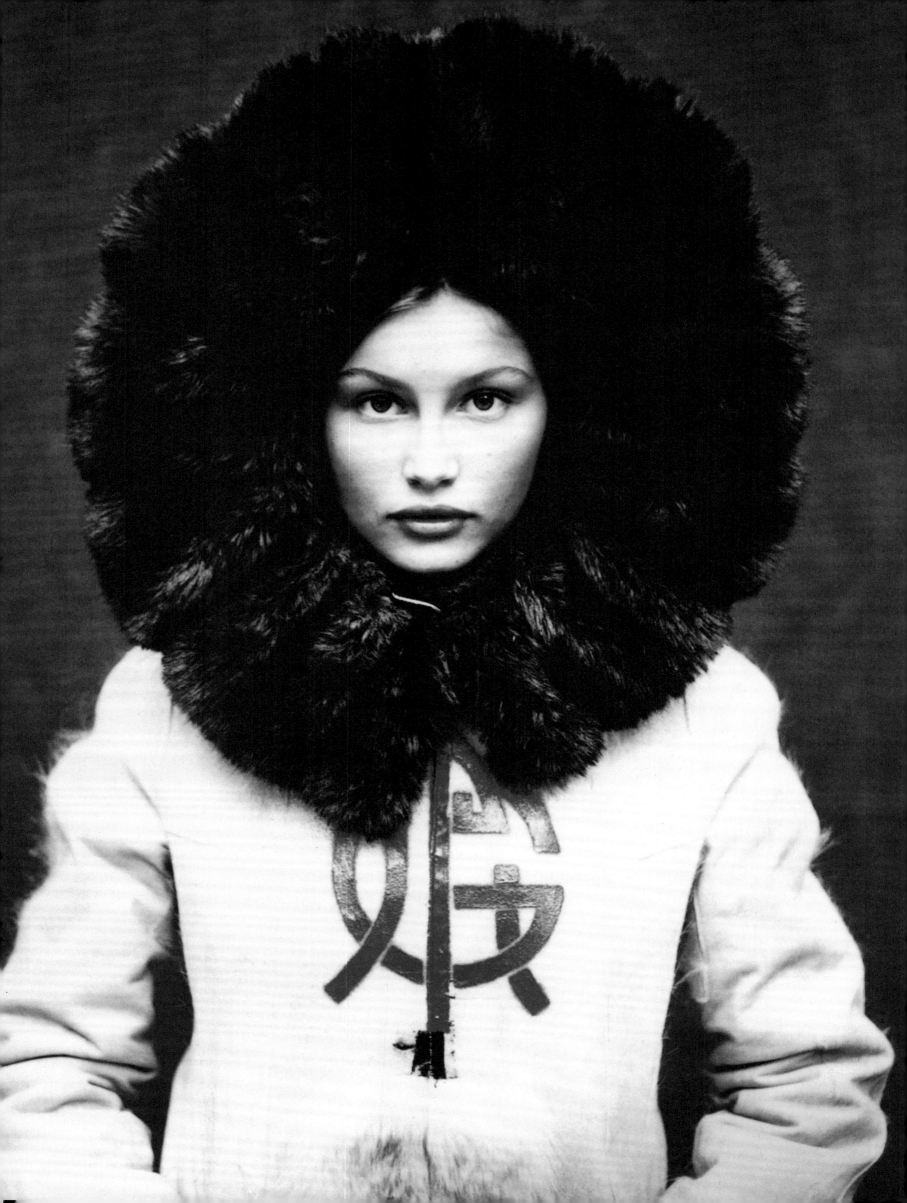

ALL NATURAL

"I tell people my breasts were made in Normandy from butter and crème fraîche!"

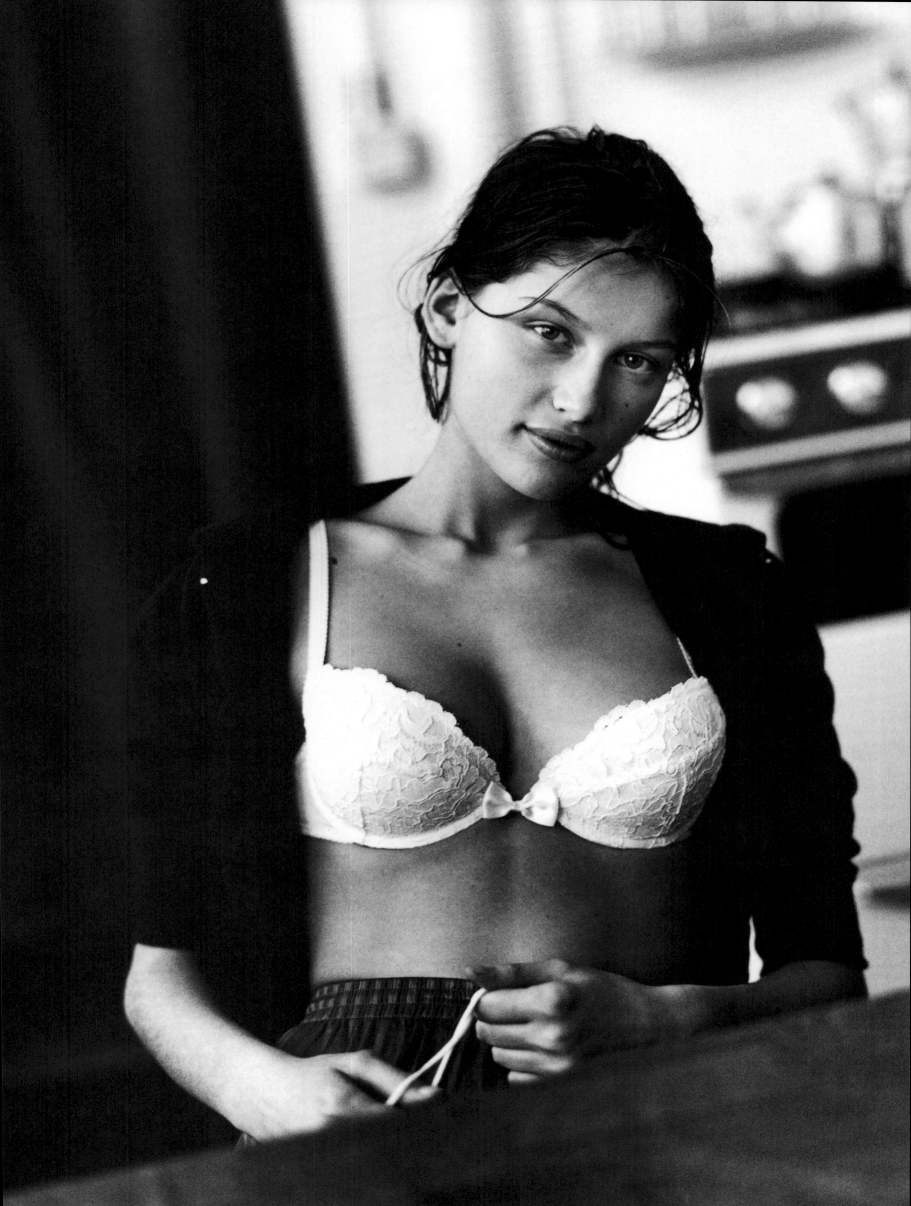

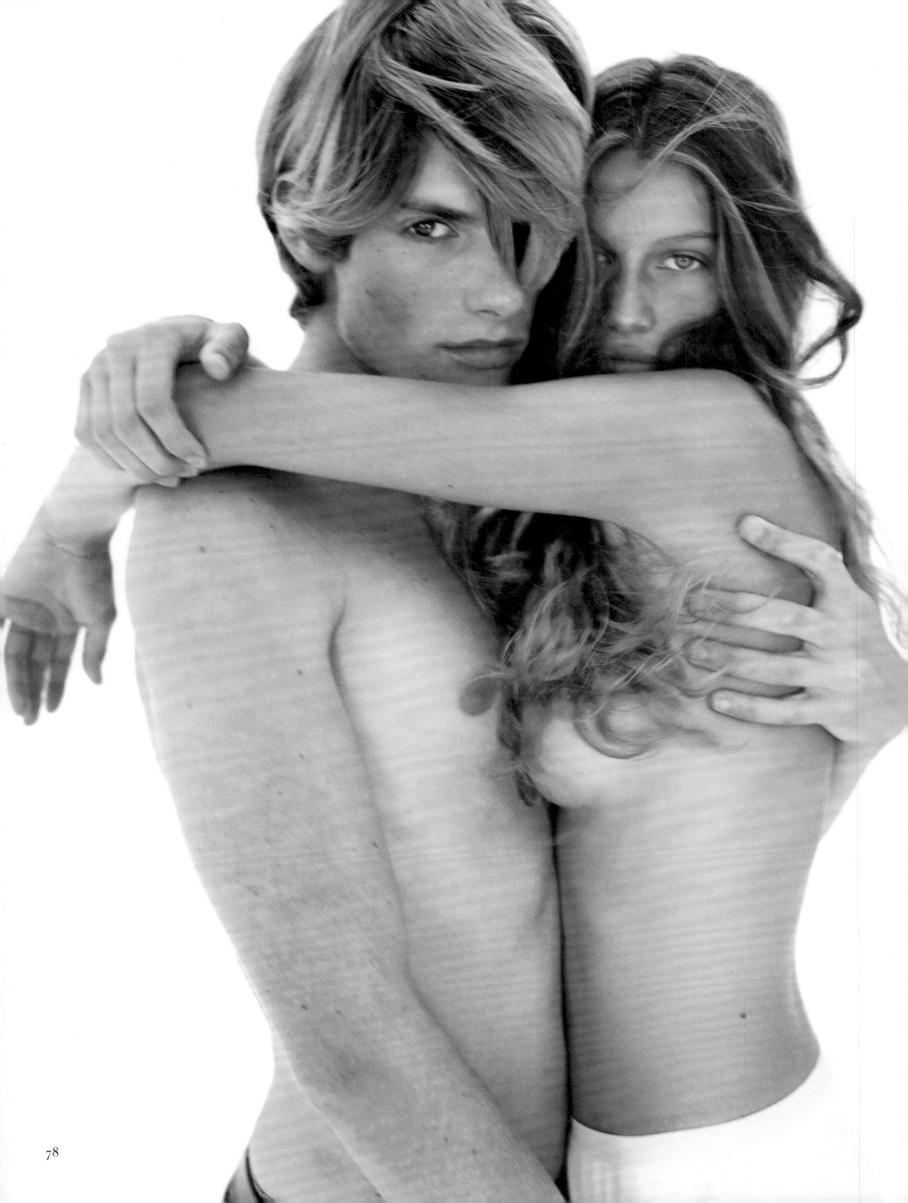

LOVE

"The press says I have so many lovers. Usually I just shrug it off, but there are times that it enrages me! The rumors are not true, of course. I live my life the way I want and spend time with whomever I want."

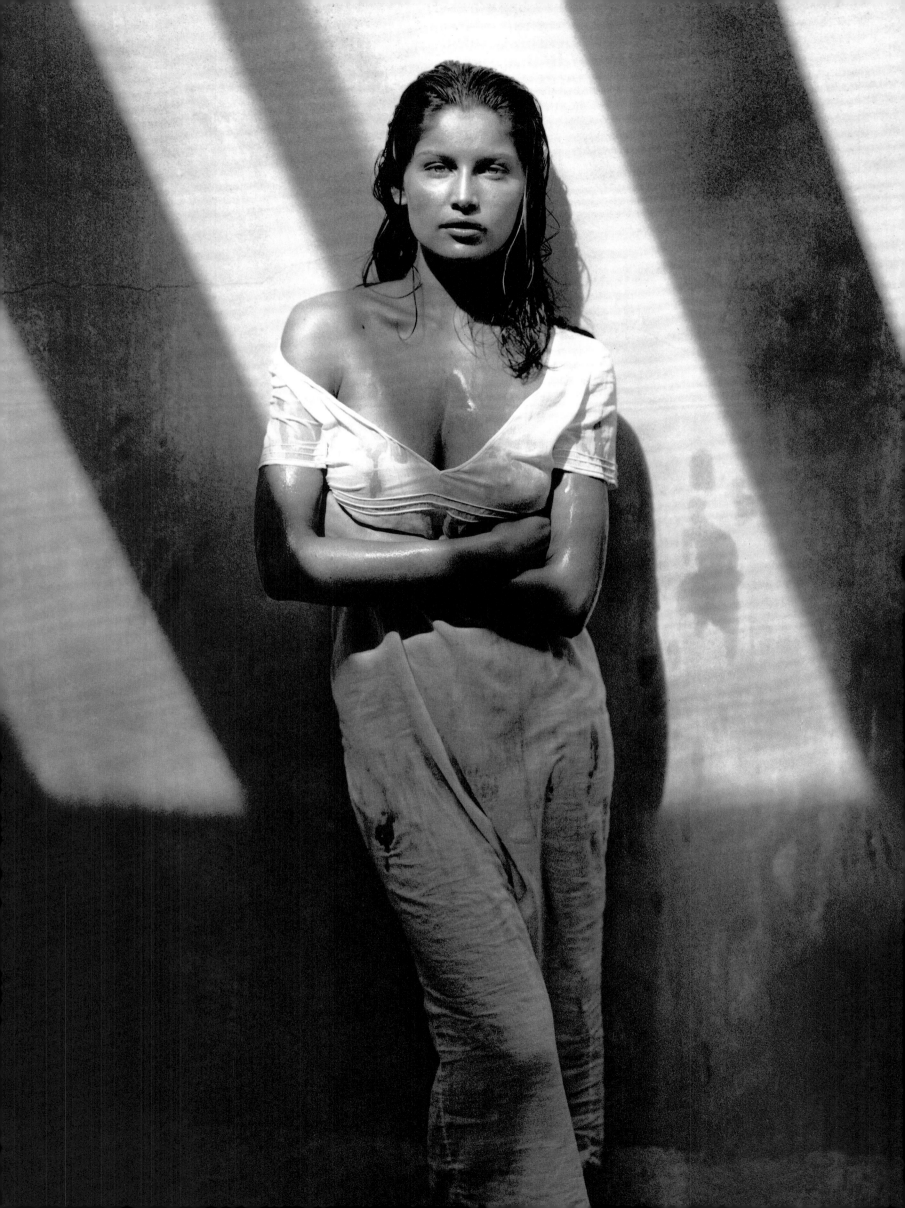

Books

"I have loved literature from the time I first read *Matilda,* a passionate children's story by Roald Dahl.

"And there have been other wonderful books that have helped me to understand how the world works. *First Love* by Ivan Turgenev is the story of a young girl who uncovers the woman within her, and in doing so begins to understand the power of her beauty.

"Thomas Hardy's *Tess of the d'Urbervilles* is a novel I have read over and over again. Tess is a pure child who has an inner glow none of the others in the book possess. They reject her because she is different, and they try in every possible manner to destroy her, because they are jealous. It is an extraordinary love story."

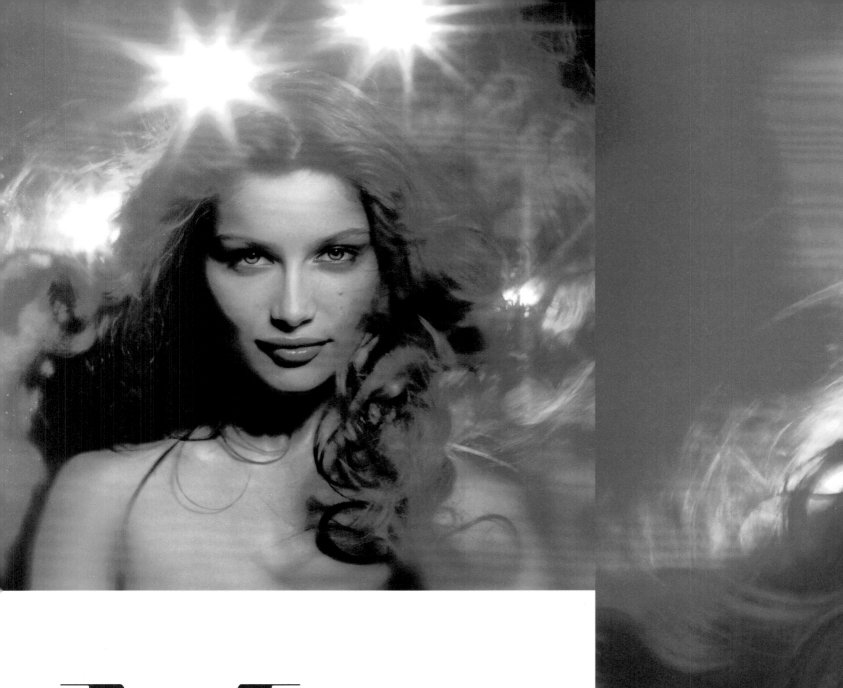

Men

"When I see a man I look into his eyes to find his true self. I don't look at his body. It is his heart and his passion that will give me what I want. What interests me is a man's soft spot, his vulnerability. It is when a man is vulnerable that he is beautiful. When he is unguarded and honest, then a man is like a child."

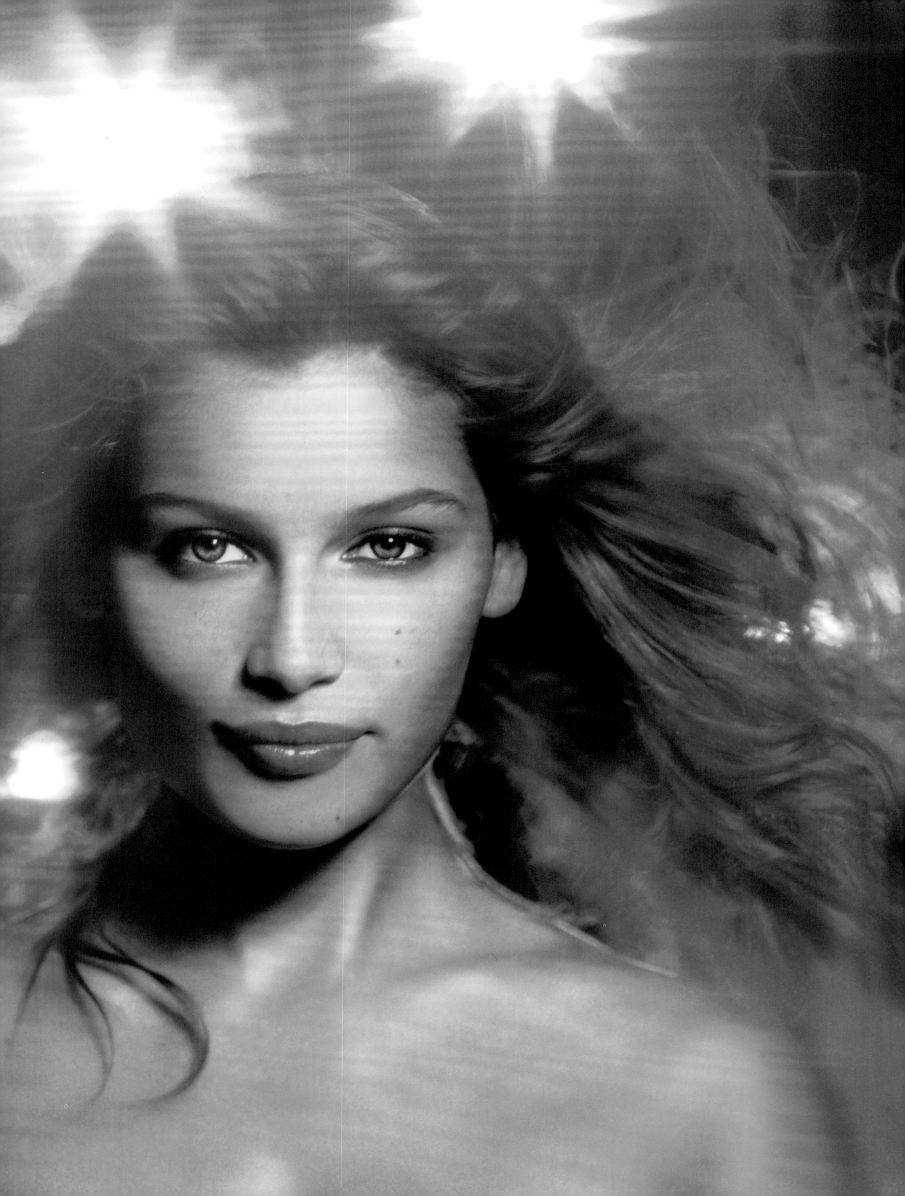

BEAUTY

"There is a wonderful poem by Pablo Neruda that I know by heart. It tells of a woman, both ugly and pure, and her hidden beauty that few ever see. Only the person who loves her can see it and understand it."

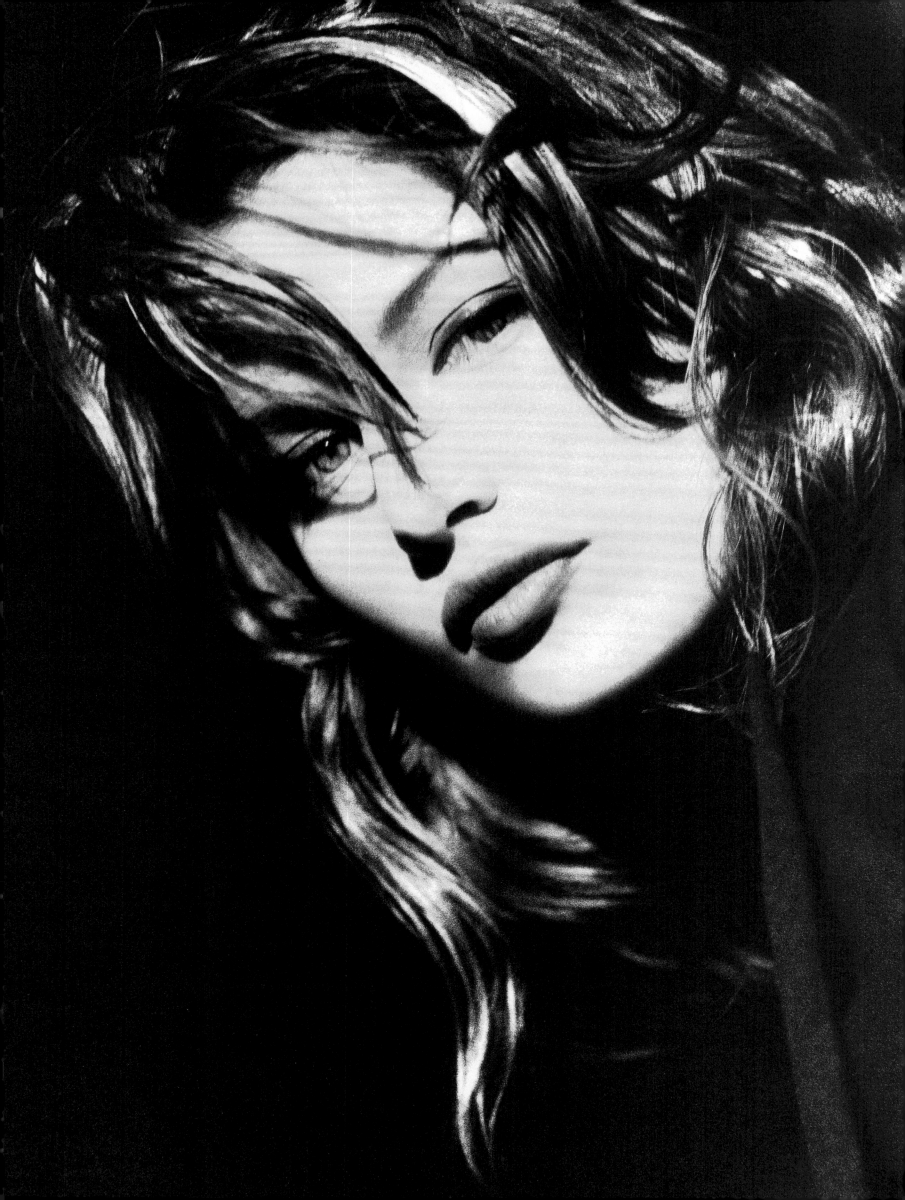

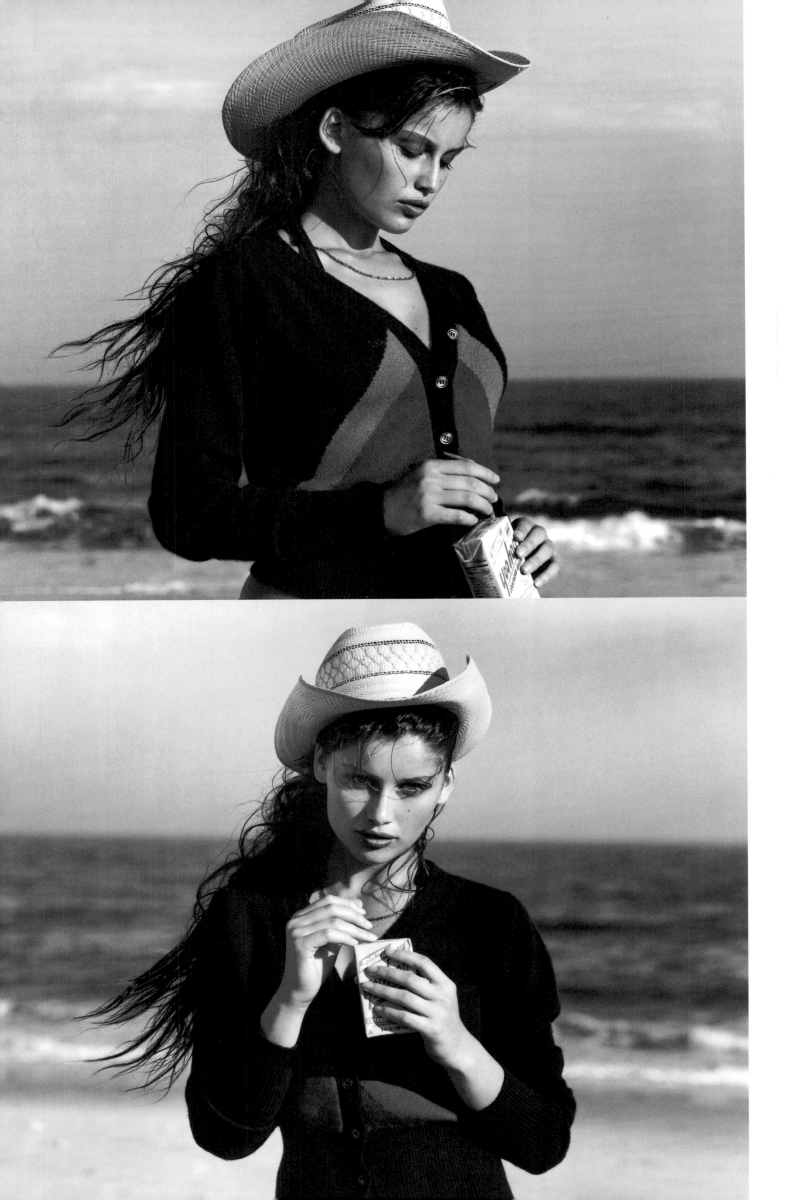

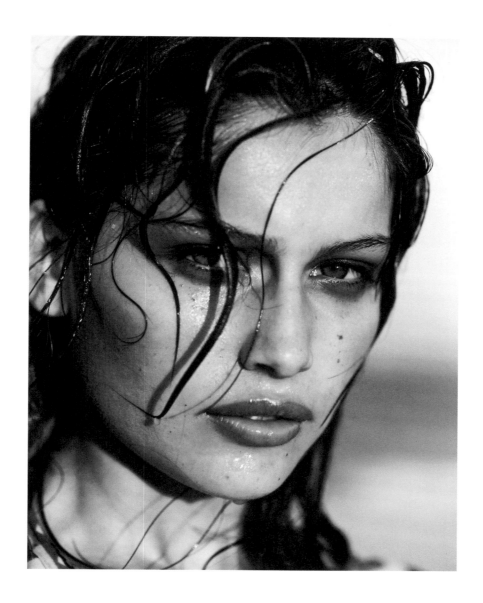

"I love food: hamburgers, pizza, gnocchi, mashed potatoes, and especially chocolate. I enjoy eating for the sake of eating. Sometimes I feel sad for the models who don't want to eat. When you love food, you love life. When you love life, you love to love."

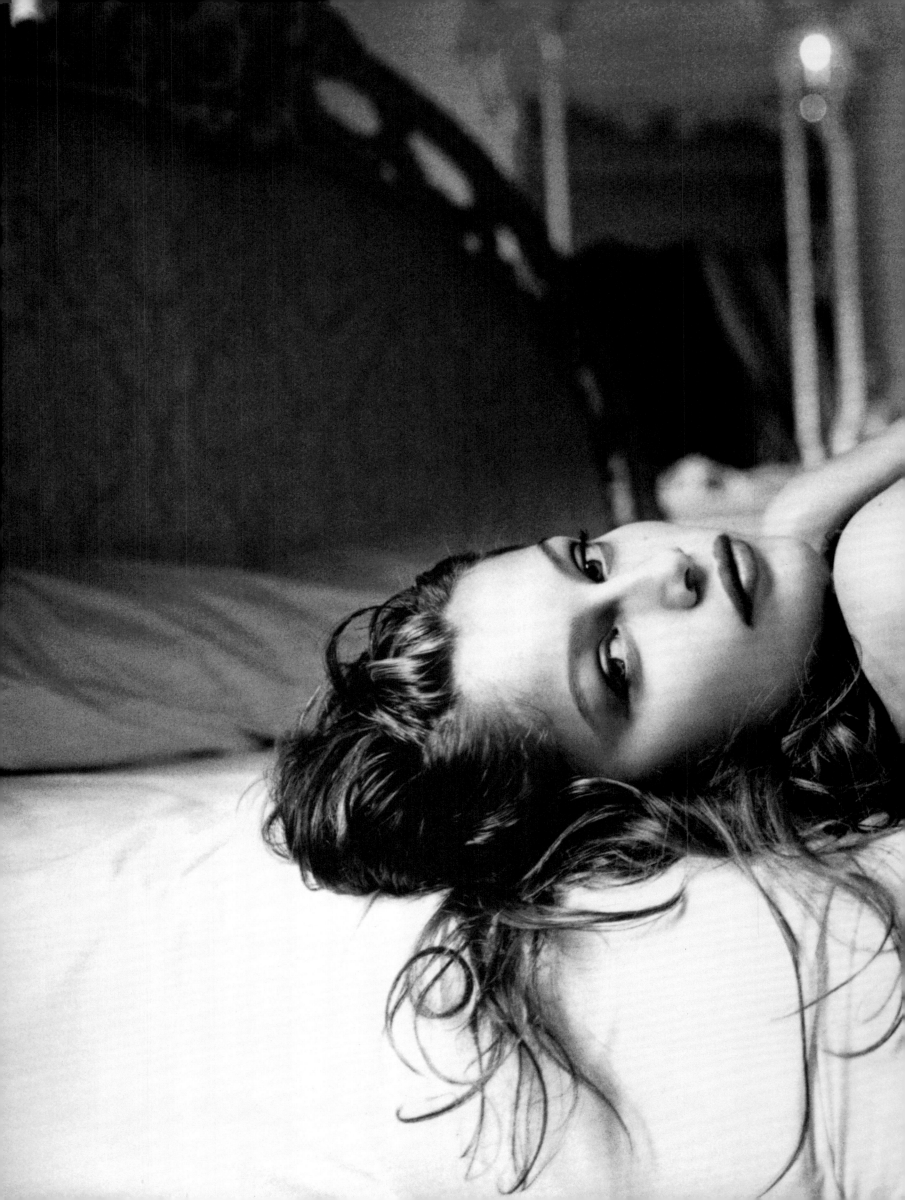

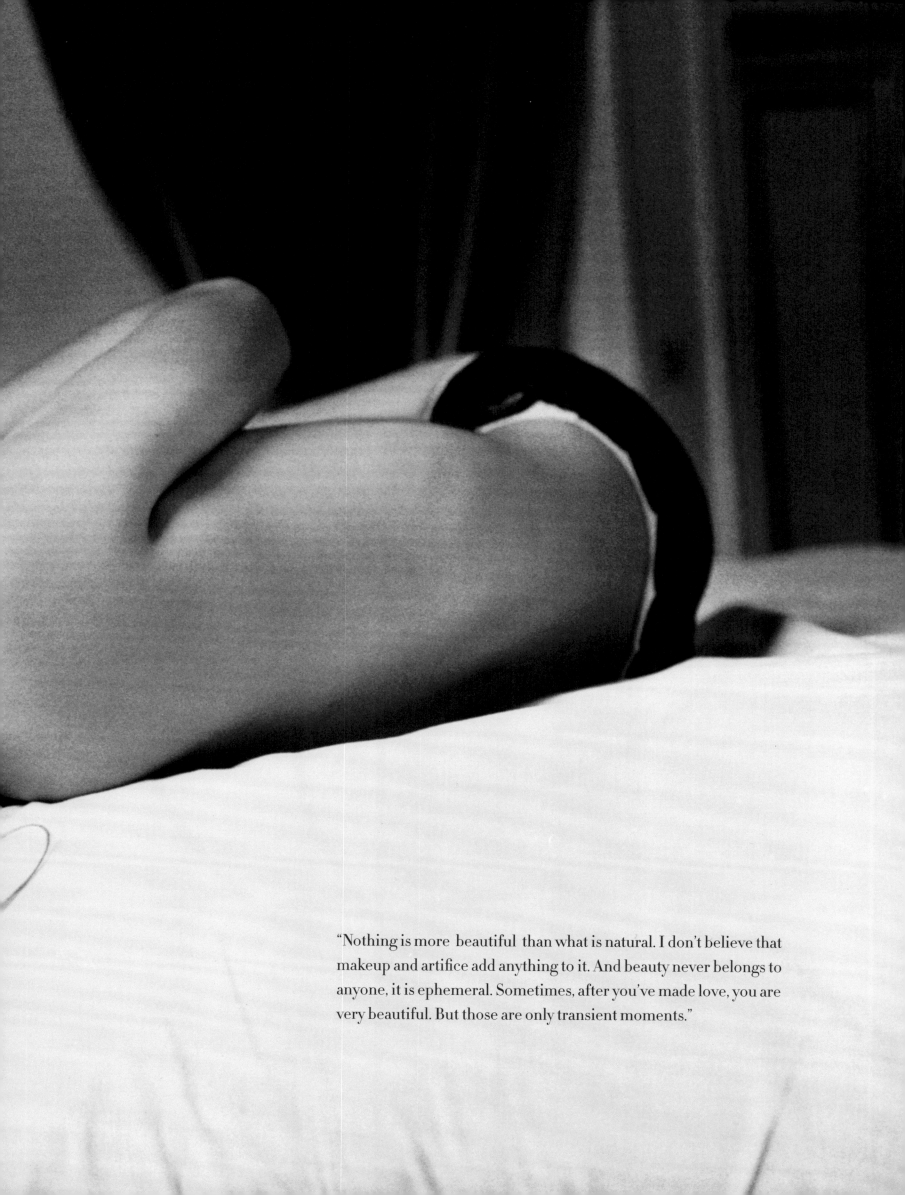

"Nothing is more beautiful than what is natural. I don't believe that makeup and artifice add anything to it. And beauty never belongs to anyone, it is ephemeral. Sometimes, after you've made love, you are very beautiful. But those are only transient moments."

"Just 'be beautiful and shut up?' Not me!"

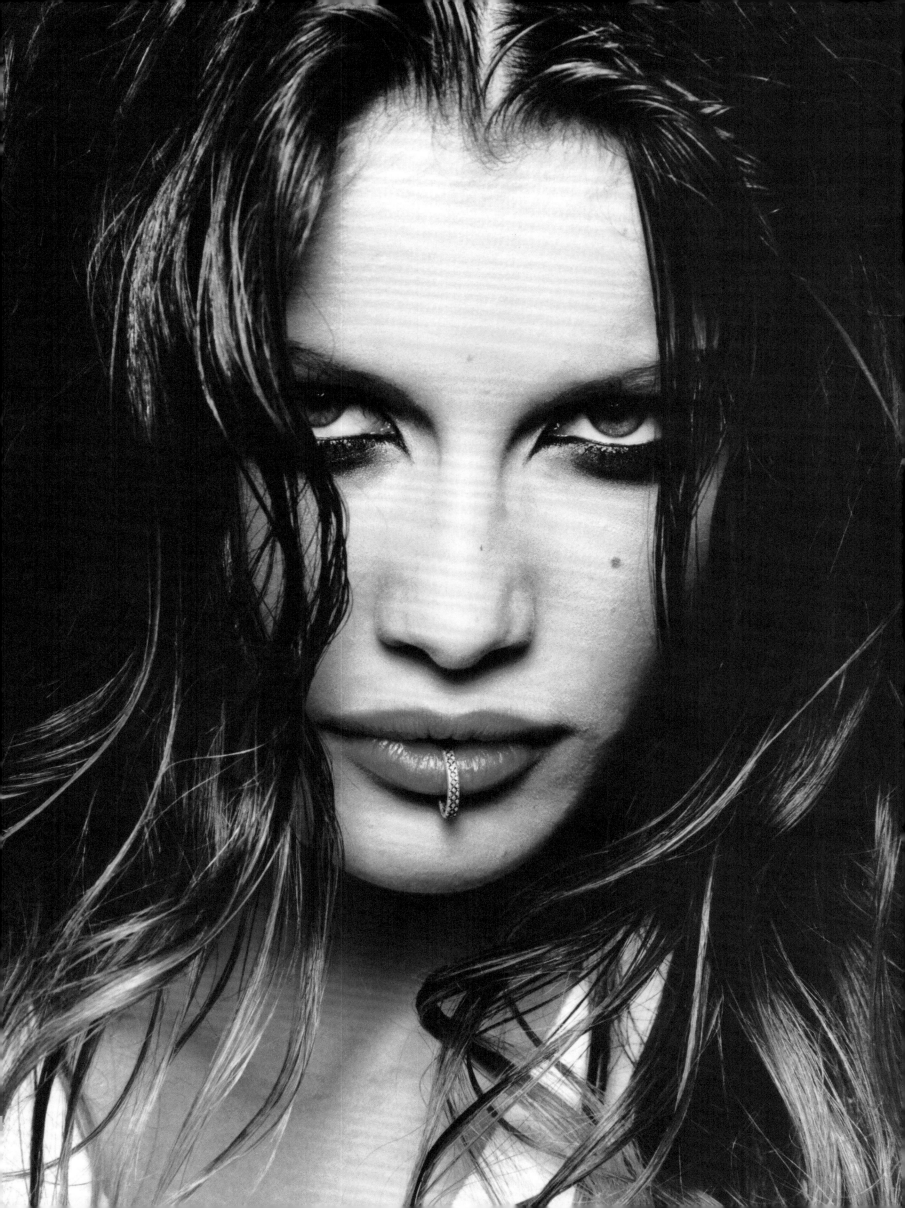

Water

"Water makes me feel at peace. In Corsica, I spend most of my time on the beaches or in the rivers. That's one reason I love it there so much. The water is so clean and fresh – you can drink it straight out of the rivers! This island is my secret garden."

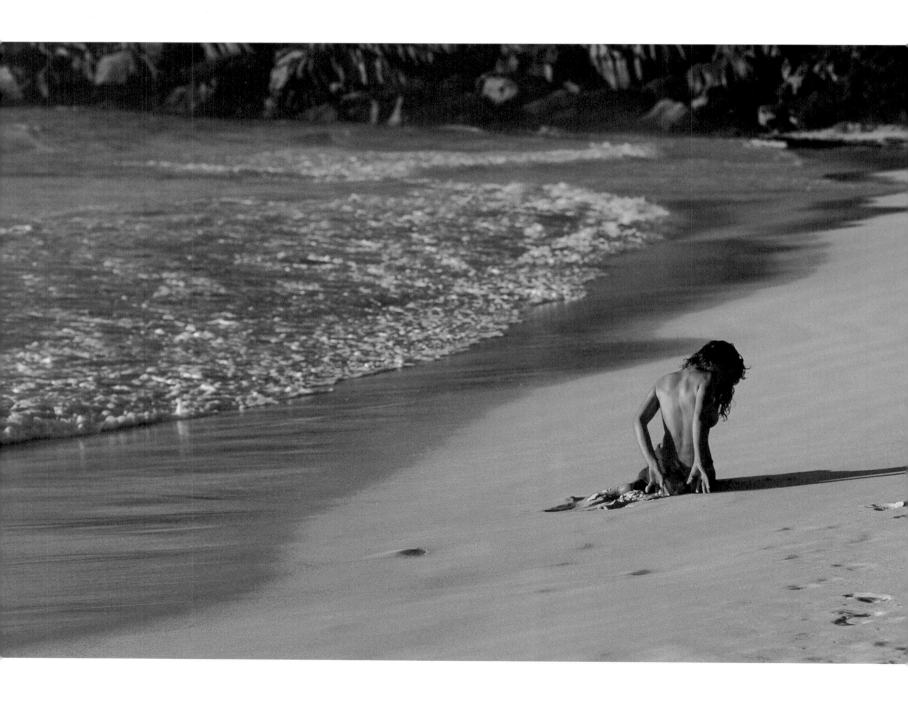

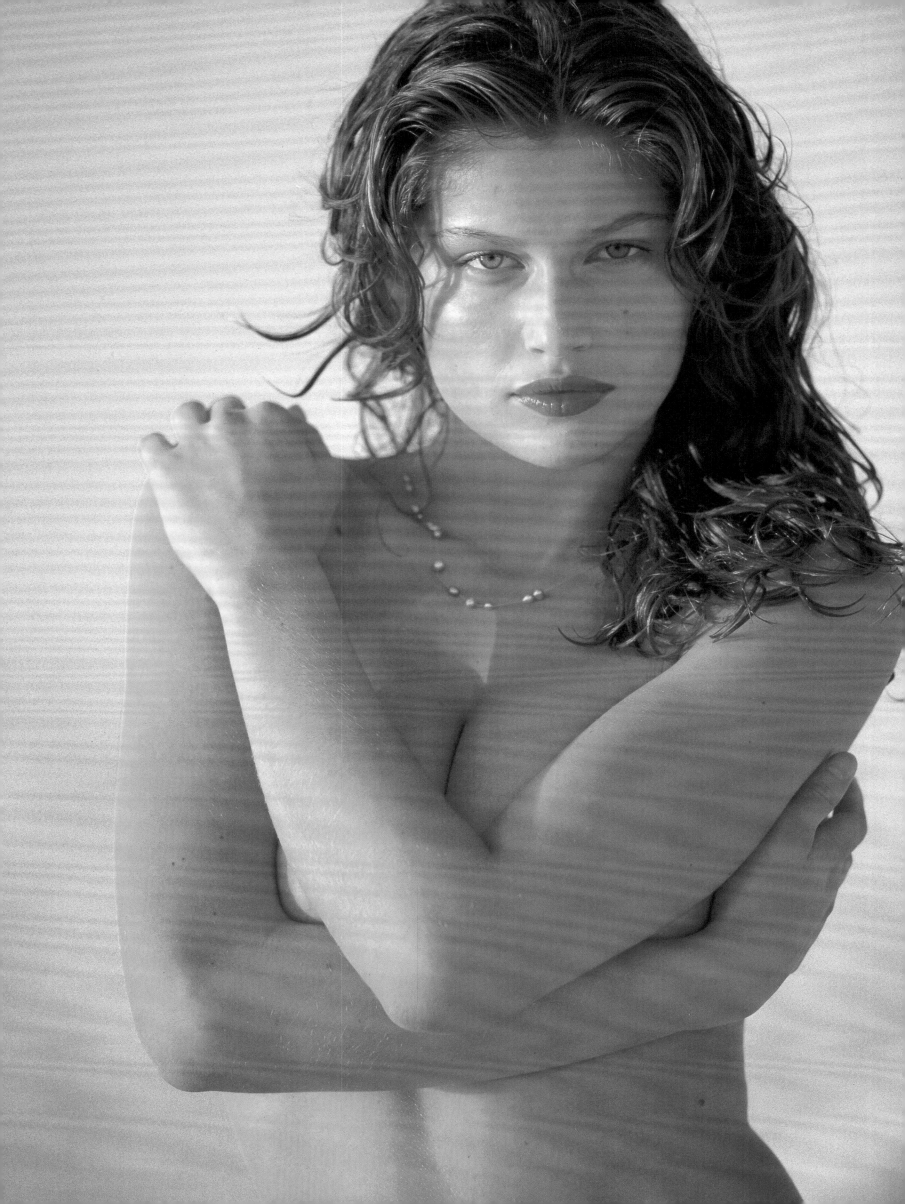

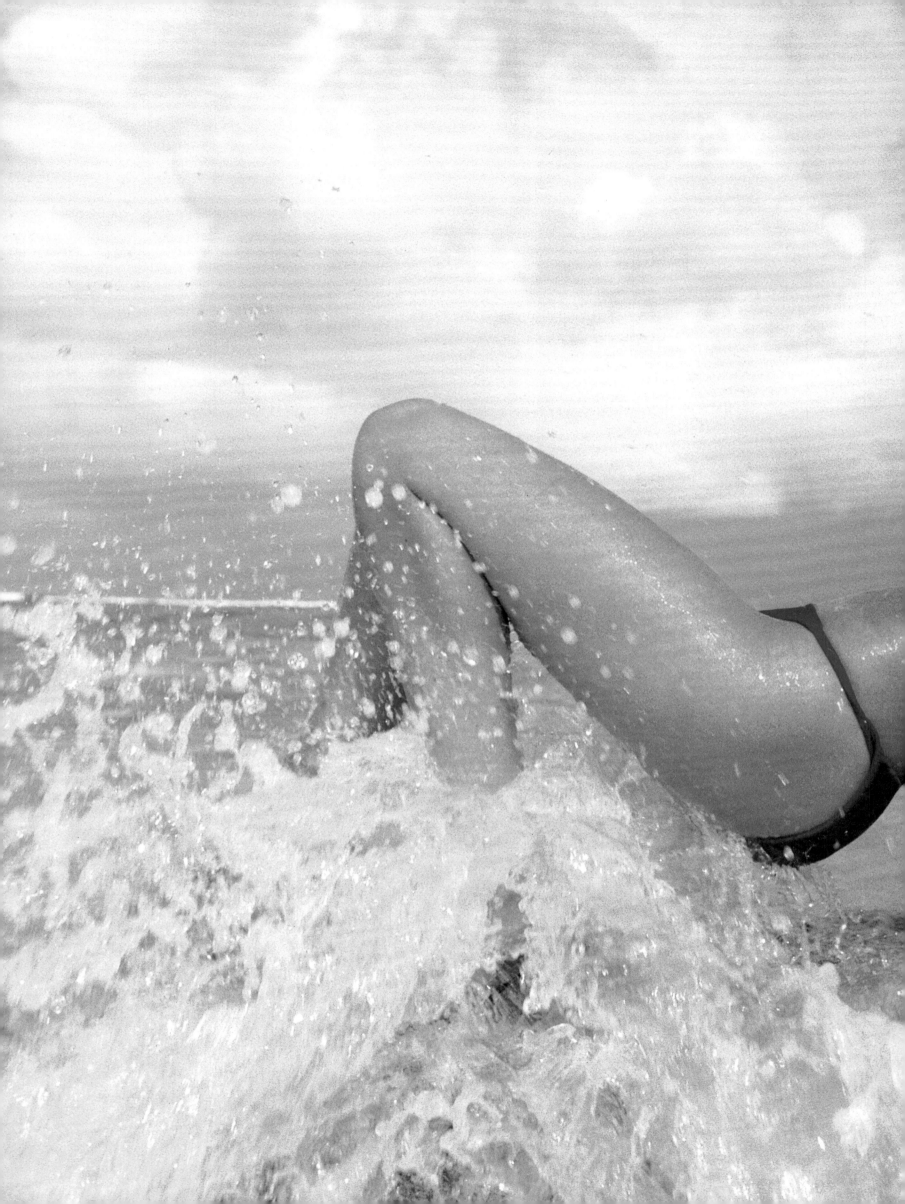

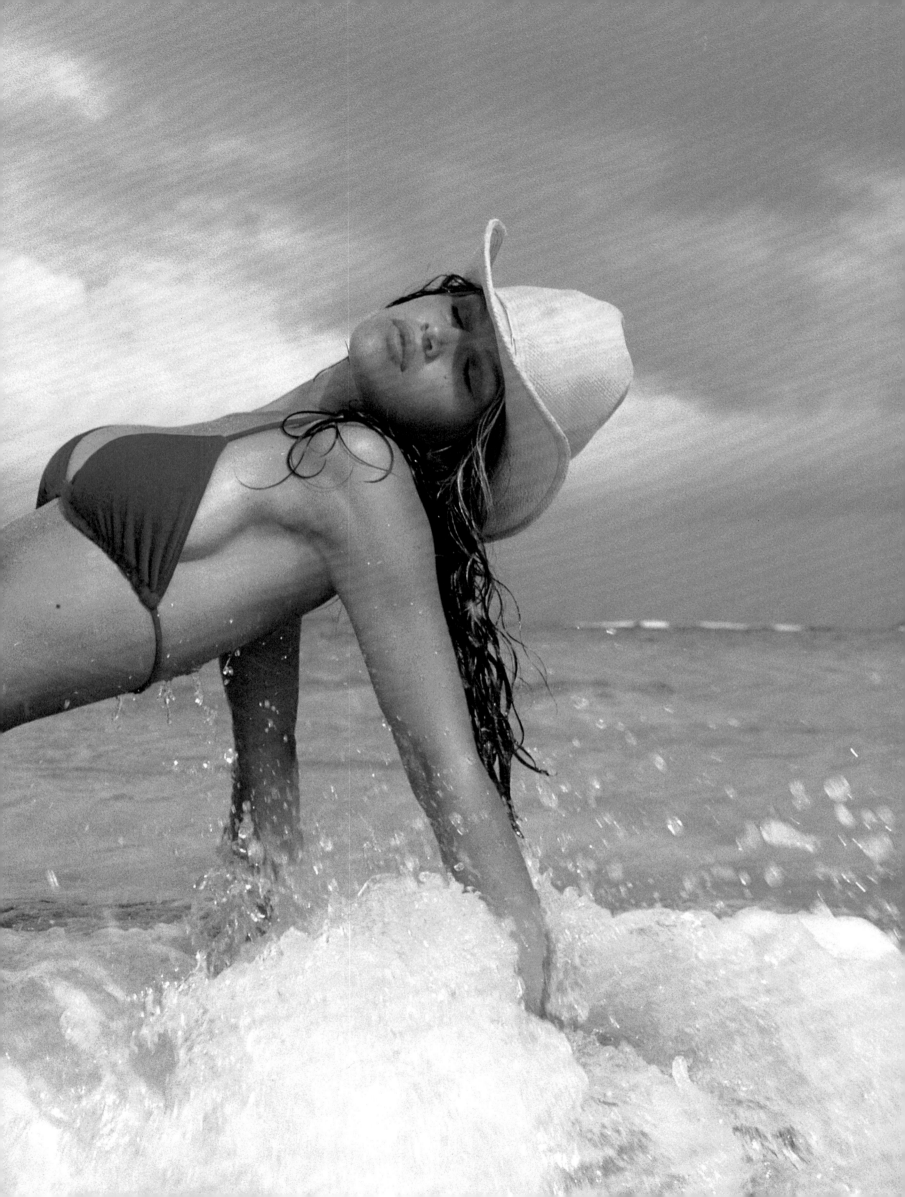

femininity

I was a tomboy when I was little. It was only when I started modeling that I became more reserved in my behavior, and more feminine. That was when I really started to appreciate beautiful things."

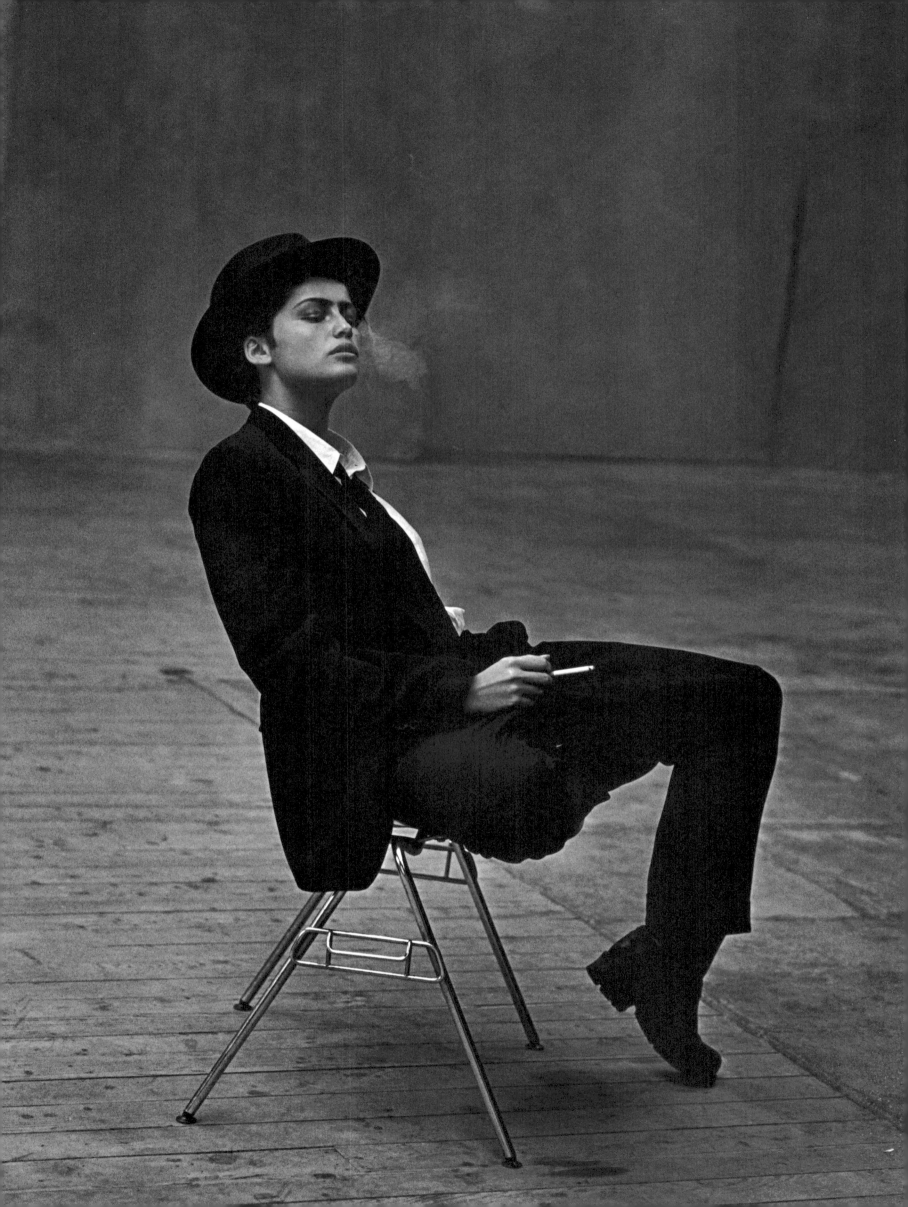

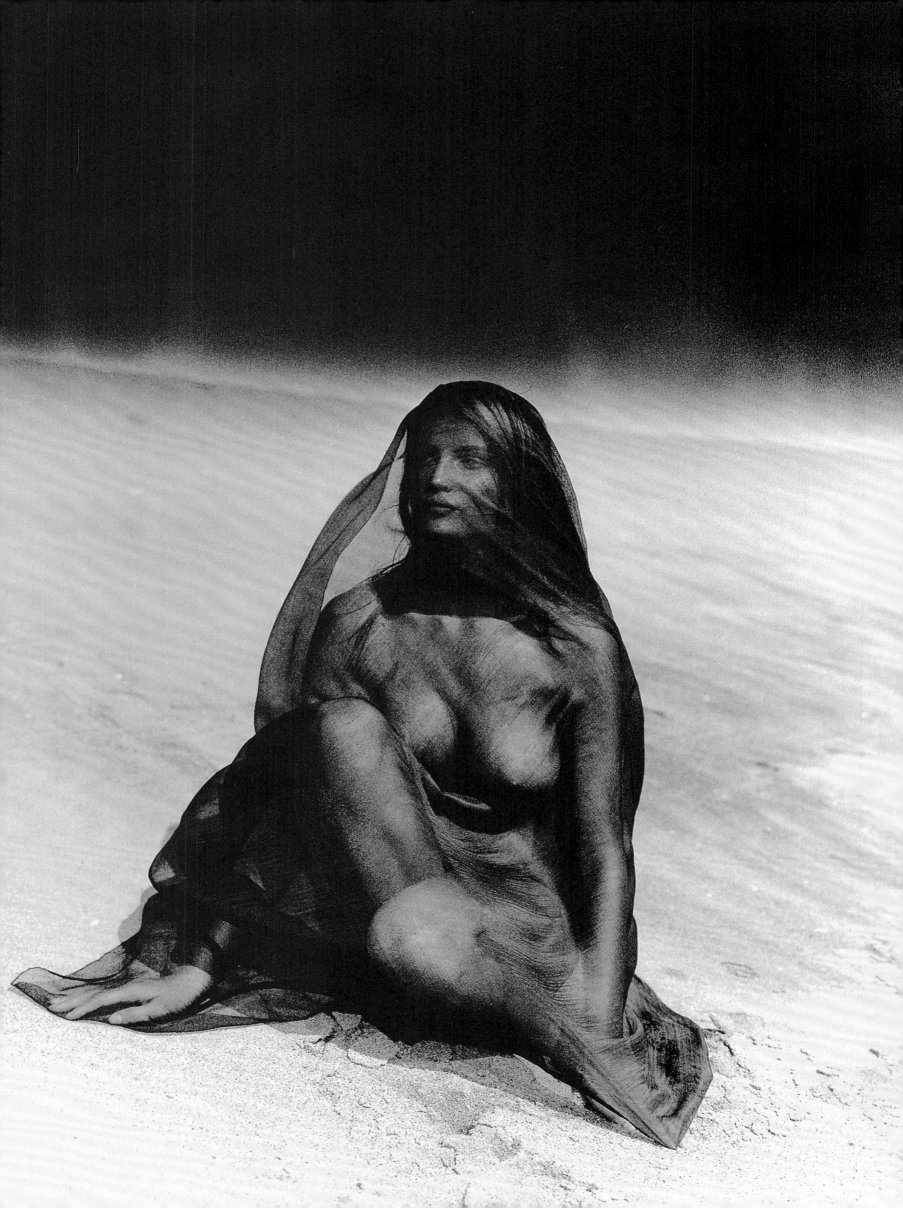

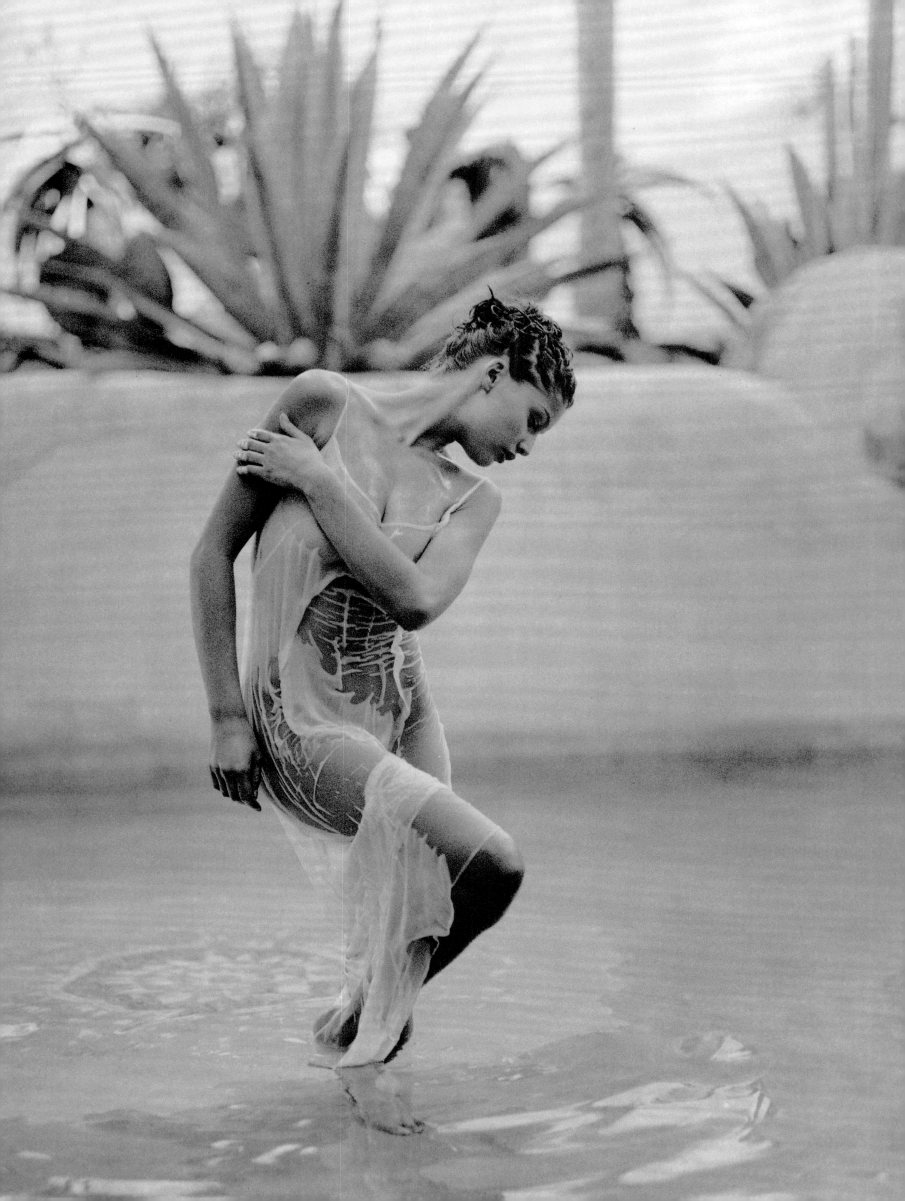

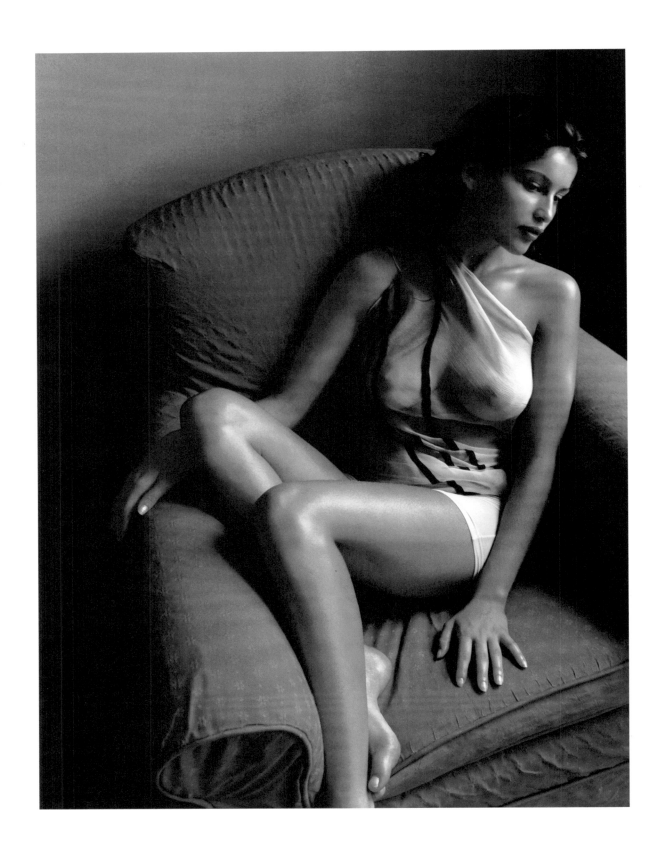

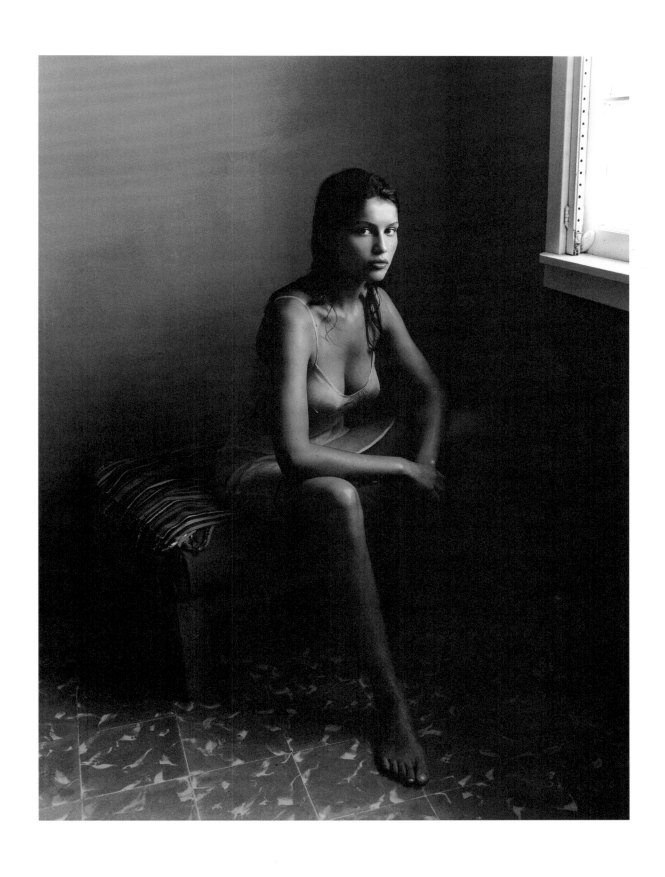

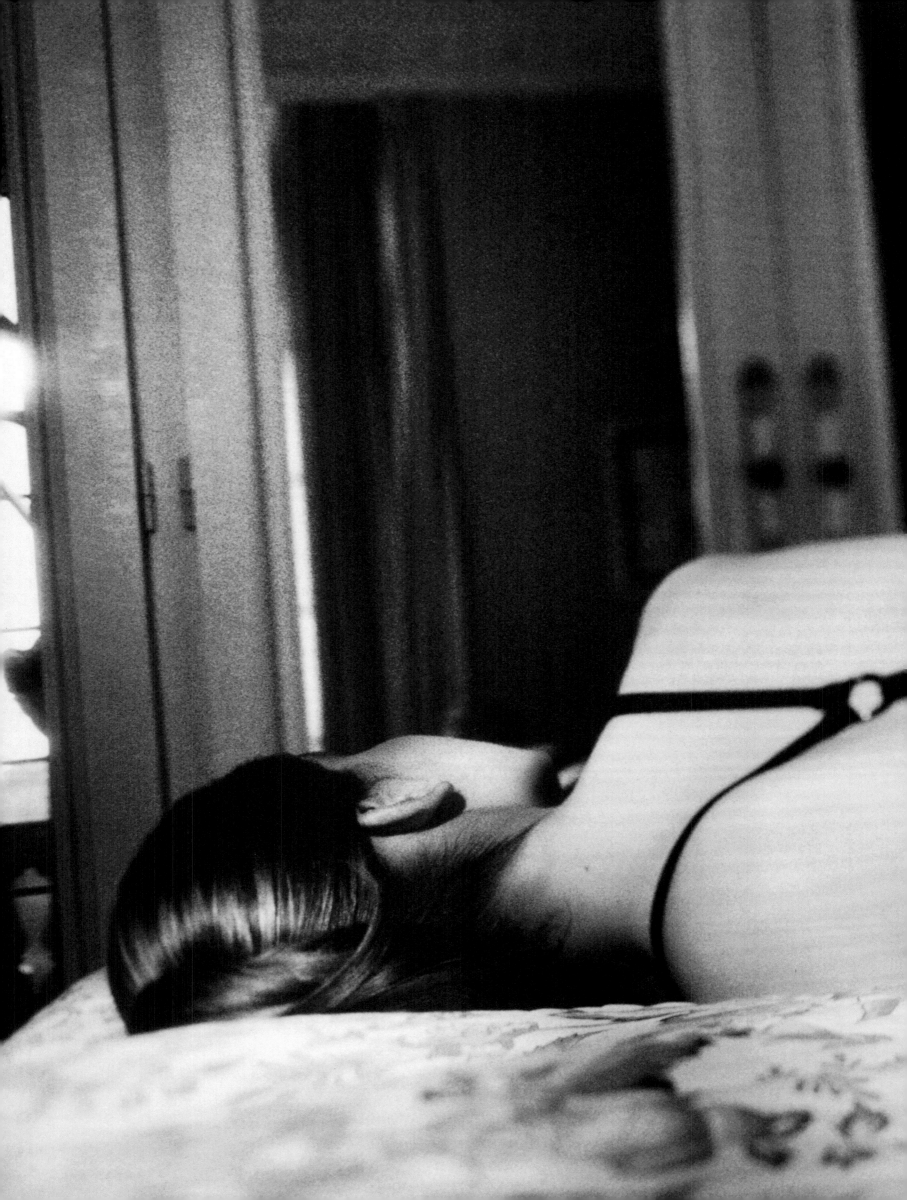

n u d i t y

"It's a natural state. I've seen more vulgarity in people wearing clothes."

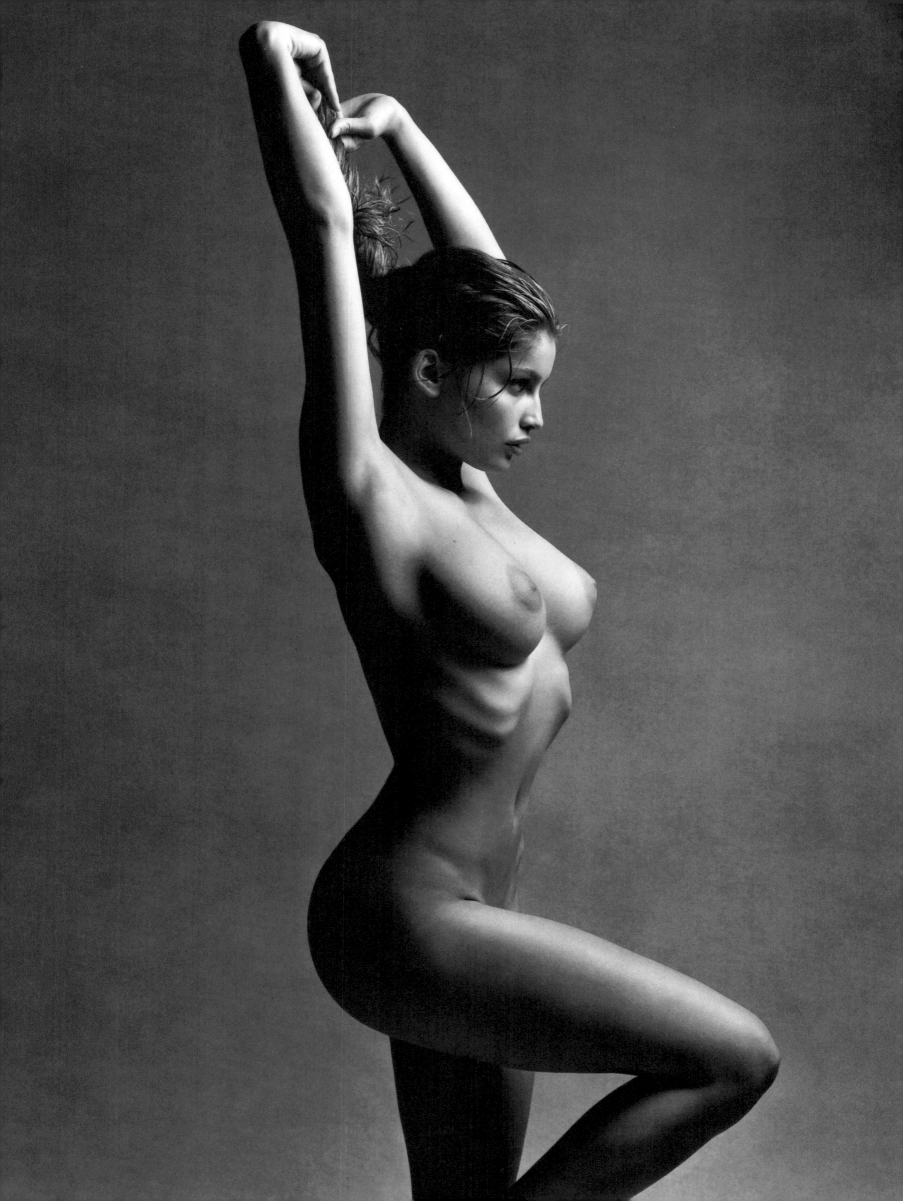

"Once, at work, an imbecile said to me, 'Ah, your name is Casta [which means "pure" in Latin], but you are anything but pure. Just look at your photos.' That hurt a lot and made me angry. 'My thoughts have always been pure,' I answered him. I don't want to hide my body, but at the same time I would never show it all!"

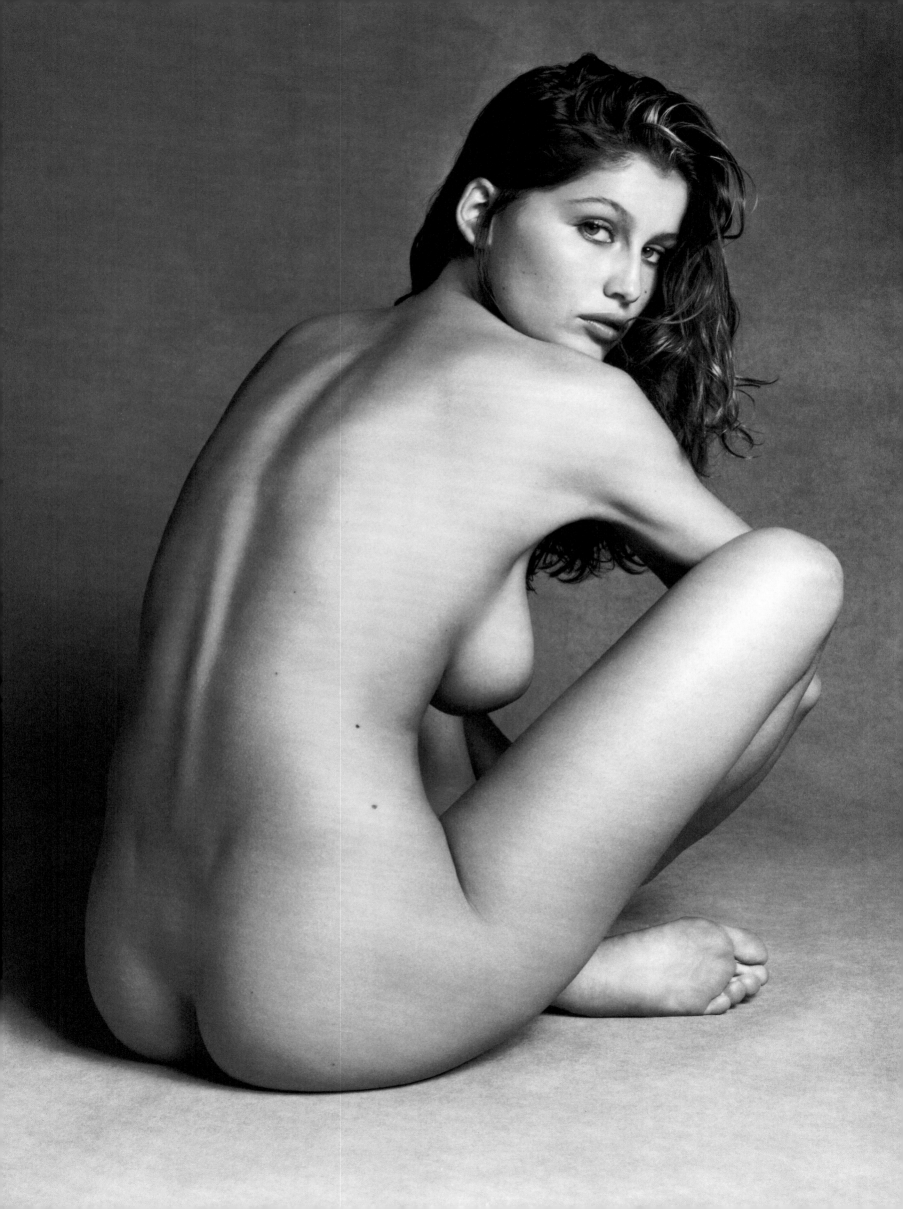

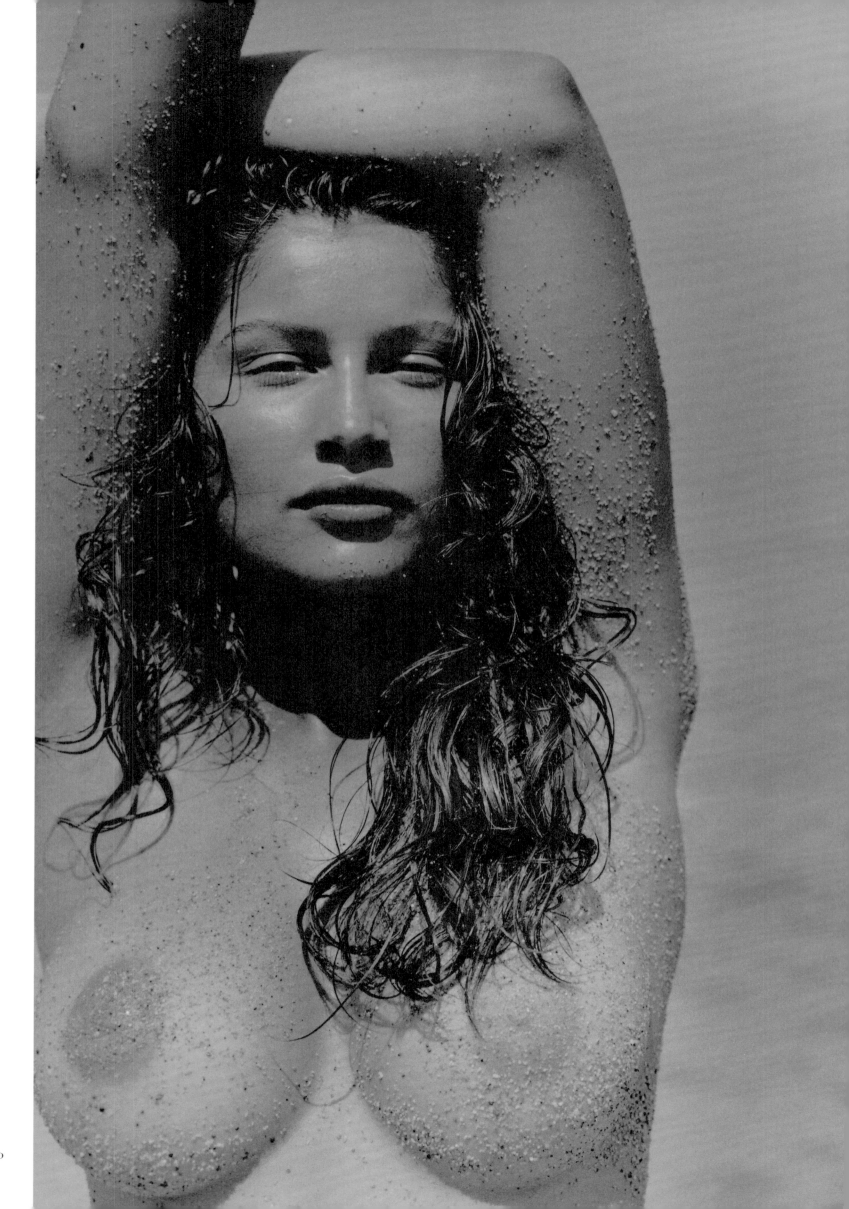

"I have never regretted posing nude. At the same time, I don't like the chaos that is triggered by it, and therefore I don't intend to pose anymore without clothes."

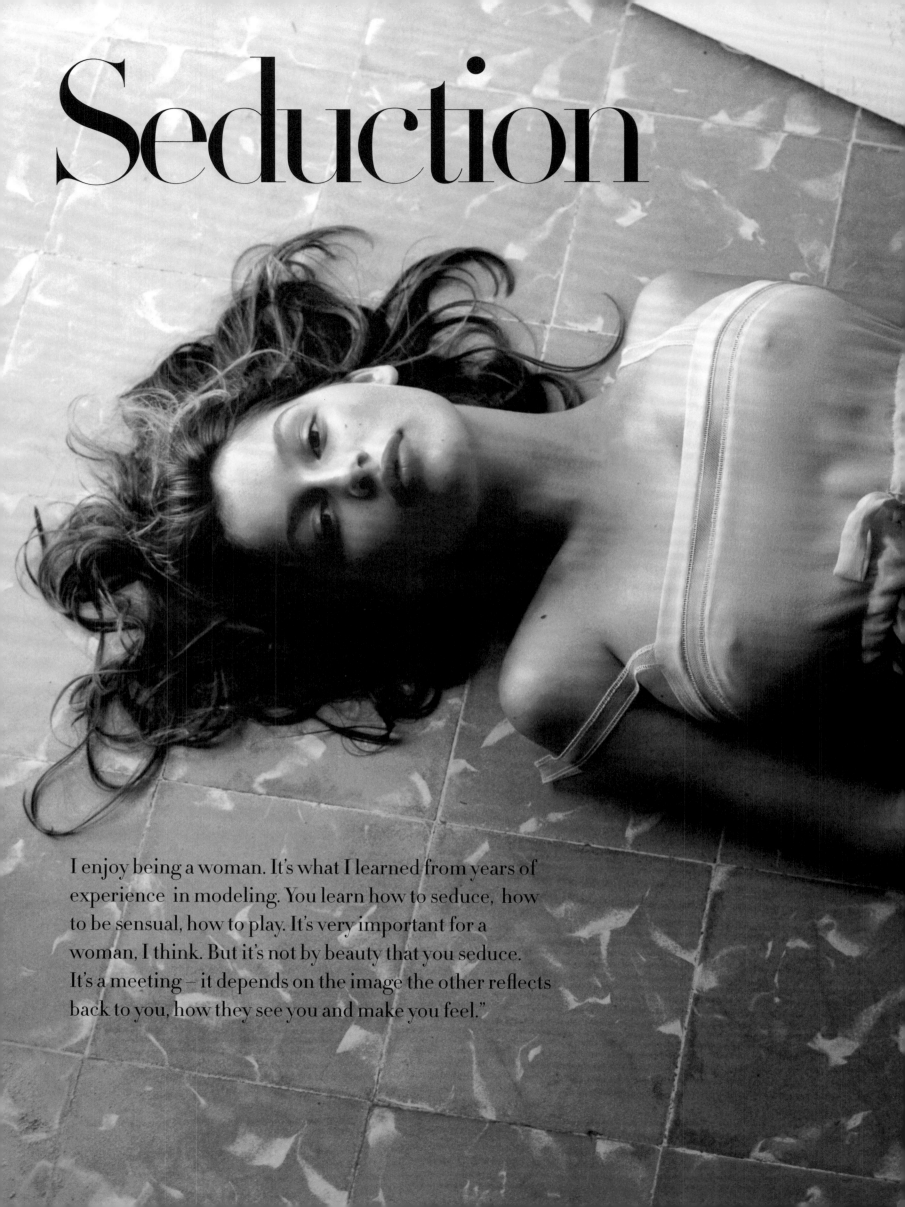

Seduction

I enjoy being a woman. It's what I learned from years of experience in modeling. You learn how to seduce, how to be sensual, how to play. It's very important for a woman, I think. But it's not by beauty that you seduce. It's a meeting – it depends on the image the other reflects back to you, how they see you and make you feel."

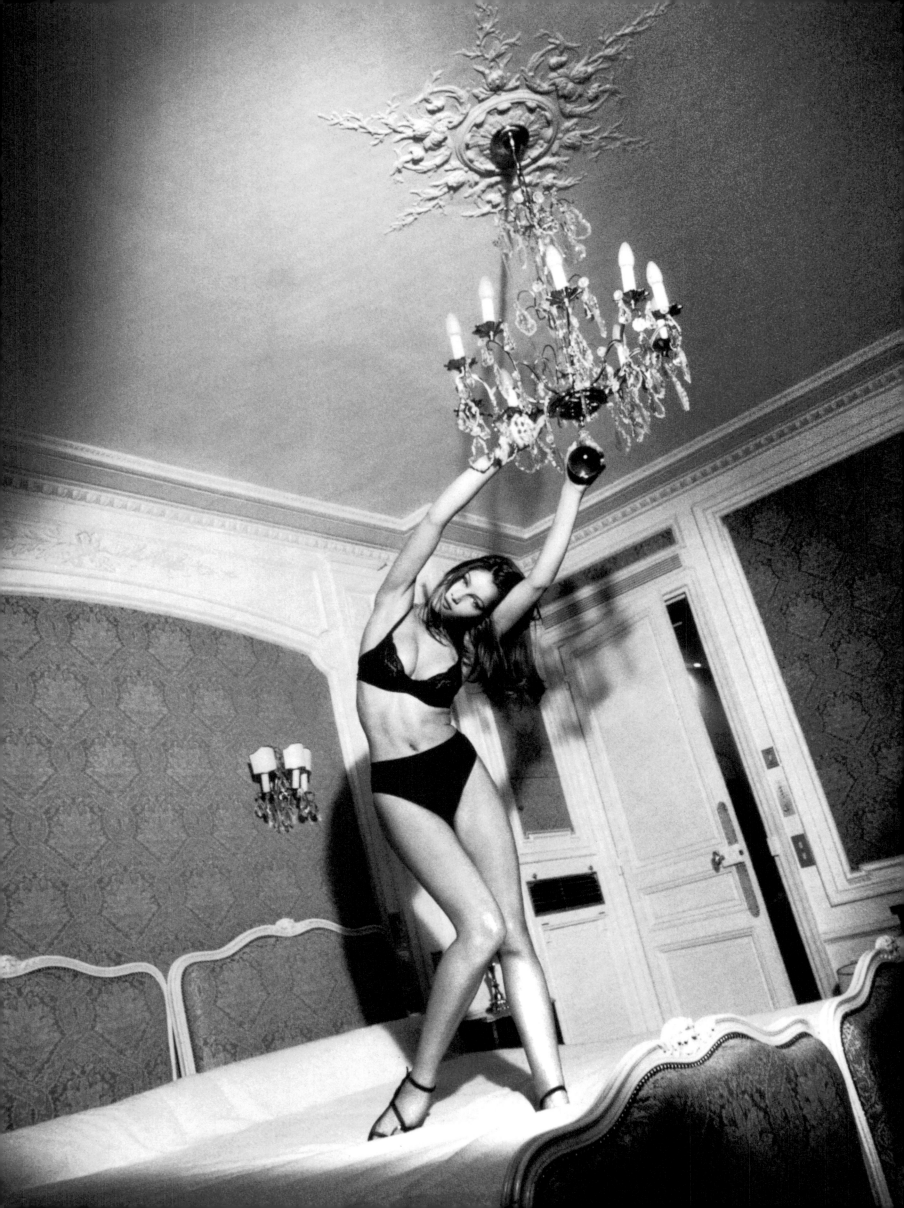

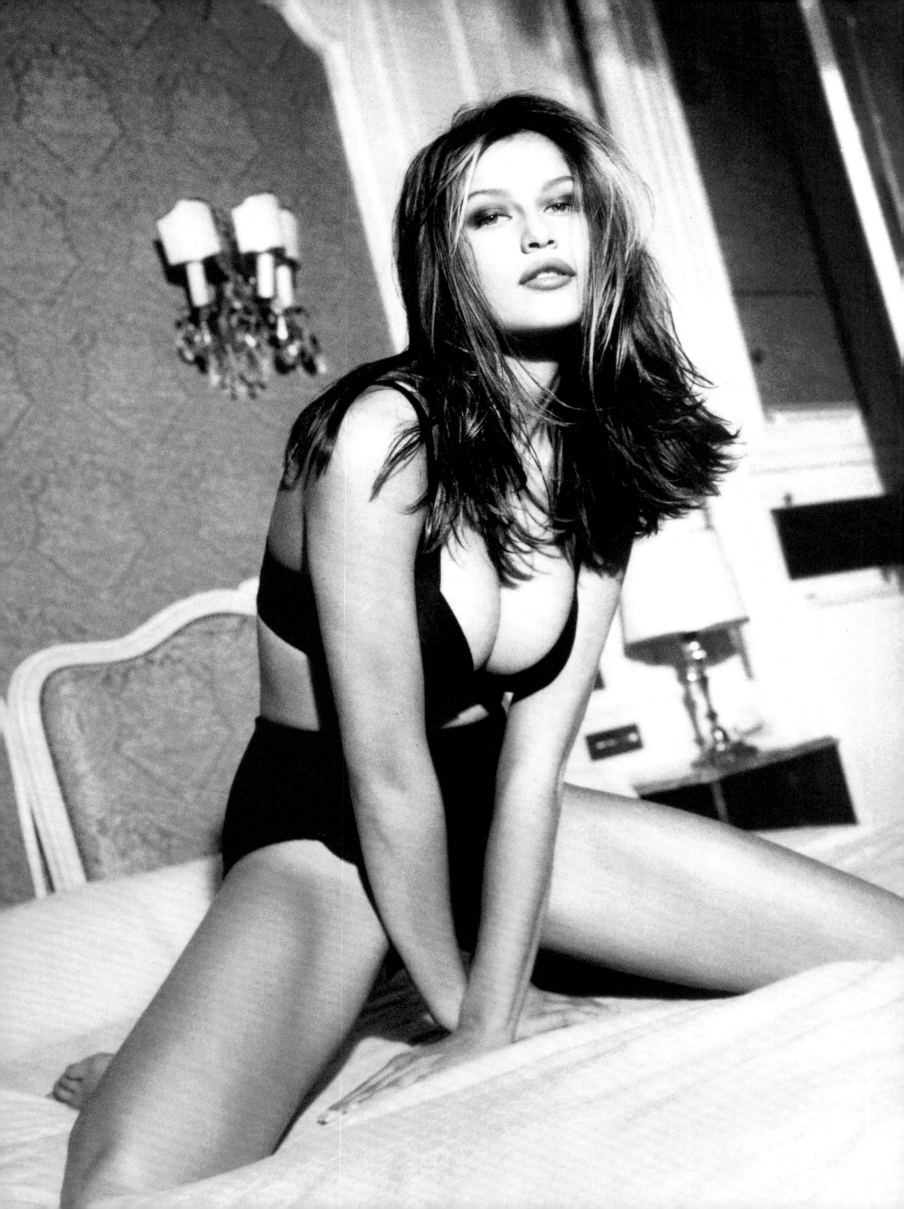

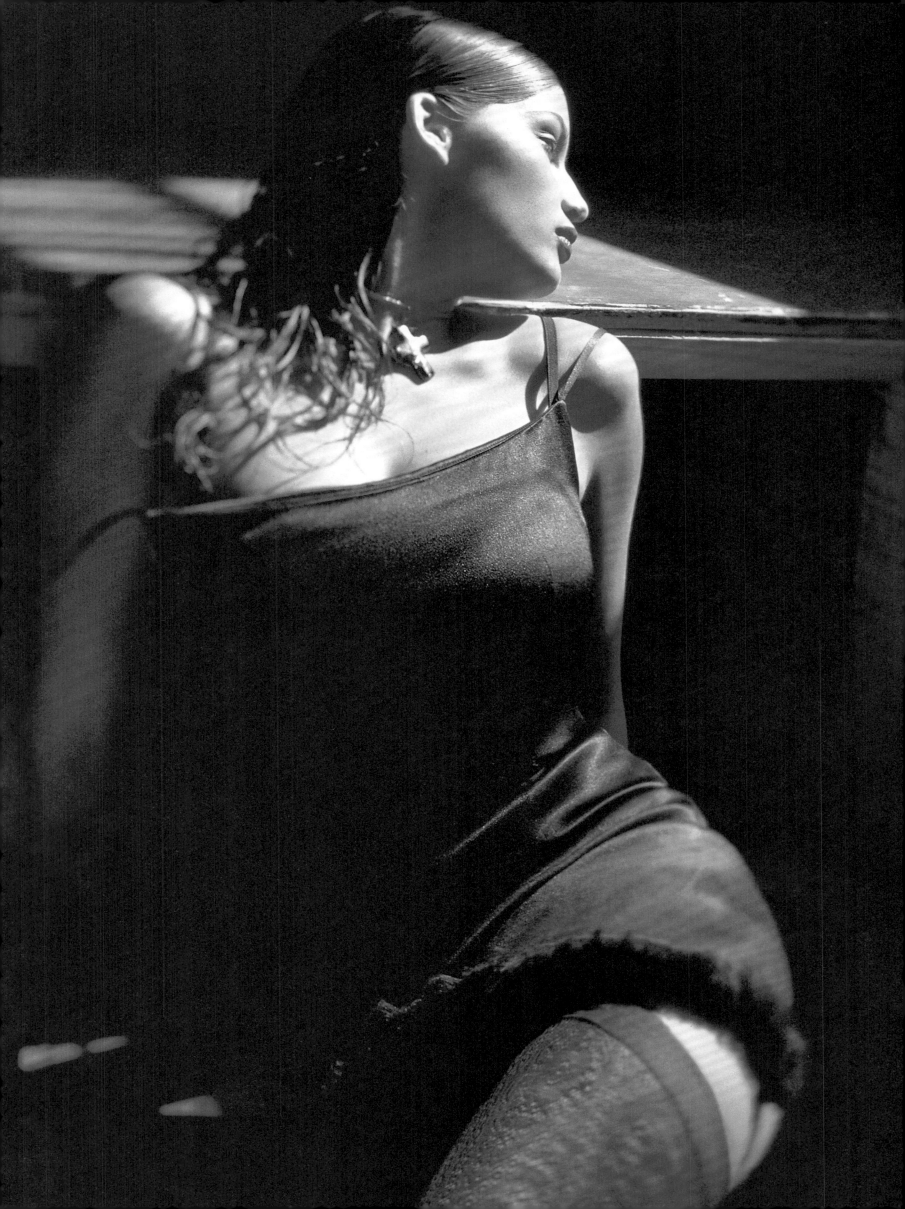

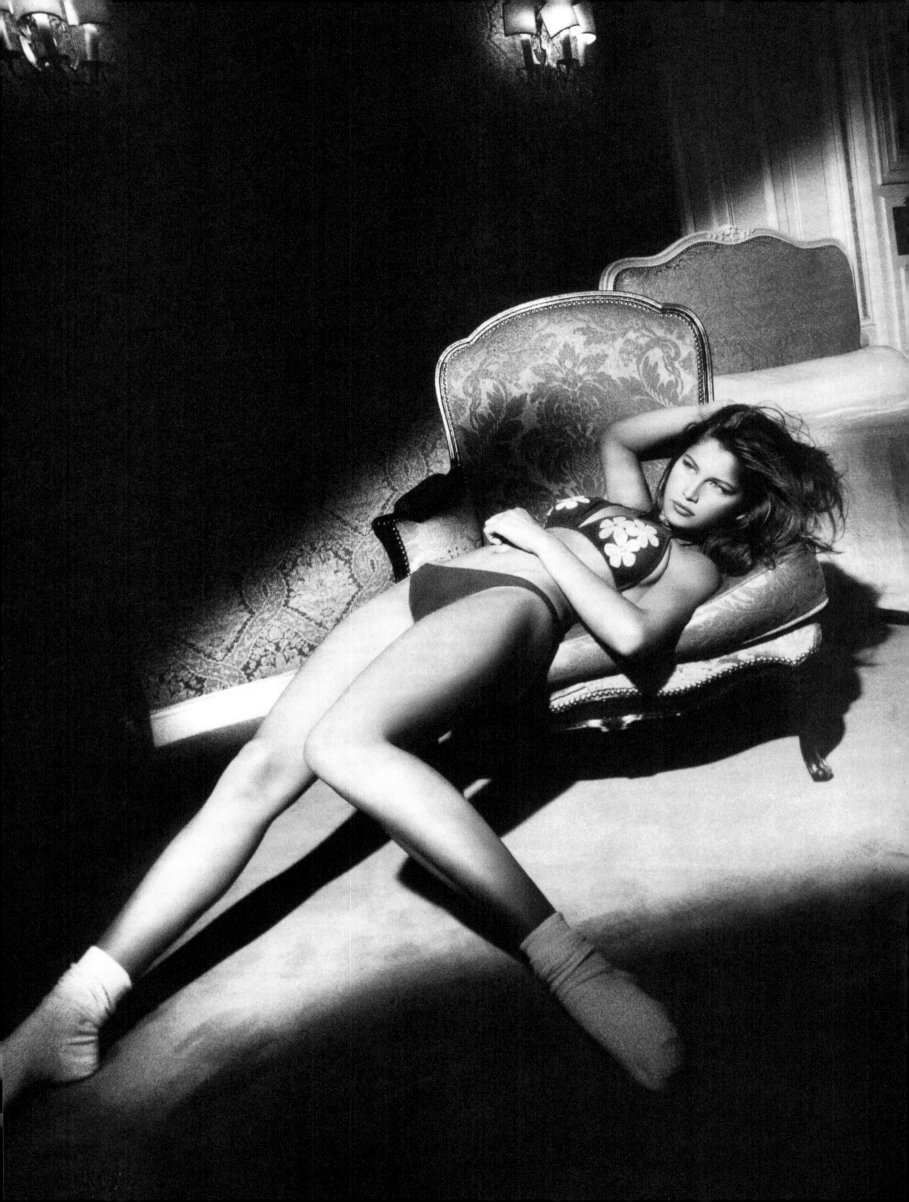

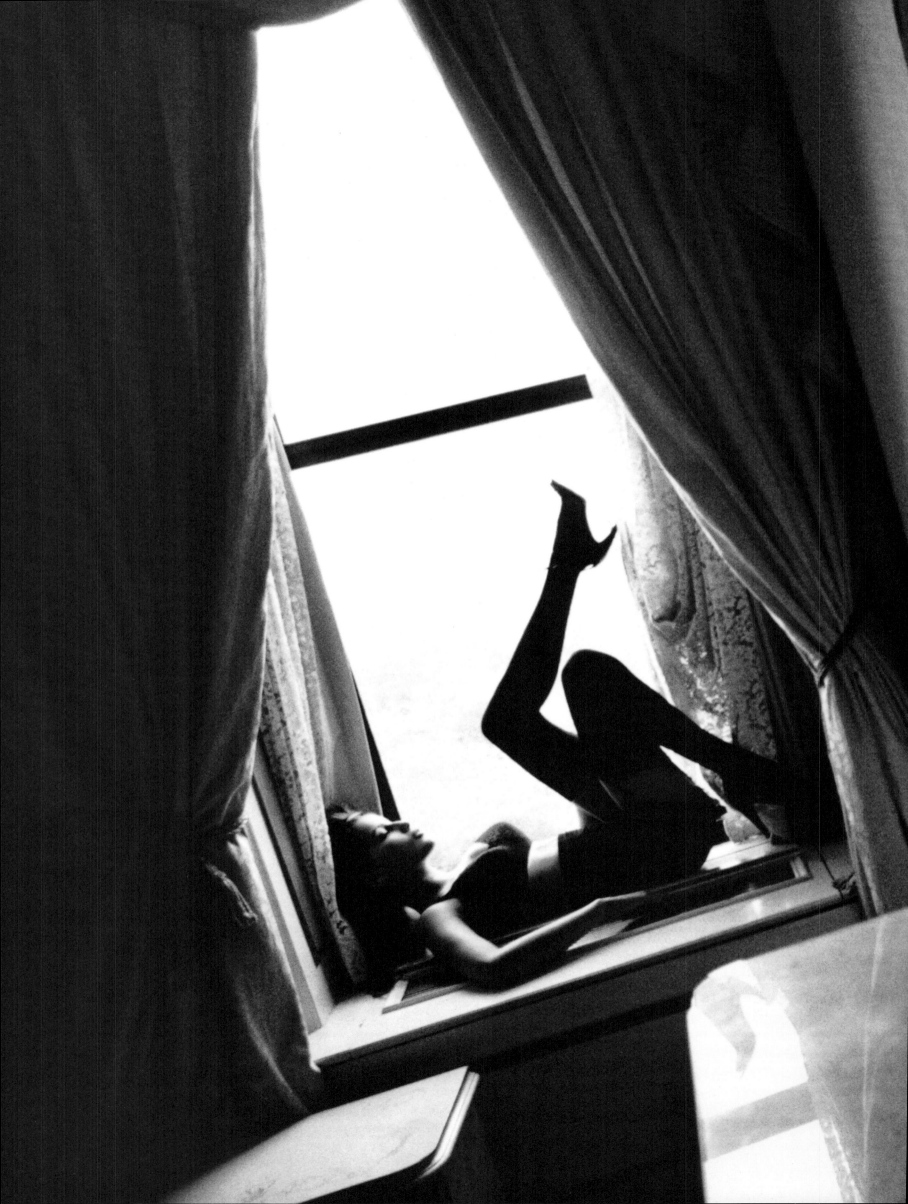

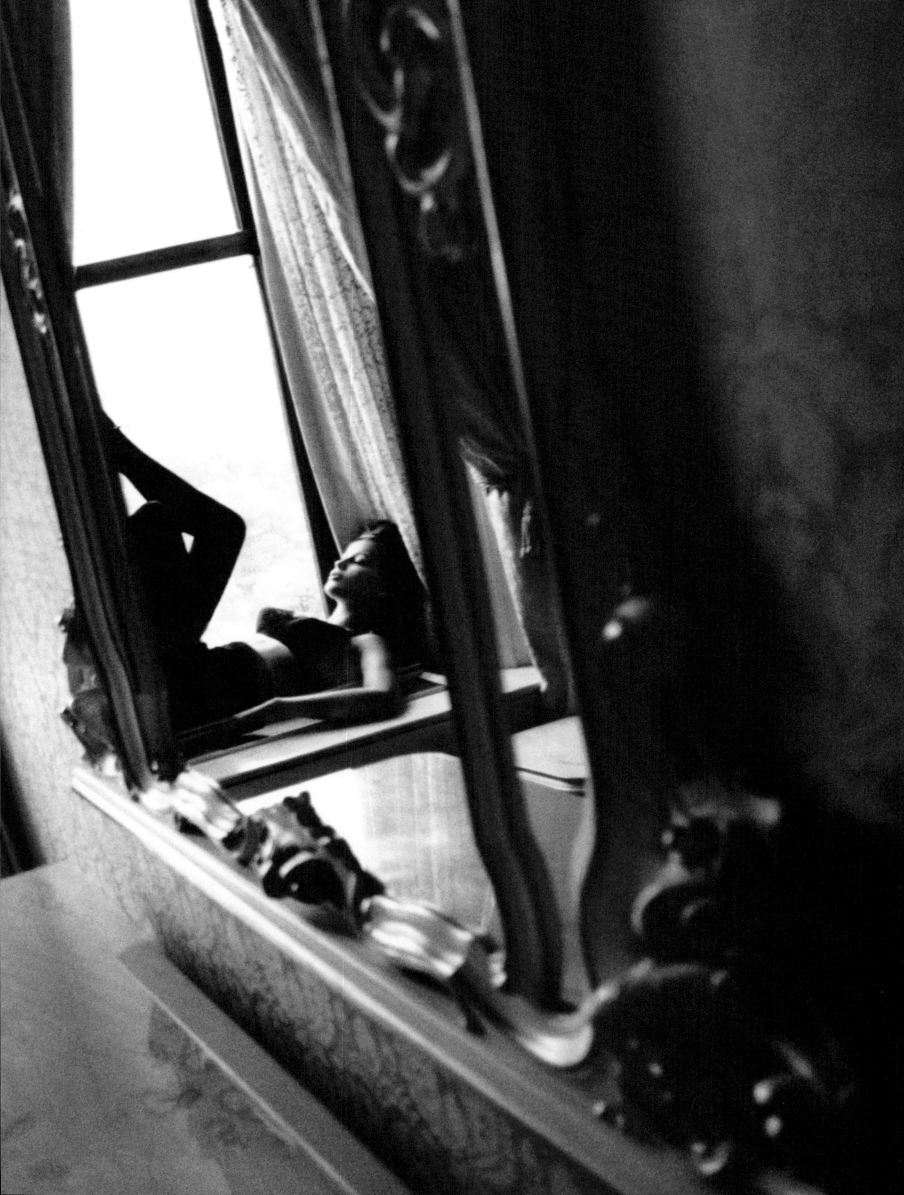

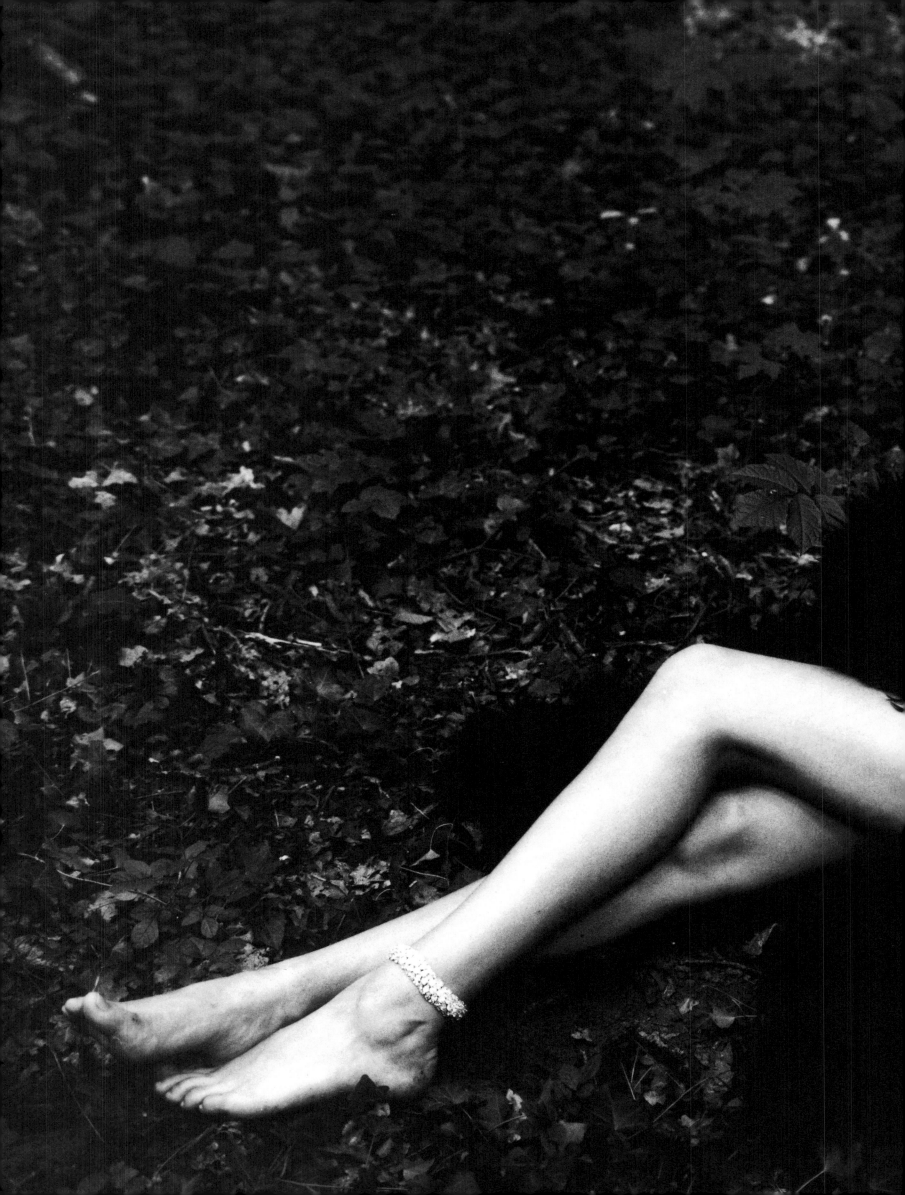

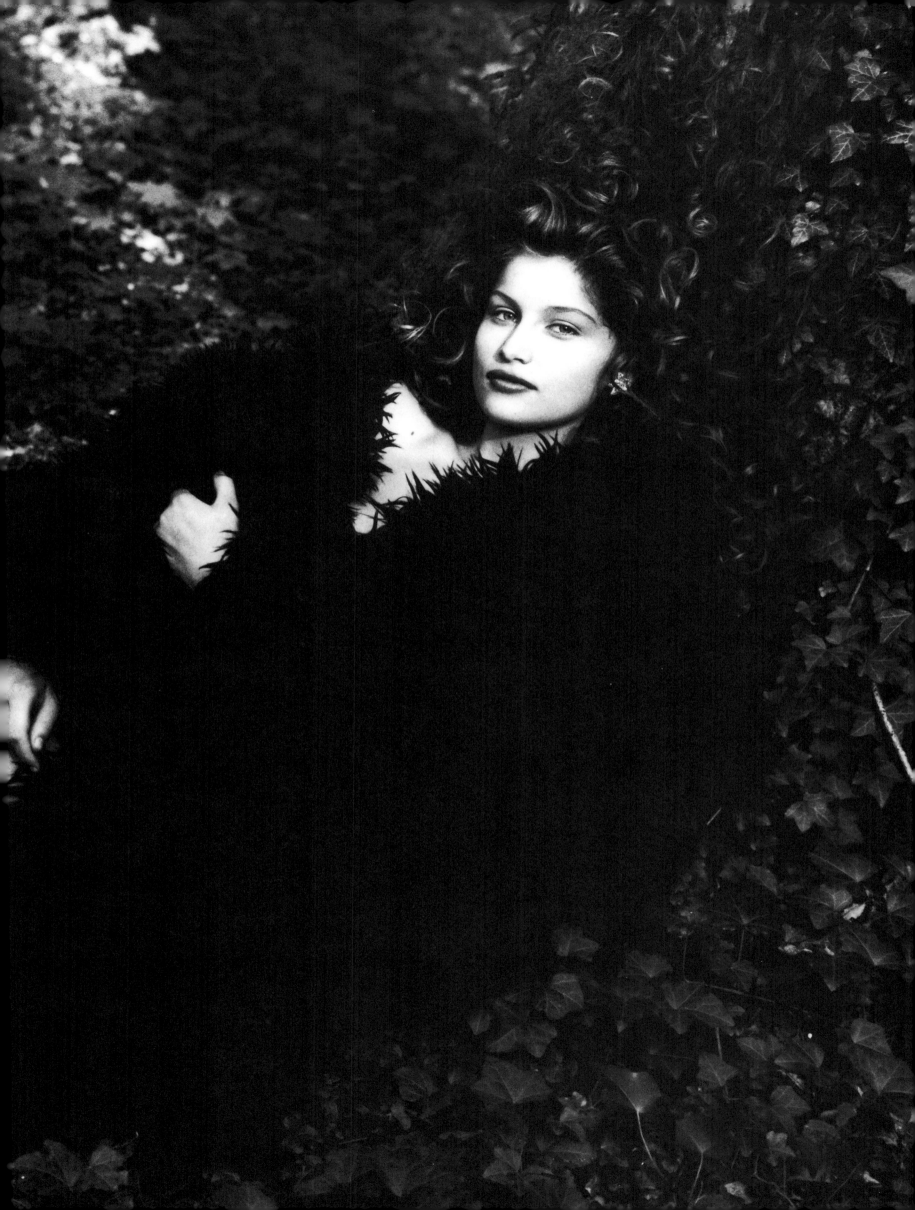

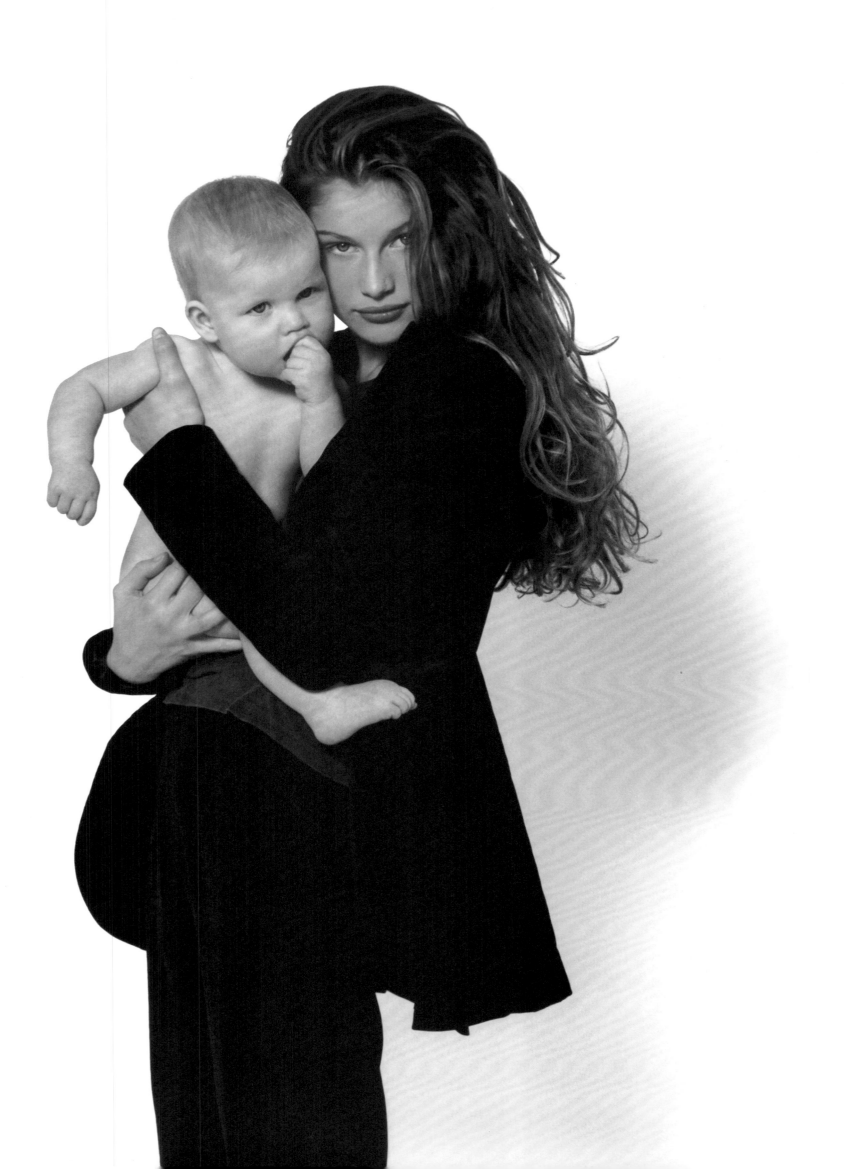

Family

"My family is the most important thing in my life. I would love passionately to have my own children. To have a baby inside of me – it's one of my dreams in life. I would love to hold my children, to run to them, to give them the same happiness my family gives me."

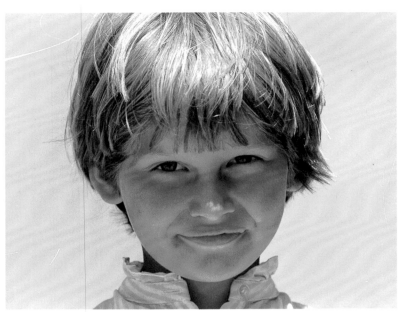

My Island Home

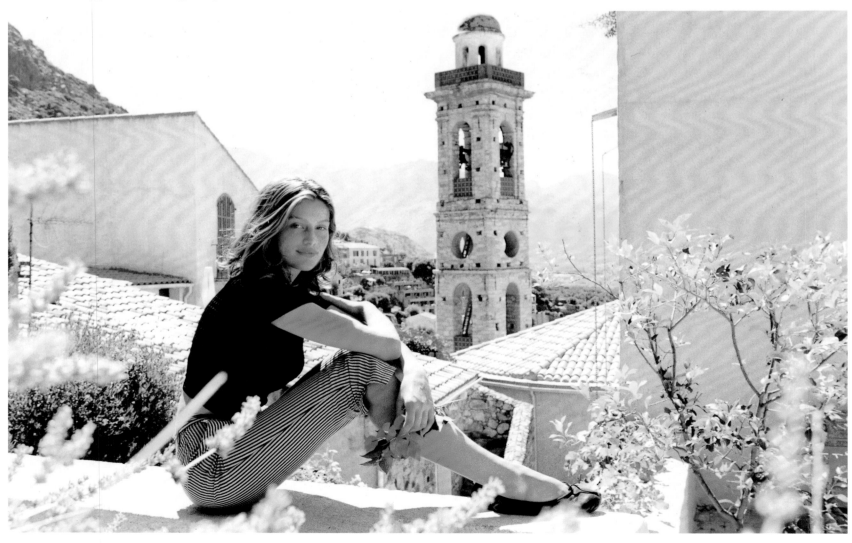

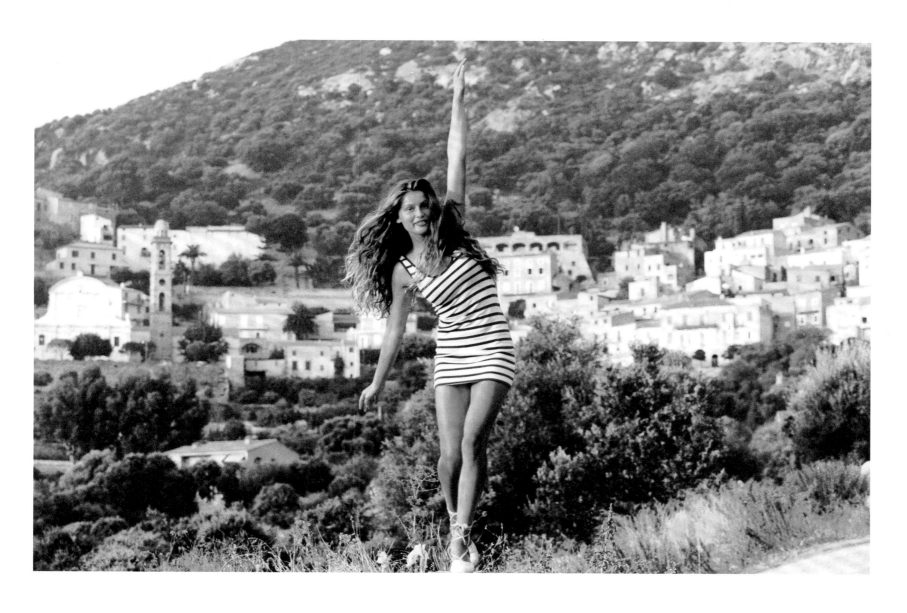

To Lumio, the Corsican village where it all began.
I will always keep you in my heart as a refuge.

To my parents and to all my family, for whom the greatest treasure is their children.

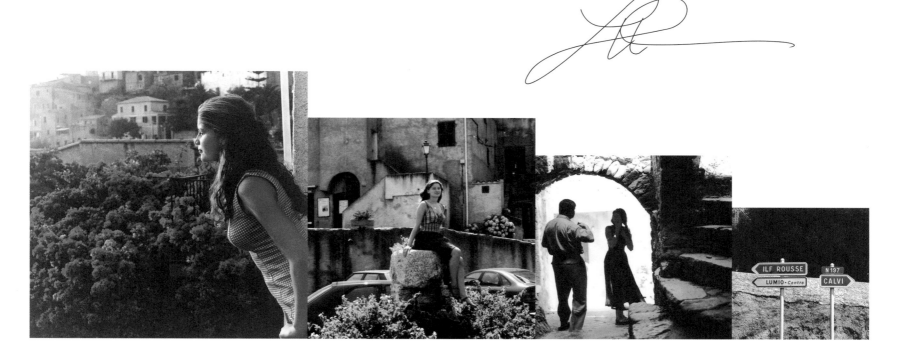

Photo Credits

Front and back cover by Phillip Dixon

2-3 Dominique Issermann for *Sports Illustrated*, 1999

4-5 Dominique Issermann for *Details*, 1999

6-7 Art director: Paul Marciano, photographer: Dah Len, GUESS? © 1997

8 Dominique Issermann for French *Elle*, 1998

10-11 Lothar Schmid, 1997

13 Top Row, left to right: In foreground, Laetitia's paternal great-grandfather, Sirius Giovannetti, Corsica, c.1950; at far right, Laetitia's maternal great-grandparents, Hermenie & Emile Rombaut, Normandy, c. 1939; paternal great-grandmother, Antoinette Casta, Corsica; paternal great-grandfather, Dominique Casta, Corsica; 2nd Row: paternal grandparents, Jean & Laure Casta, Corsica; maternal great-grandparents, Maurice & Adolphine Blin and children, Normandy, c.1924; mother Line Blin at four years of age, Normandy, c. 1956; paternal great-grandmother Zelinda Giovannetti, Corsica; parents' wedding, from left: paternal grandparents Jean & Laure Casta with Antoine (Dominique's brother), father Dominique, mother Line, maternal grandparents Robert & Maria Blin, Normandy, 1974; 3rd Row: Laetitia, one year old, Normandy, 1979; three years old, Normandy, 1981; with brother Jean-Baptiste, Corsica, 1985; with Jean-Baptiste, Normandy, 1984; 4th Row: at the dinner table, Normandy, 1983; judo class, Normandy, 1986; First Communion, Paris, 1991; sophomore in high school, Normandy, 1992; Line & Dominique, Corsica, 1997; Bottom Row: EuroDisney, from left: Line, Laetitia, sister Marie-Ange, Jean-Baptiste, 1993; with Marie-Ange, Corsica, 1997; from left: Line, Laetitia, and Laure, Corsica, 1997

14 Top Row, left to right: Laetitia, back row, second from left; swimming in Corsica, 1987; with Jean-Baptiste in judo class, Paris, 1991; 2nd Row: Corsica, 1992; twentieth birthday party, from left: cousin Pierre-Jean, Marie-Ange, Laetitia, Line, Paris, 1998; with Marie-Ange, Paris, 1992; 3rd Row: with Line and Marie-Ange, Corsica, 1992; with Dominique, San Remo Music Festival, Italy, 1999; Marie-Ange, Corsica, 1997; Bottom Row: with Marie-Ange and Jean-Baptiste, Corsica, 1997; with Line, Corsica, 1996

16 Michel Luccioni, Corsica, 1998

17 Andrea Danese, Corsica, 1998

18 All pictures taken in Corsica. Clockwise from upper left: Laetitia herding goats, 1998; with family, from left: Line, Marie-Ange, Laetitia, Dominique, 1995; chatting with Vincent & Marie, Santa Reparata, 1997; above and below: with the French Legion Exchange, 1997; a quiet moment, 1997; Lumio, 1997; fishing for lobsters, 1998

19 All pictures taken in Corsica. Clockwise from upper left: fishing for lobsters, 1998; next six images – all by Michel Luccioni: playing in the mountain rivers, 1998; a sunset in Lumio by Nicholas Callaway, 1998; winning the Miss Lumio Beauty Pageant, 1993; playing guitar, 1997; below: diving for lobsters, 1998; above: chatting with friends at the local drinking establishment, Lumio; below: on the beach, 1998; above: riding a donkey with Uncle Joseph, 1992; sunset in Lumio, 1997

20 Michel Comte for Italian *Vogue*, 1993

21 Photograph from Laetitia's first modeling shoot by Horst Deikgerdes, 1993

22 Top: with Yves Saint Laurent after his show, 1998; Bottom: wearing the flower ensemble designed especially for Laetitia by Yves Saint Laurent, Saint Laurent show, 1998

23 Sketch by Yves Saint Laurent of the flower ensemble he designed for Laetitia, 1999

24 Clockwise from upper left: Wearing a heart necklace designed for Laetitia by Yves Saint Laurent, 1998; wearing a wedding gown, Saint Laurent show, 1998; a heart for Laetitia, sketched by Saint Laurent, 1999; Laetitia and Marie-Ange play in the puddles after the Yves Saint Laurent show, while Line and Laure follow (at right), 1998

25 Saint Laurent show, 1998; happy birthday wish to Laetitia from Christophe Girard, 1999; Saint Laurent show, 1998; the headress; Saint Laurent show

26 Art director: Paul Marciano, photographer: Dah Len, GUESS? © 1997

28-29 Art director: Paul Marciano, photographer: Dominique Issermann, GUESS? © 1997

30 Top left: Art director: Paul Marciano, photographer: Dewey Nicks, GUESS? © 1996
Top right: Art Director: Paul Marciano, photographer: Dean Isidro, GUESS? © 1995
Bottom left: Art director: Paul Marciano, photographer: Dewey Nicks, GUESS? © 1995
Bottom right: Art director: Paul Marciano, photographer: Dewey Nicks, GUESS? © 1996

31 Art director: Paul Marciano, photographer: Dewey Nicks, GUESS? © 1995

32-33 Art director: Paul Marciano, photographer: Daniela Federici, GUESS? © 1999

35 Dominique Issermann, 1999. Reproduction courtesy of Victoria's Secret

36 Marc Hispard, 1998. Reproduction courtesy of Victoria's Secret

37 Marc Hispard, 1998. Reproduction courtesy of Victoria's Secret

38-39 Walter Chin for *Sports Illustrated*, 1998

40-41 Dominique Issermann for *Sports Illustrated*, 1999

42 Herb Ritts for *Rolling Stone*, 1998. Rolling Stone® is a registered trademark of Straight Arrow Publishers Company, L.P. All Rights Reserved. Reprinted by Permission.

45 Herb Ritts for the 1999 Pirelli Calendar. Copyright © 1999 Pirelli UK Tyres Limited.

46-47 Wolfgang Ludes for L'Oréal, 1999

48 Top Row, left to right: Laetitia arriving at the 1999 Cannes Film Festival; 2nd Row: the 1998 Cannes Film Festival; 3rd Row, first four images: on-stage at the San Remo Music Festival; Laetitia playing with a soccer ball at the final of the 1998 World Cup Tournament; at San Remo with co-presenter Fabio Fazio; below: joking on-stage at San Remo with Fazio; 4th Row: World Cup Tournament with the winning team; at San Remo with Fazio and her other co-presenter, Renato Dulbecco; Bottom Row: practicing for the Yves Saint Laurent show that preceded the World Cup final; at the World Cup final; having fun at the World Cup final

52 Laetitia as Falbala, Dominique Issermann for French *Elle*, 1999

53 With Gérard Depardieu as Obélix, Dominique Issermann for French *Elle*, 1999

54-55 Dominique Issermann for French *Elle*, 1999

56 Top: Laetitia as Falbala by Etienne George, 1998; Bottom left: storyboard for *Astérix & Obélix* by Fabien Lacaf; Bottom right: promotional poster

57 Counter-clockwise, from top – first three by Etienne George: Falbala and Obélix; Falbala and Obélix; Falbala; storyboard by Fabien Lacaf; snapshot on the set; snapshot on the set; 1998 Cannes Film Festival, from left: Christian Clavier, Laetitia, Gérard Depardieu

59 Herb Ritts for American *Vogue*, 1995

60-61 Sculptures by Jean-Marc de Pas, 1997

63 Freidmann Hauss for French *Elle*, 1998

65 Michel Nafziger for *20 Ans*, 1993

67 Dominique Issermann for the *New York Times Magazine*, 1998

68-69 Christian Kettiger, 1994

71 Paolo Roversi for British *Vogue*, 1995

72-73 Paolo Roversi, 1995

74 Charcoal drawing by Laetitia, 1998

75 Christian Kettiger for *20 Ans*, 1994

76-77 Walter Chin for Italian *Vogue*, 1995

78 Satoshi Saikusa for Italian *Glamour*, 1993

79 Charcoal drawing by Laetitia, 1998

80-81 Charcoal drawing by Laetitia, 1998

82 Phillip Dixon for *Top Model*, 1997

85 Stephane Sednaoui, 1999

87 Dominique Issermann, 1999

88-89 Randall Mesdon, 1997

90-91 Dominique Issermann, 1999

92 Starfish by Laetitia, 1999

93 Michel Nafziger for *20 Ans*, 1993

94-95 Hans Feurer, 1998

96-97 Dominique Issermann for *Sports Illustrated*, 1999

99 Peter Lindbergh for German *Marie Claire*, 1996

100 Phillip Dixon for French *Elle*, 1997

101 Phillip Dixon for *Top Model*, 1997

102-103 Lothar Schmid for French *Elle*, 1997

104-105 Dominique Issermann for *DS Magazine*, 1997

107 Patrick Demarchelier, 1998

109 Patrick Demarchelier, 1998

110 Phillip Dixon, 1996

112-113 Lothar Schmid for French *Elle*, 1997

114-115 Dominique Issermann for French *Elle*, 1997

116 Dominique Issermann for French *Elle*, 1998

117 Art director: Paul Marciano, photographer: Dominique Issermann, GUESS? © 1997

118-119 Dominique Issermann, 1999

120-121 Arthur Elgort for Italian *Vogue*, 1994

122 Michel Nafziger for *20 Ans*, 1993

124 Top: Laetitia, Corsica, 1986; Bottom: Lumio, 1997

125 Top: Lumio, 1997; Bottom, left to right – all by Nicholas Callaway: Lumio, 1998; Santa Reparata, 1998; Dominique and Laetitia, Lumio, 1998; road signs, Corsica, 1998

127 Cartoon by Brian Nice, 1998

128 Collage by Mike, 1999

Back endpaper: Starfish family by Laetitia, 1999

Acknowledgments

I give a big kiss to all whose photographs appear in my book, and to everyone
who has made this book possible.
A very special thanks to Madison Models and to everyone else who has supported
me throughout the years. I couldn't have done it without you.
I thank you all for your patience, collaboration, kindness, and understanding.

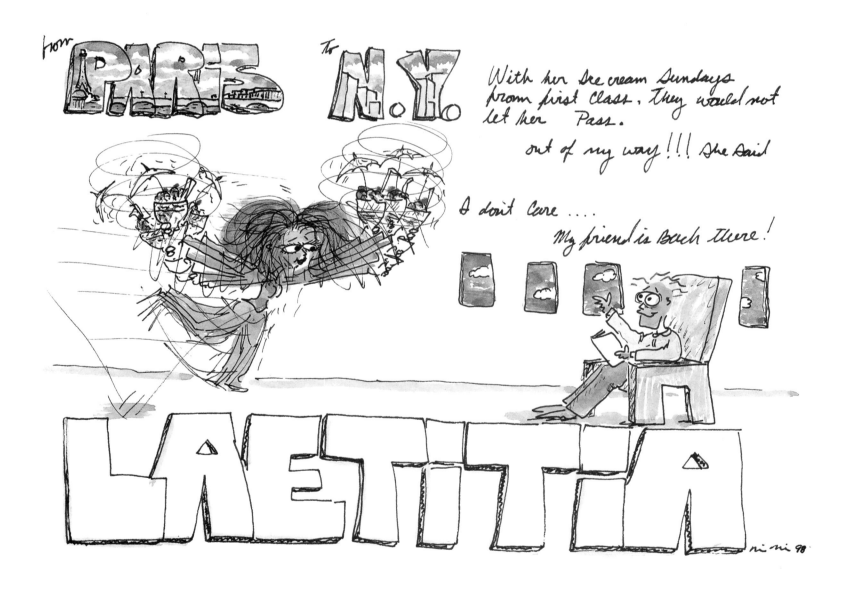

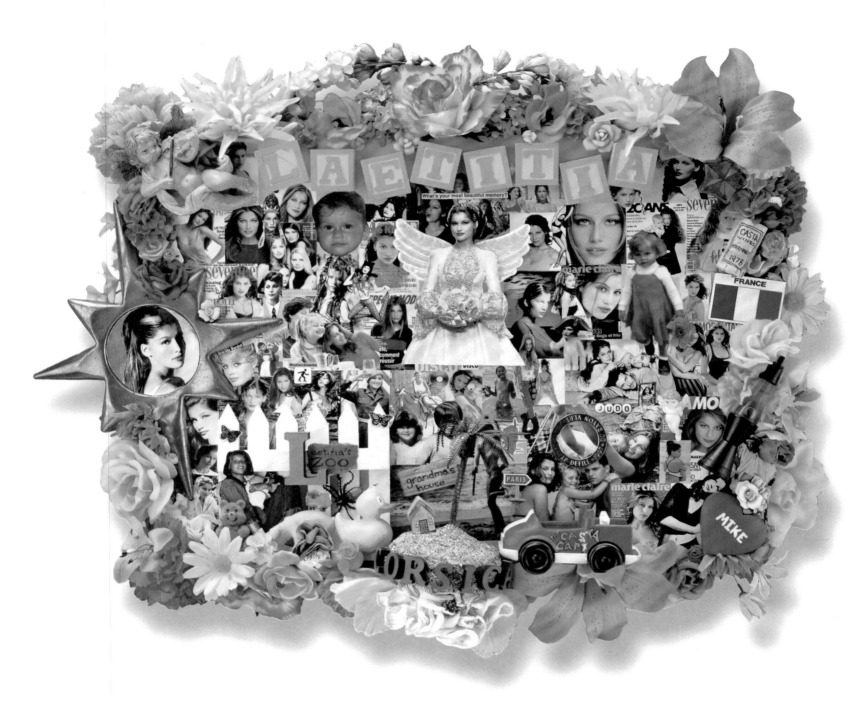

This book was produced by Callaway Editions.
Toshiya Masuda, Designer.
The typeface used is Didot, drawn by Jonathan Hoeffler,
and Linoscript by Adobe Systems, Inc.

Printed and bound by Palace Press International in China.

Please visit Laetitia at her website http://www.laetitiacasta.com

VIKING STUDIO

Published by the Penguin Group
Penguin Putnam, Inc., 375 Hudson Street,
New York, New York 10014, USA
Penguin Books Ltd, 27 Wrights Lane,
London W8 5TZ, England
Penguin Books Australia Ltd, Ringwood,
Victoria, Australia
Penguin Books Canada Ltd, 10 Alcorn Avenue,
Toronto, Ontario, Canada M4V 3B2
Penguin Books (N.Z.) Ltd, 182-190 Wairau Road,
Auckland 10, New Zealand

Penguin Books Ltd, Registered Offices:
Harmondsworth, Middlesex, England

First Published in 1999 by Viking Studio
A member of Penguin Putnam, Inc.

Text appearing on pages 12, 15, 17, 18, 19, 53, 66, 69, 70, 84, 86, and 108 is based upon an article
written by Roberto di Caro in the December 27, 1998, issue of *L'Espresso*.
Copyright © 1998 *L'Espresso*

Text on pages 25, 49, 64, 79, and 83 by Roberto di Caro

Poem on page 58 copyright © 1999 by G.F. Bernardini of I Muvrini

CIP data available upon request.

ISBN 0-670-88819-2

10 9 8 7 6 5 4 3 2 1

First Printing